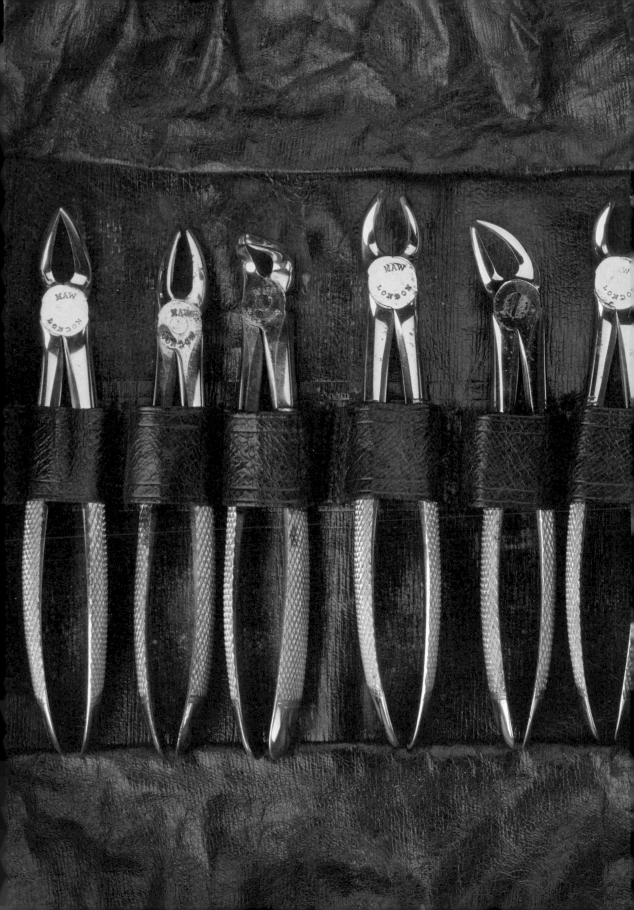

THE
SMILE
STEALERS

THE
FINE + FOUL
ART OF
DENTISTRY

RICHARD BARNETT

Thames & Hudson

FRONT COVER | Hand-tinted illustration after H. Jacob
showing an extraction technique using dental pliers, from
the 1841 abridged Italian edition of Jean-Baptiste Marc
Bourgery's *Traité complet de l'anatomie de l'homme
comprenant la médecine opératoire*, volume 1, plate 25.
BACK COVER | Illustration from the 1933 cover of the
trade catalogue for the Rathbone dental unit.

The Smile Stealers © 2017 Thames & Hudson Ltd, London

Text © 2017 Richard Barnett

Design by Daniel Streat at Visual Fields

This book is published in partnership
with Wellcome Collection and the Wellcome
Library, part of the Wellcome Trust,
215 Euston Road, London NW1 2BE.

www.wellcomecollection.org

wellcome
collection

Wellcome Collection is the free visitor destination for the
incurably curious. It explores the connections between
medicine, life and art in the past, present and future. It is
part of the Wellcome Trust, a global charitable foundation
that exists to improve health for everyone by helping great
ideas to thrive. The Wellcome Trust is a charity registered
in England and Wales, no. 210183.

All the images reproduced in this book are reproduced
courtesy of the Wellcome Library, except where stated. For
further information about individual images, see page 251.

First published in 2017 in hardcover in the United States
of America by Thames & Hudson Inc., 500 Fifth Avenue,
New York, New York 10110

www.thamesandhudsonusa.com

Library of Congress Control Number 2016941841

ISBN 978-0-500-51911-0

Manufactured in China by Imago

Over 500 illustrations

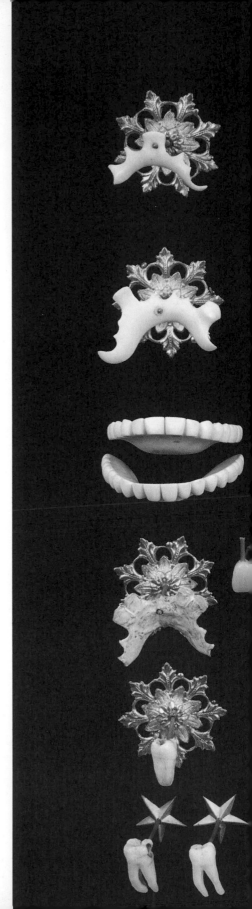

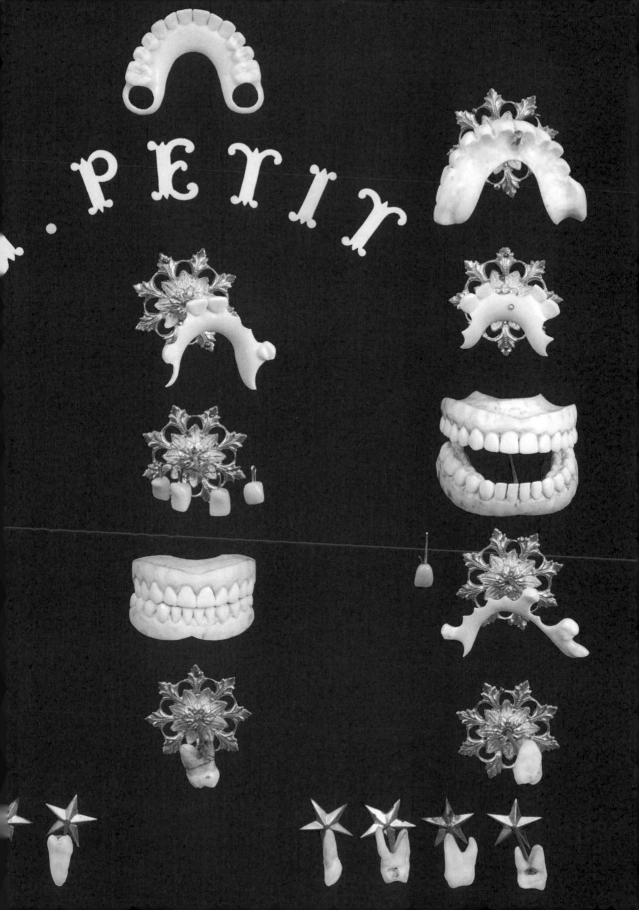

PAGE 1 | Watson and Sons (Electro-Medical Ltd.) manufacturer's catalogue (c. 1924). The application of X-rays to dentistry: a simplified summary of X-ray theory and practice for the dental practitioner.

PAGE 2 | Dental forceps in a black leather roll case by British medical instrument manufacturer S. Maw, Son and Thompson (1870–1901). The different types of forceps were used on various sizes and shapes of teeth. Each of them has the words 'MAW LONDON' punched into the surface in reference to the manufacturer.

PAGES 4–5 | Advertisement for a dentist's window display unit, illustrating ivory work and extracted teeth. Made for J. Petit, Paris (c. 1880).

PAGES 6–7 | *Portrait of St Apollonia*, patroness of dentistry. Oil painting by a follower of Francisco de Zurbarán.

PAGES 8–9 | Various models of adjustable dental chair, including a cast iron hydraulic chair with mahogany fittings, for use with children, by The Dental Manufacturing Co., England (1910–30, bottom left) and the 'Diamond 2', by the S. S. White Dental Manufacturing Company of Philadelphia (1925–35, bottom right).

PAGES 10–11 | *An Operator Extracting a Tooth*. Seventeenth-century oil painting after Adriaen Brouwer.

PAGES 12–13 | Illustration of various dental instruments, including lancets, dental keys, tools to remove the root of a tooth and utensils to clean teeth and remove tartar. From *Il Dentista Istruito* (1834) by J. C. F. Maury.

PAGE 14 | This painting (c. 1912) by British artist Ernest Board illustrates the first use of ether as an anaesthetic in 1846 by dental surgeon William Thomas Green Morton.

PAGE 15 | In this nineteenth-century painting by Luciano Nezzo, a surgeon holds a dental key behind his back to conceal it from the patient. One of the themes of the painting is the contrast between the two figures: for example, she is trustingly exposing her person, while he is deceptively hiding the dental tool.

PAGES 16–17 | A group of full and partial dentures held in storage at Blythe House, London.

PAGES 18 and 19 | Two young patients have their rotten teeth examined at Friern Hospital, London. From a collection of clinical pathological photographs (c. 1890–1910).

PAGE 20 | A selection of images from *Methods of Filling Teeth* (1899) by Rodrigues Ottolengui.

PAGE 22 | The metal, glass and ceramic Tri-Dent dental station was introduced in c. 1920 by Ritter Dental Manufacturing Company Inc., which pioneered the grouping of dental operating tools within a single unit. Air, gas, water and electricity were all close to hand, along with a high-speed electric drill, directional light and a fountain spittoon.

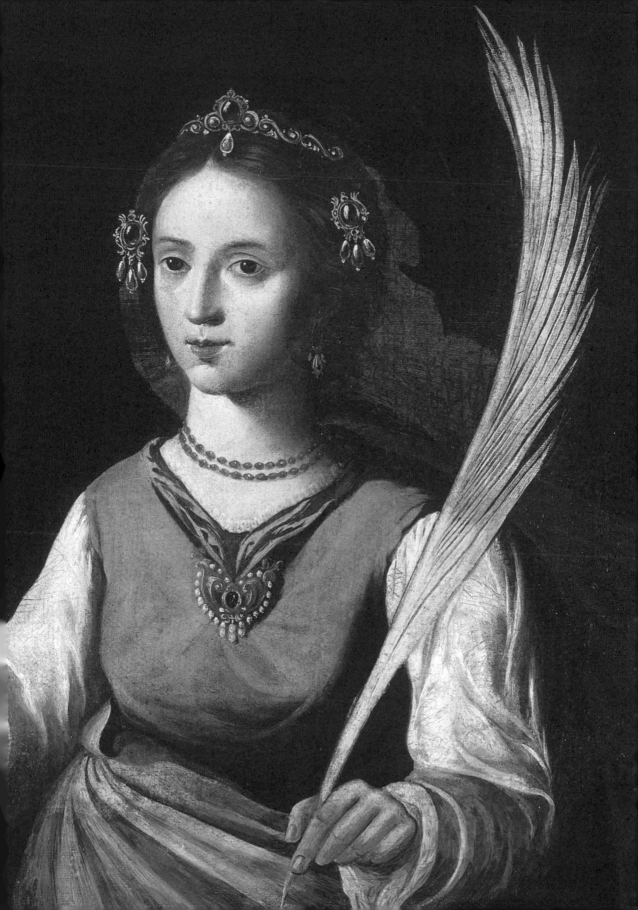

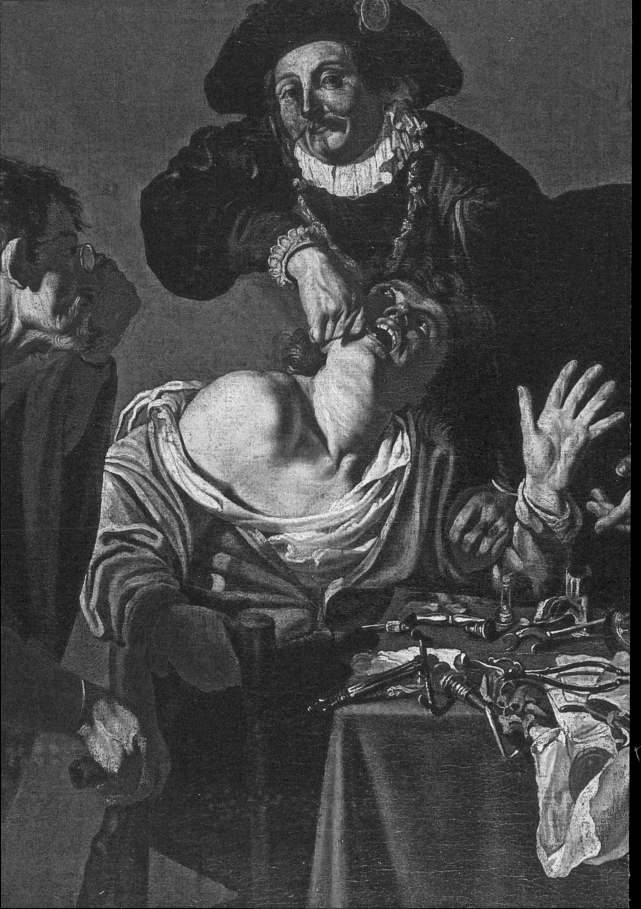

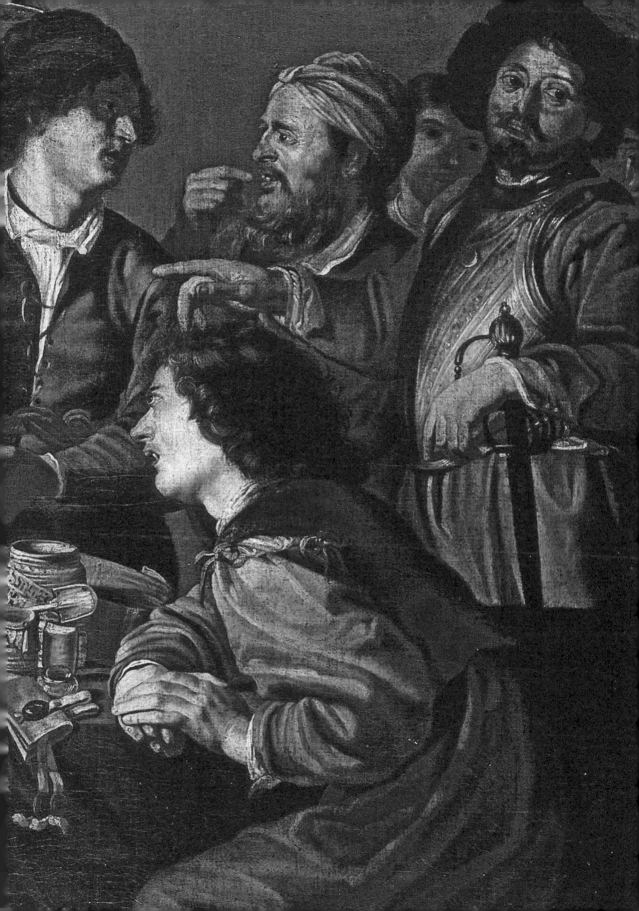

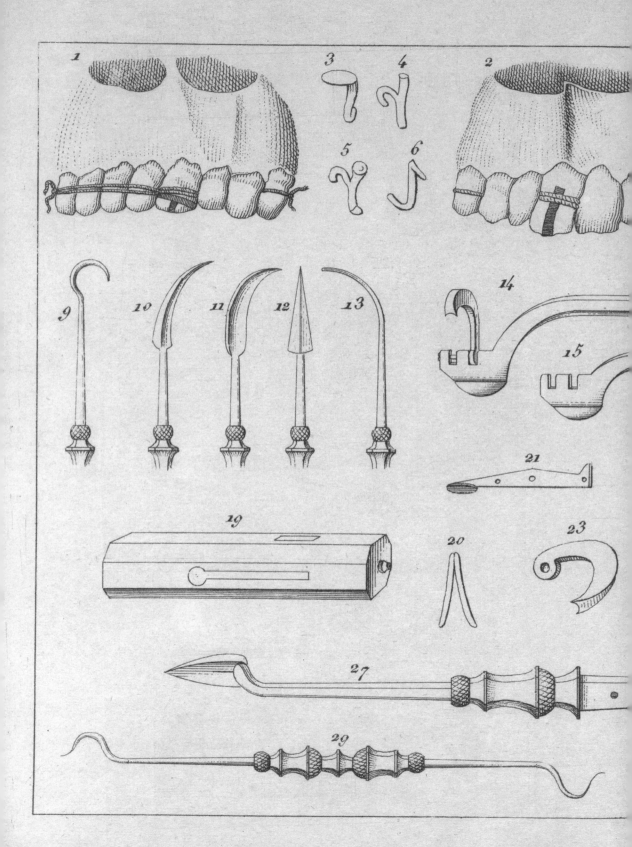

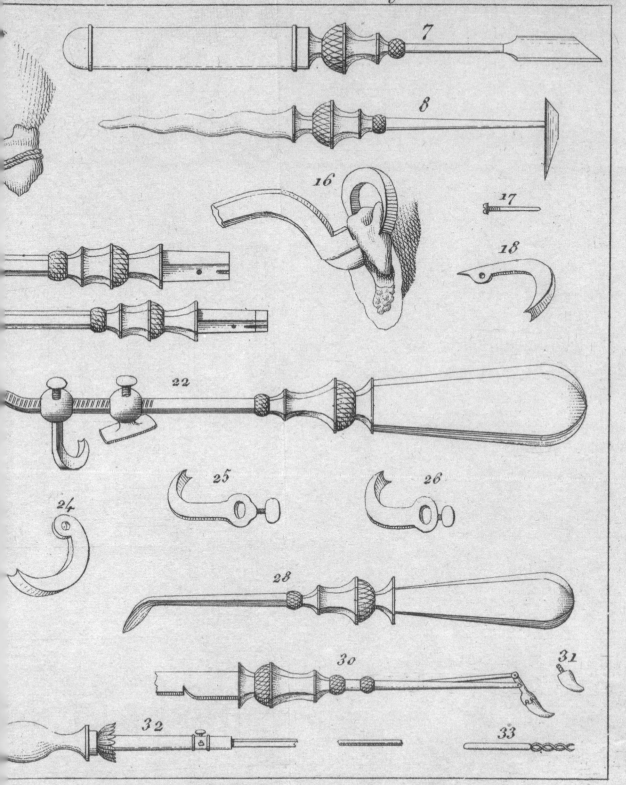

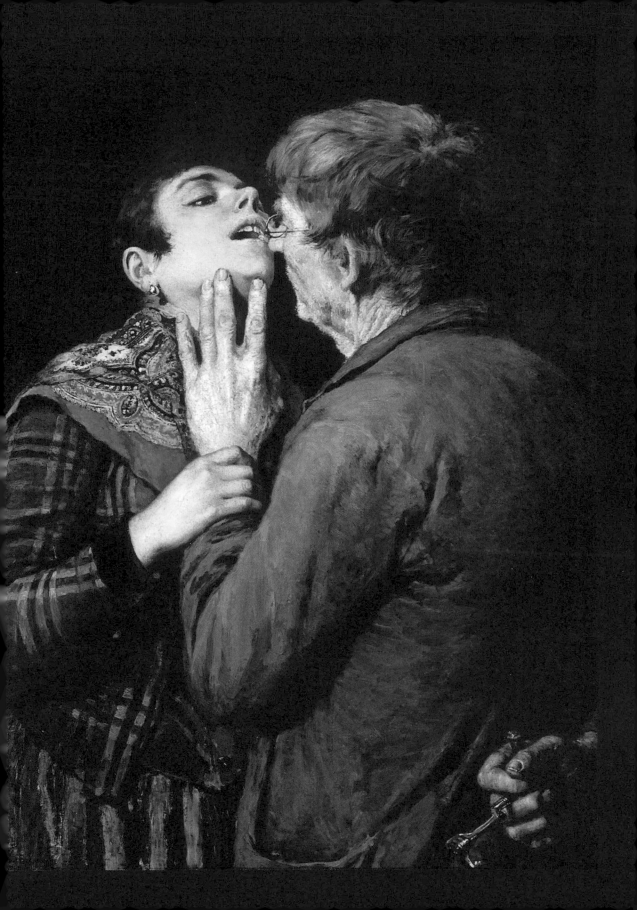

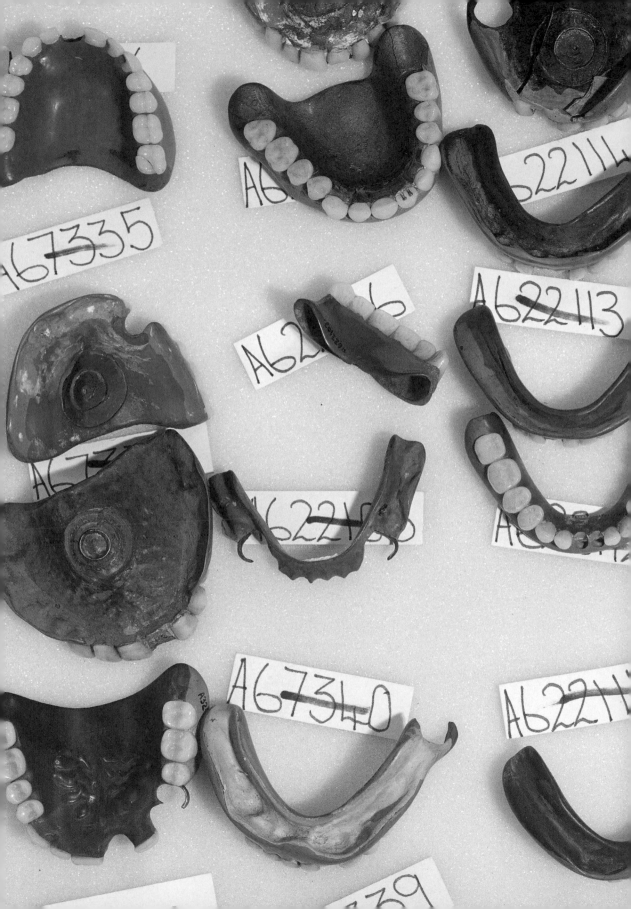

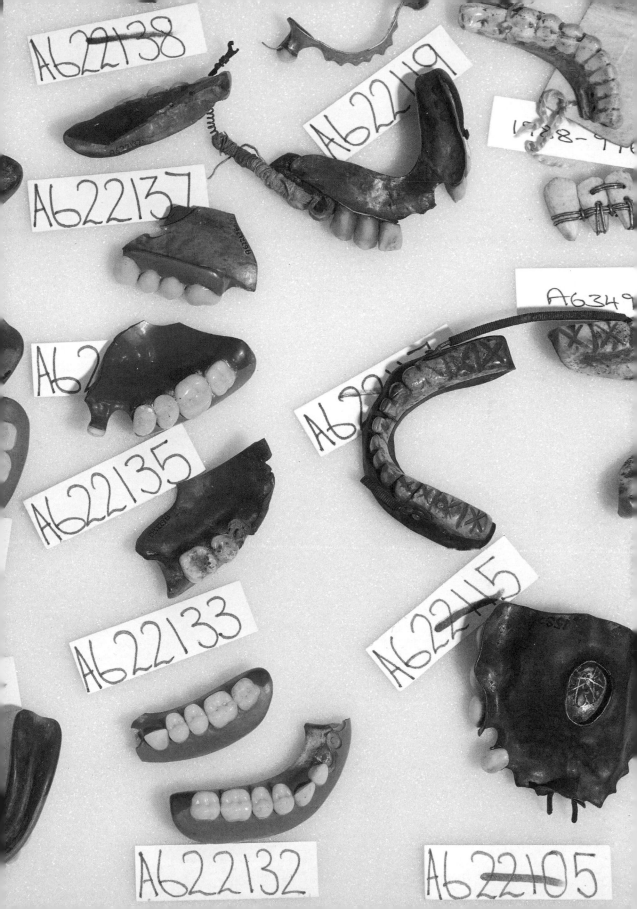

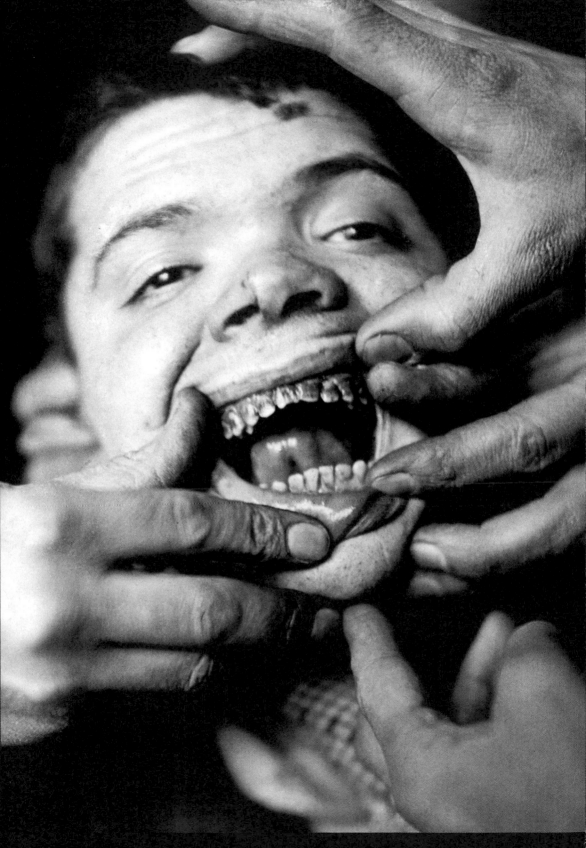

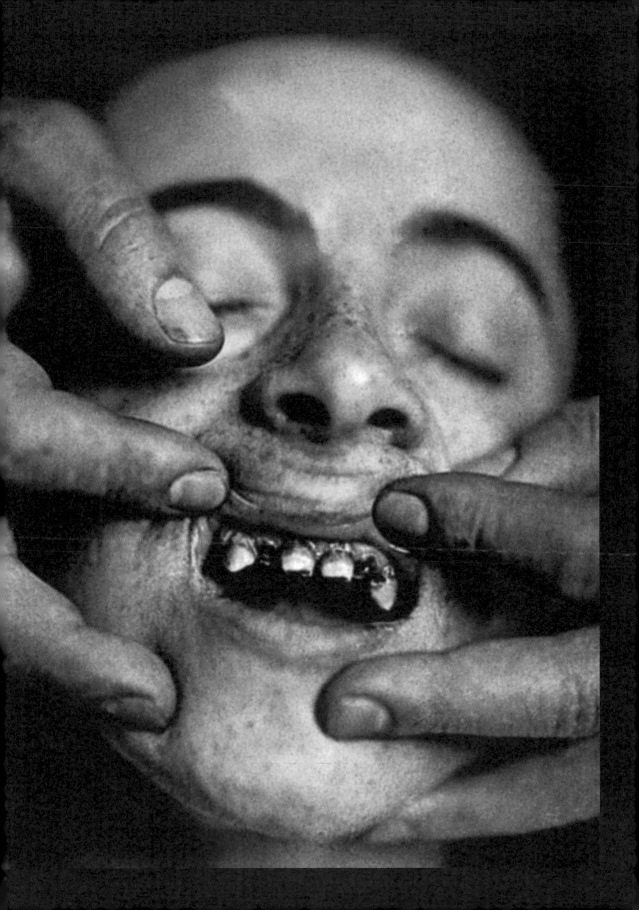

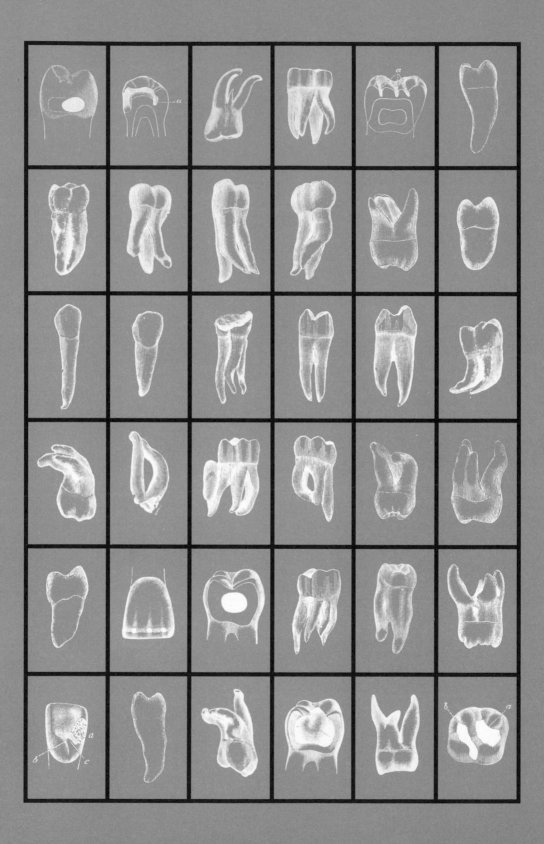

CONTENTS

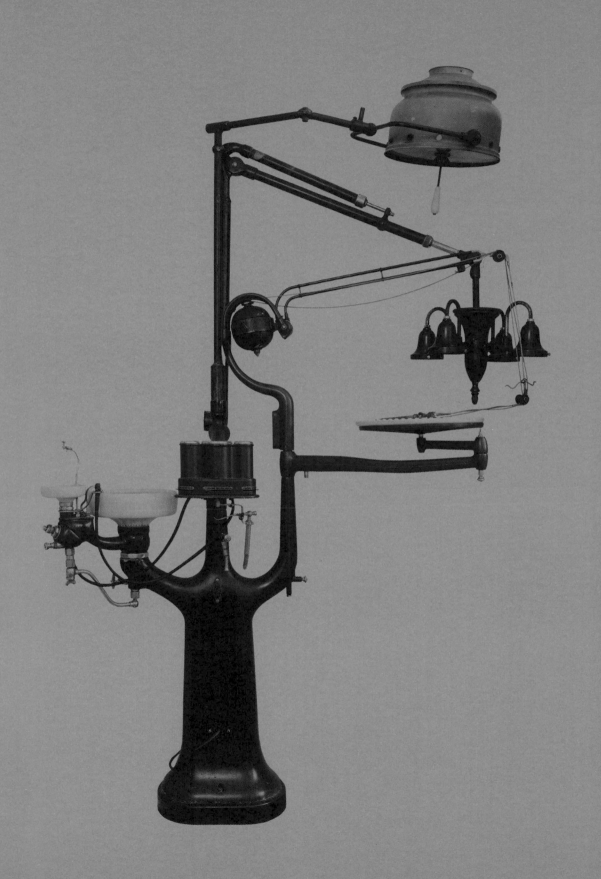

INTRODUCTION

YOU

KNOW

THE

DRILL

If Marcel Duchamp had been asked to choose a readymade to represent the tree in Samuel Beckett's *Waiting For Godot* (1952), he could hardly have done better than the Ritter Tri-Dent dental station (see p. 22). This spindly tangle of glass and porcelain and rust-spotted chrome, manufactured in the early 1920s, stands on a low plinth in the Reading Room of Wellcome Collection in London. Limbs and branches grow out of a chunky stem like a pollarded oak, painted to resemble polished wood. One holds a platter for tools and materials, another a spittoon, a third an adjustable spotlight and a lamp with four glass globes – but most visitors' eyes are drawn to the drill. Strung with ropes running from an electric motor in its base, this articulated armature of fine steel tubes might be a prototype Anglepoise lamp or a steampunk prosthesis.

As I look at it, as I walk around it, this remarkable object evokes two kinds of responses. Thinking as a historian, I find the Tri-Dent speaks of a particular moment in the history of

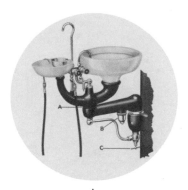

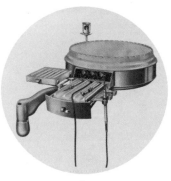

A B C

medicine: the reinvention of dentistry for the age of mass industry. It encodes new ideas of ergonomic efficiency and, like the industrial assembly lines invented by the previous generation, it turns its human participants into components of a larger machine. The electric drill and electric lights remind us that this new dentistry was wired into the national power grids of the early twentieth century. We can trace the influence of germ theory and aseptic surgery in the white, washable spittoon and tool platter, while the nozzle for anaesthetic gas recalls the nineteenth century's great achievement in making dentistry less painful (if not always painless). Together, dentist, patient and dental station became a kind of cyborg, a machine for mass-producing healthy mouths in the era of Hollywood smiles and fluoride toothpaste.

Approaching it as a patient, though, the Tri-Dent provokes a completely different set of feelings: anxiety, apprehension, a deep and intimate kind of body horror. I remember the rubber-

gloved fingers probing my cheeks and gums, the sudden heat of a polishing brush on my molars, the jagged scratching of a dental pick against plaque and, more than anything, the ominous whine of a high-speed drill. When we talk about these sensations, we say they go right through you – a revealingly physical image for what we worry about when we sit in the dentist's waiting room. In this sense, the Tri-Dent embodies a profound paradox in our attitudes to looking after our teeth, one that lies at the heart of *The Smile Stealers*. Ask anyone to list the markers of medical progress, and the odds are that modern dentistry will be high on their list. Ask the same person to name the most unsettling moments in twentieth-century cinema, and they are likely to recall the notorious scene from *Marathon Man* (1976) in which Laurence Olivier straps Dustin Hoffman into a dental chair and tries to extract a confession with a pick and a drill.

Societies in most times and places have had specialists to maintain, repair, extract and replace bad teeth – but to call

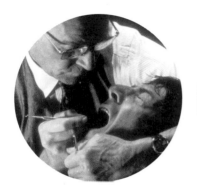
D

E

F

this disparate collection of practitioners 'dentists' is to miss the very particular history and meaning of the name. The *dentistes* who emerged in Paris at the end of the seventeenth century built a new professional identity around this contradictory mixture of aspiration and fear. Men such as Pierre Fauchard figured themselves as distinctively modern: not only armed with the very latest tools and techniques for creating *la bouche orneé*, but also attentive to the sensibility and suffering of their well-to-do patients. In doing so, they framed their predecessors as brutal, illiterate swindlers – although the differences between Fauchard, sometimes called the first dentist, and his exact contemporary, *Le Grand Thomas*, the last of the great Parisian charlatans, were not as clear as either would have wished. Furthermore, the subsequent story of dentistry, unlike that of surgery, was no meteoric rise to status and success. European and American dentists spent much of the nineteenth and twentieth centuries embroiled in a series

of arguments over their position within (or outside) medicine and their troublesome relationship with the state.

In his *Physiognomische Fragmente zur Beförderung der Menschenkenntnis und Menschenliebe* (Physiognomic Fragments for Furthering the Knowledge and Love of Man), published between 1775 and 1778, the Swiss physiognomist Johann Kaspar Lavater insisted that 'clean, white and well-arranged teeth ... [show] a sweet and polished mind and a good and honest heart', while rotten or misaligned teeth reveal 'either sickness or else some melange of moral imperfection'. Whatever we think of his notion that one can read human character directly from the face, Lavater reminds us that dentistry has never been only about teeth. Possession of a functional, pain-free mouth is a practical necessity – we all must breathe and eat and talk – but it is also central to our sense of self. Pain in the head can seem unbearably close to the core of who we are, and stinking breath or black teeth carry a stigma that is both peculiarly personal and

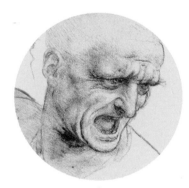

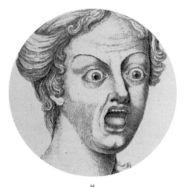

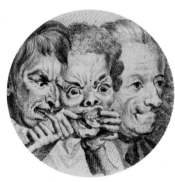

G H I

entirely public. Dental treatment has, as we will see, always been cosmetic, concerned with aesthetics as much as function – but in contemporary consumer culture Lavater has had the last laugh. A booklet published in 2000 by the American Association of Orthodontists claims that straightened teeth represent 'a highly visible commitment to self-improvement' and 'tangible proof that mom and dad are doing right by the kids', expressing 'the beauty of conformity' and 'the beauty of achievement'.[1]

This twenty-first-century version of *la bouche orneé* is a world away from the experiences of most of our ancestors, their teeth worn down by millstone grit in bread or eroded by cheap sugar. The images collected in *The Smile Stealers* tell stories of health and disease, chronicling the shift away from heroic extraction and towards contemporary preventative dentistry, but they also cast light on the history of beauty and ugliness, food and fashion, cultural ideals and individual unease. Writers and artists from Dante Alighieri to Francis Bacon have taken the gaping,

screaming, jagged-toothed mouth as an emblem of the most profound human suffering. In the words of the Russian critic Mikhail Bakhtin:

> ... FOR THE GROTESQUE THE MOST IMPORTANT PART OF THE ENTIRE FACE IS THE MOUTH. IT DOMINATES ALL. A GROTESQUE FACE CAN BASICALLY BE REDUCED TO A GAPING MOUTH AND ALL THE REST SERVES MERELY AS A FRAME FOR THIS MOUTH, FOR THIS BODILY ABYSS THAT GAPES WIDE AND SWALLOWS.[2]

Let's follow Bakhtin, and fall in.

① Eric K. Curtis, *Orthodontics at 2000*, American Association of Orthodontists, 2000, p. 10.
② Mikhail Bakhtin, *Rabelais and His World*, trans. Hélène Iswolsky, MIT Press, 1968, p. 317.

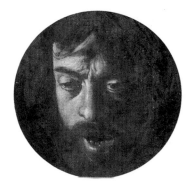

J

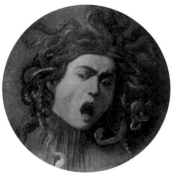

K

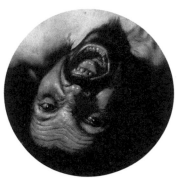

L

PREVIOUS | Rathbone dental unit parts as seen in the manufacturer's catalogue of dental unit equipment (1933): [A] Rathbone spittoon [B] Rathbone bracket table [C] Rathbone warm and cold water syringe/air compressor. [D] Laurence Olivier tortures Dustin Hoffman by drilling holes in his teeth in a scene from *Marathon Man* (1976). [E] Steve Martin stars as a violent and abusive dentist in *Little Shop of Horrors* (1986). [F] Christopher Lee as Willy Wonka's dentist father in *Charlie and the Chocolate Factory* (2005).

OPPOSITE AND ABOVE | [G] *Study for the Head of a Soldier in the Battle of Anghiari*, (1503–05), charcoal drawing by Leonardo da Vinci. [H] *Fear and Terror*, engraved by J. Mynde, from *Human Physiognomy Explain'd: In the Crounian Lectures on Muscular Motion* (1747) by James Parsons. [I] Engraving of three villains, from *Essays on Physiognomy: Designed to Promote the Knowledge and the Love of Mankind* (1799) by Johann Kaspar Lavater. [J] Detail from *David with the Head of Goliath* (1610) by Caravaggio, Galleria Borghese, Rome. [K] *Medusa* (1596-98) by Caravaggio, Uffizi, Florence. [L] Detail from *Apollo and Marsyas* (1637) by Jusepe de Ribera, Museo Nazionale di San Martino, Naples.

OVERLEAF | Straight-backed New Kingdom Egyptian chair from Thebes. The frame is made from sycamore fig and the seat is woven string.

THE

NATURAL

AND

ANCIENT

HISTORY OF

THE TEETH

1

By comparison with the rest of the animal kingdom, human teeth are, it seems, fairly dull. As the British archaeologist Simon Hillson has observed, we find the most striking and strange examples of dentition in the mouths of other mammals:

WHO COULD RESIST, FOR EXAMPLE, THE ELEGANT UPPER MOLARS OF A RHINOCEROS, OR THE FINE LINES OF MICROCHIROPTERAN BAT TEETH? NOT TO MENTION THE ASTONISHING INTRICACY OF THE COMPLEX-TOOTHED SQUIRREL *TROGOPTERUS*, WHICH PROBABLY HAS THE MOST COMPLICATED TEETH IN THE MAMMAL WORLD, AND THE COMPUTER-CHIP-LIKE DETAIL OF [THE WOODLAND JUMPING MOUSE] *NAPAEOZAPUS*, WHICH IS DIFFICULT TO BELIEVE WHEN SEEN FOR THE FIRST TIME UNDER THE MICROSCOPE.[1]

Whether they grow in the jaws of a rhinoceros or a mouse, mammalian teeth share a common basic structure. A crown of hard, vitreous enamel above the gums provides resilient surfaces for cutting and grinding, and a root anchors the tooth in the jawbone. Beneath the crown is a plug of dentine, more familiar to us in the form of walrus or elephant ivory – ironically, one of the most common materials from which early false teeth were made. Running up through the dentine is a soft pulp of blood vessels and nerves – the conduits of so much human suffering – and each tooth is held in its socket by cement and a tough, fibrous, periodontal ligament. Within this basic form, the teeth of mammals vary widely, but almost all can be classified (running from the front to the back of the mouth) into incisors, canines, premolars and molars. Almost every mammal has two sets of teeth, deciduous and permanent, both of which grow from buds within the infant's jawbone.

The environment into which these teeth erupt is a kind of jungle: warm, wet, ecologically diverse and often hostile. Indeed, the human mouth hosts one of the richest arrays of microscopic flora in the body, and colonies of bacteria, viruses, yeasts and protozoa all flourish in this sheltered, nutrient-rich cavity. As in any ecosystem, different niches favour different forms of life: streptococci dominate the valleys of the molars, whereas the gaps between the teeth are home to colonies of anaerobic *Actinomyces*.

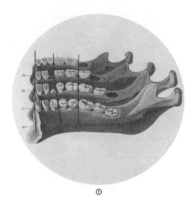

①

Plates from *The Natural History and Diseases of the Human Teeth* (1914) by Joseph Fox. ① The developmental changes in human teeth and the formation of permanent teeth in the jaw at age six [A], age eight to nine [B], the appearance of second molars [C] and as an adult [D]. ② Examples of teeth affected by absorption, decay and disease. ③ Examples of permanent teeth with irregular growth.

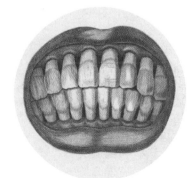

②

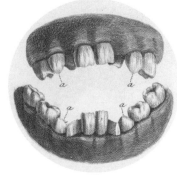

③

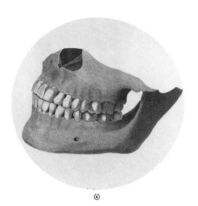

④

Plates from Fox's *The Natural History and Diseases of the Human Teeth*. ④ A permanent set of human teeth. The full illustration shows the difference between the temporary and the permanent teeth of the upper jaw and lower jaw. ⑤ Further examples of teeth affected by absorption, decay and disease. ⑥ The teeth marked with 'a' are temporary teeth and should be extracted to correct the growth pattern.

⑤

⑥

Because of this, even the most well-maintained mouth will likely have spots of plaque in inaccessible places. Like teeth, plaque owes its strength to its composition: a mixture of proteins from saliva, polymers produced by bacteria and crystals of calcium phosphate. Plaque itself does not damage teeth, but it shelters bacteria that metabolize carbohydrates – especially sugars – and excrete acids as a waste product. These plaque acids are largely responsible for dental caries, demineralizing the enamel and the underlying dentine, eroding cavities and generating abscesses. If it is not removed, plaque can build up into painful and disfiguring concretions, as described in this grim example from the London dentist Thomas Berdmore's *A Treatise on Disorders and Deformities of the Teeth and Gums* (1768):

A GENTLEMAN OF THE BANK, NOT ABOVE TWENTY-THREE YEARS OF AGE, APPLIED TO ME FOR ADVICE CONCERNING HIS TEETH ... WHICH GAVE HIM CONSTANT PAIN. I FOUND THEM PERFECTLY BURIED IN TARTAR, BY WHICH EACH SET WAS UNITED IN ONE CONTINUOUS PIECE, WITHOUT ANY DISTINCTION, TO SHOW THE INTERSTICES OF THE TEETH, OR THEIR FIGURE OR SIZE. THE STONY CRUST PROJECTED A GREAT WAY OVER THE GUMS ON THE INNER SIDE, AS WELL AS ON THE OUTER, AND PRESSED UPON THEM SO HARD AS TO HAVE GIVEN RISE TO THE PAIN HE COMPLAINED OF. ITS THICKNESS AT THE UPPER SURFACE WAS NOT LESS THAN HALF AN INCH.

For archaeologists, fossil teeth have cast light on the deep history of humanity. They endure longer in the ground than even the largest bones, and because they are laid down in childhood and change very little after they erupt, they encode information about the growth of an individual. Perikymata – tiny concentric ripples on the permanent teeth, visible under an electron microscope – are laid down at regular intervals as a tooth forms, and variations in their spacing can indicate periods of stress or malnutrition, or the influence of diseases such as congenital syphilis. By comparing the teeth of living humans with those of other great apes and fossil hominids, archaeologists have clarified the branching of our evolutionary family tree – and teeth have

also illuminated some of the turning points in the emergence of modern humans.

Hillson points out that the appearance of the genus *Homo*, with its smaller molars, could be interpreted as a move away from the omnivorous foraging of the great apes and towards meat-eating and 'persistence hunting' – wounding prey in a surprise attack, then chasing it until it is exhausted. Teeth from more recent archaeological sites have been used to date the next great shift, from nomadic hunter-gathering to farming and a more settled lifestyle, and also to provide evidence of the changing burden of dental disease. Most prehistoric peoples suffered comparatively little caries, but a diet full of grit from quernstones and pots caused extensive wearing of molar enamel and dentine. Teeth with exposed pulps bear mute witness to the pain that must have burdened our ancestors if they survived into their thirties or forties.

What we do not find in the archaeological record and in the earliest surviving texts are the roots of a story that leads directly and inexorably to modern dentistry. Modification of the teeth may have many meanings and contexts, and indigenous cultures around the world – from Australia and Papua New Guinea to the Americas – have marked rites of passage or expressed their notions of beauty and belonging by chipping and filing teeth, and inlaying them with rock crystal, gold or obsidian. However, we do find a diverse and culturally embedded set of myths and stories woven around the suffering and disfigurement caused by bad teeth, and a collection of rituals and practices intended to mitigate or correct them. The most widespread and enduring of these stories, discovered in sources across the Middle East and Asia, explained toothache as the work of a malevolent worm. A vivid version of this tale was inscribed on a clay tablet in the library of King Ashurbanipal in Nineveh some time in the seventh century BC. A worm comes crawling out of the marshes to demand food from the gods, but is outraged by their offer:

> FOR ME! WHAT IS THIS? DRIED FIGS OR APRICOTS?
> LET ME INSERT MYSELF INTO THE INNER OF
> THE TOOTH AND GIVE ME HIS FLESH FOR MY
> DWELLING. OUT OF THE TOOTH I WILL SUCK

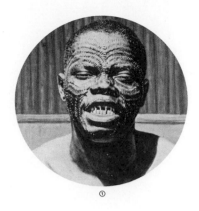

① In Bopoto, Northern Congo, it is customary to sharpen the upper teeth with a small chisel at the age of about fifteen, when the patient is able to bear the pain. ② A cedar panel from the mastaba of Hesi-Re, chief of dentists under Djoser, 3rd dynasty king of Egypt. ③ An Ottoman miniature depicting the anatomical view of a tooth. The source of toothache is shown as demons of hell.

②

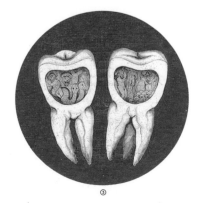

③

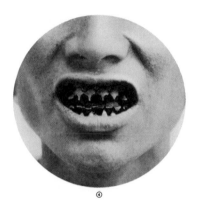

④ In the Philippines, the Bagobo modify their teeth by sharpening them into points. ⑤ Detail of the head of an Egyptian mummy, with teeth preserved, Museo Egizio, Turin. ⑥ *The Tooth Worm as Hell's Demon*, eighteenth-century ivory carving showing the infernal torments of a toothache depicted as a battle with the 'tooth worm', complete with mini skulls, hell fire and naked humans wielding clubs.

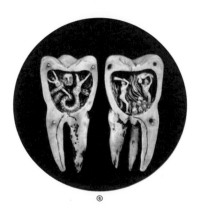

HIS BLOOD, AND FROM THE GUM I WILL CHEW THE MARROW. SO I HAVE ENTRANCE TO THE TOOTH!

A few lines later, the tablet combines prayer and the power of a medicinal plant to provide a remedy: 'You shall pulverize henbane and knead it with gum mastic and place it in the upper part of the tooth, and three times you shall recite this incantation.' When Ashurbanipal's scribe set down this story, the notion of the tooth worm had been common currency for more than two thousand years in cultures across the Middle East and Asia. The authors of early Chinese medical texts such as the *Pen Ts'ao* (*c.* 3700 BC) and the *Canon of Medicine* (*c.* 2700 BC) argued over whether toothache was caused by tooth worms or by a humoral imbalance, and recommended a pungent medicine for relieving it:

ROAST A PIECE OF GARLIC AND CRUSH IT BETWEEN THE TEETH, MIX WITH CHOPPED HORSERADISH SEEDS OR SALTPETRE, MAKE INTO A PASTE WITH HUMAN MILK; FORM PILLS AND INTRODUCE ONE INTO THE NOSTRIL ON THE OPPOSITE SIDE TO WHERE THE PAIN IS FELT.

In these societies, greater power went hand in hand, generally speaking, with poorer teeth. The mummies of Egyptian Middle Kingdom priests and aristocrats are riddled with tooth cavities and abscesses, and in life dental care became something of an obsession for them. Some employed servants specifically for cleaning the teeth, and when King Djoser's 'chief toother', Hesi-Re, died in *c.* 2600 BC he was immured in his own well-appointed tomb. Around the same time, Indian court jewellers were securing the loose teeth of their wealthy clients with threads of silk or gold. Two and a half thousand years later, Roman dentistry had equalled and even surpassed this technical sophistication. Thanks to the early Roman habit of removing jewelry and dental work before cremating a body, then mixing them with the ashes for burial, we know that Roman practitioners could create elegant gold crowns, bridges and false teeth in ivory or boxwood.

As was so often the case in Classical culture, Roman thought and practice drew heavily on Greek antecedents. The authors of the *Hippocratic Corpus* (*c.* 400 BC) concluded that the immediate cause of

caries was particles of food trapped between the teeth, but that an individual's particular balance of humours might strongly predispose them to bad teeth. The leading physician in Rome, Claudius Galen, took this further, arguing that toothaches were caused by 'acrid and corroding humours' irritating the sensitive dental pulp. According to the fifth-century North African writer Caelius Aurelianus, the standard Roman tool for extraction – a pair of pincers known as a *dentiducum* – was a direct copy of the Greek *odontagogon*. Both the *dentiducum* and the *odontagogon* were made of soft lead, introduced in response to the problem of pulling teeth without shattering them and leaving fragments of root stuck in the jaw. In his encyclopaedic *De Medicina*, compiled in the first century AD, Aulus Cornelius Celsus recommended that carious teeth should be filled temporarily with lead and felt, to strengthen them for extraction. Celsus also proposed a less violent, though more protracted, method of removing bad teeth, using a lancet to cut the gum away from around the tooth before easing it out of its socket by hand – a technique said to have been the preference of ancient Japanese tooth-pullers.

In Classical Rome, as for centuries to come, extraction was the most common response to the torment of toothache – although there were other options. Scribonius Largus, physician to the emperor Claudius, advised his patients to fumigate their mouths with the smoke of henbane seeds, in the hope that this would drive out the tooth worms responsible for decay. He also recorded a recipe for tooth powder favoured by Messalina, Claudius' empress, composed of ammonium chloride, mastic resin and antler ashes. A near contemporary of Largus, the Syrian-Greek Archigenes, described a hand-powered trephine (hole saw) for boring into a bad tooth to release the accumulated humours. But a constant theme in early treatises on the teeth was the intractability of toothache, the drawn, haggard faces of those who suffer it over weeks or months and the great difficulty of relieving it. Celsus prescribed a soothing tonic containing mandrake root, opium and cinnamon, and Galen recommended the application of pickled chrysanthemum root directly to painful teeth; practitioners in other parts of the world tried henbane, hashish and therapies such as acupuncture.

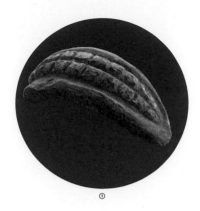

① Roman terracotta votive (200 BC–AD 200). Such objects were left at religious sites as offerings to gods such as Asklepios, the Greco-Roman god of medicine. It was intended to indicate the part of the body that needed help or as thanks for a cure.
② *Toothache*, detail of a carved wooden roof boss at Lincoln Cathedral, UK.
③ Anon, *Torture of St Apollonia* (*c.* 1515, detail), hand-coloured woodcut.

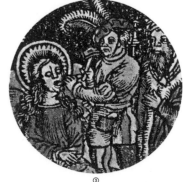

④ A mole's foot amulet (1890–1910). Mole's feet have a long and wide tradition as an amulet against toothache. They were recommended by the Roman writer Pliny in the first century AD. ⑤ *Toothache*, detail of a carved stone roof boss at Wells Cathedral, UK. ⑥ Anon, *St Apollonia* (1516, detail), from *Hortulus Animae*, hand-coloured woodcut, heightened with gold.

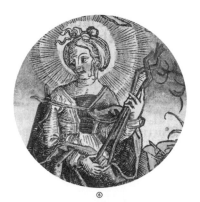

Given this enduring association between the teeth and excruciating pain, it is scarcely surprising that we can trace a parallel history of tooth extraction as torture and punishment. Perhaps the most notorious instance is the story of St Apollonia, who lived and died in Egypt in the second century AD. Almost everything we know of Apollonia comes from later hagiographies, and the details – that her mother had prayed to the Virgin Mary for a child, that Apollonia became a disciple of St Anthony of Egypt, that it was her father, a magistrate, who condemned her to death – seem like pious embroidery. But the earliest versions of her life have her meeting her end in an outbreak of anti-Christian persecution in Alexandria in 248–49. Shortly afterwards, Dionysius, bishop of Alexandria, recorded the manner of her death in a letter:

AT THAT TIME APOLLONIA, *PARTHÉNOS PRESBYTIS* [LITERALLY, 'SACRED VIRGIN', A PRIEST] WAS HELD IN HIGH ESTEEM. THESE MEN SEIZED HER ALSO AND BY REPEATED BLOWS BROKE ALL HER TEETH. THEY THEN ERECTED OUTSIDE THE CITY GATES A PILE OF WOOD AND THREATENED TO BURN HER ALIVE IF SHE REFUSED TO REPEAT AFTER THEM IMPIOUS WORDS. GIVEN, AT HER OWN REQUEST, A LITTLE FREEDOM, SHE SPRANG QUICKLY INTO THE FIRE AND WAS BURNED TO DEATH.

In the macabre manner of medieval Catholicism, St Apollonia was taken up as the patron saint of tooth-pullers and those suffering toothache. In icons and stained-glass windows, she is depicted with the instrument of her suffering – typically a long, blunt pair of blacksmiths' pincers – and the cathedral of Porto in Portugal possesses a jewel-encrusted reliquary said to hold a tooth torn from her jaw.

① Simon Hillson, *Teeth*, Cambridge Manuals in Archaeology, Cambridge University Press, 2005, p. 6.

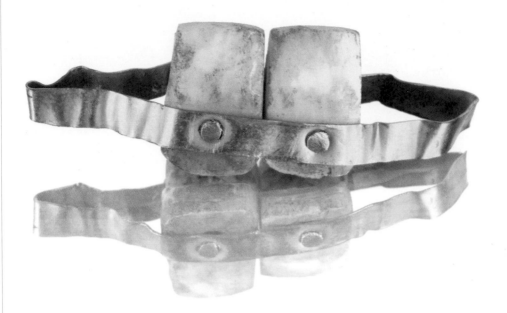

ABOVE | Etruscan two teeth lower denture. Copy of a gold setting with human teeth, discovered in a tomb in Etruria, Italy, in *c*. 700 BC.

BELOW | Roman lower bridge. Copy of a gold setting with filed-down ox tooth, discovered in a tomb in Satricum, Latium (Lazio), Italy, in *c*. 700 BC.

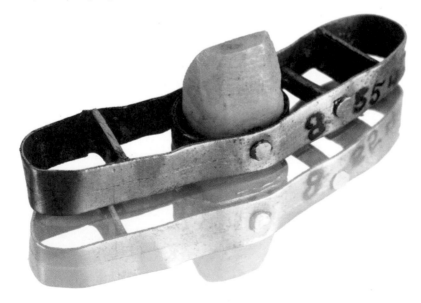

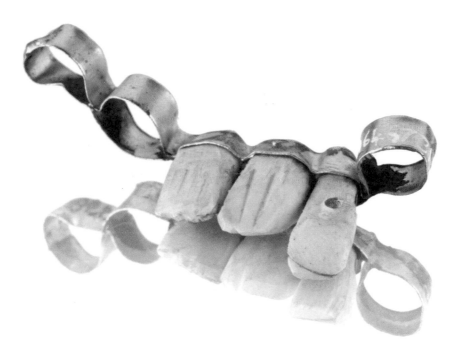

ABOVE | Metal bridge with replacement teeth,
fixed with a metal pin. The original dental bridge
was found in Teano, southern Italy.

BELOW | Gold setting fitted with replacement
animal tooth. The bridge would have been fitted
around the remaining teeth by a physician.

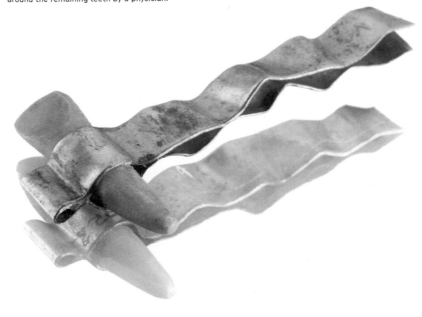

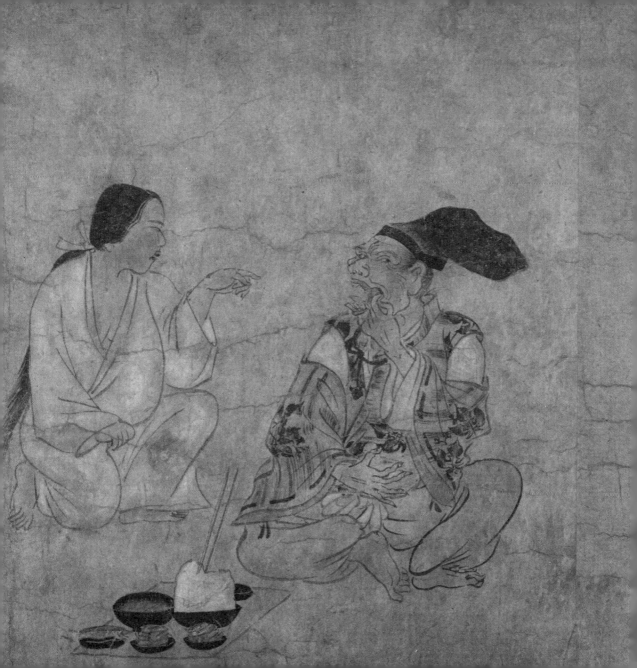

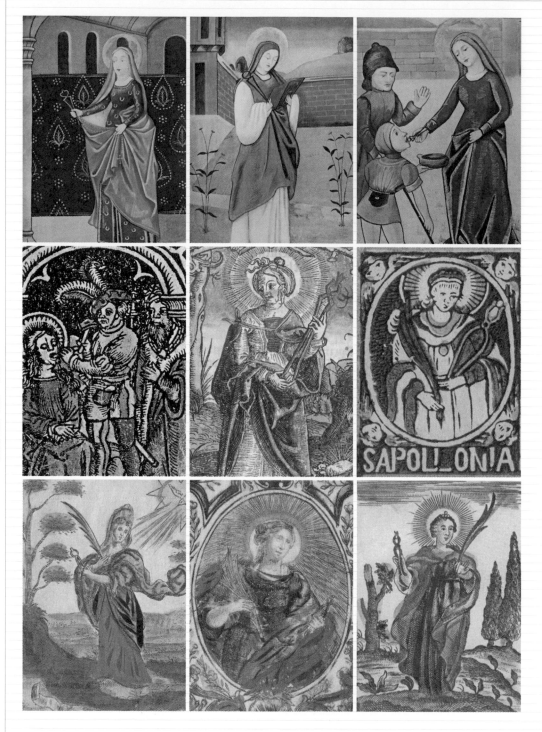

TOP L–R | Illustrations of St Apollonia, patroness of dentistry, from a fifteenth-century manuscript. CENTRE L–R | Anon, *Torture of St Apollonia* (*c*. 1515), hand-coloured woodcut; Anon, *St Apollonia* (1516), from *Hortulus Animae*, hand-coloured woodcut, heightened with gold; Anon, *St Apollonia* (*c*. 1550), woodcut in chiaroscuro. BOTTOM L–R | Michiel Cabbaey, *St Apollonia and the Dove* (*c*. 1720), hand-coloured engraving; Anon, *St Apollonia* (*c*. 1750), hand-coloured engraving; J. Busch, *St Apollonia VM* (*c*. 1750), hand-coloured engraving.

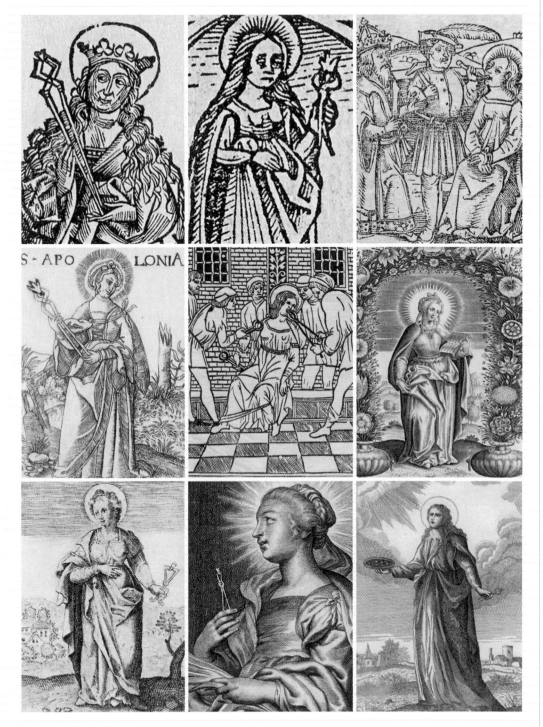

TOP L–R | From *The Nuremberg Chronicle* by Hartmann Schedel, first published in 1493; Woodcut illustration in *Hortulus Animae*, printed in 1506 by Michael Fürter; Anon, *Torture of St Appolonia* (1507), woodcut. CENTRE L–R | Anon, *St Apollonia*, holding her blacksmiths' pincers (*c.* 1550), engraving; Anon, *Torture of St Apollonia* (*c.* 1600), woodcut; Engraving by Abraham Van Merlen, *St Apollonia under an Arcadian Arch* (*c.* 1625). BOTTOM L–R | Anon, *St Apollonia* (1650), engraving; *St Apollonia* (*c.* 1650) by Schelte Bolswert, copper engraving; Anon, *St Apollonia VM, Shone from Heaven* (*c.* 1700), engraving.

PULLING TEETH IN MEDIEVAL EUROPE

2

To modern eyes, the agonies of St Apollonia capture the essence of early European dentistry. We imagine tooth-pulling charlatans with necklaces of rotten molars and shudder when we imagine what their clients must have gone through. But this gory image was, in large part, a fabrication of the first generation of *dentistes*, specialists who sought to calumniate their predecessors as mere brutes. Medieval dentistry could be excruciating, no doubt, but beyond this fearsome image we find a richer story, one that tells us much more about the hopes and fears of those who submitted to the brawny grip of the charlatans.

For most medieval and early modern Europeans, rich or poor, tooth loss was a part of life. An ordinary labourer or peasant could expect to lose one or two teeth before their fortieth birthday, and (if they lived long enough) this process would end with a toothless mouth. The most exalted figures on the continent were not exempt: Louis XIV of France, the Sun King, had lost all but a handful of his teeth by his early forties, and a German visitor to the court of Elizabeth I reported in 1578 that 'her lips are narrow and her teeth black, a defect that the English seem subject to, from their great use of sugar'. This points towards one of the great transitions in European eating habits and dental disease, from long-term attrition and wear to the black teeth, cavities and abscesses associated with a diet rich in refined sugar.

Wealthy, powerful monarchs such as Louis XIV and Elizabeth I were particularly vulnerable to the hazards of a sweet tooth. Although Europeans had been eating sugar from North Africa since the fourteenth century, it was not until the sixteenth century, when merchants established direct trade with Morocco, that large quantities came onto the market. By 1593 the English were consuming in the region of two thousand tons of sugar a year, almost all of which went straight into the mouths of the prosperous. At around nineteen pence a pound – roughly a day's wages for a skilled artisan – sugar was no mass-market commodity but an object of conspicuous consumption for the very richest. This began to change when English slave traders established plantations in the West Indies, and after the Restoration (begun in 1660) the price of this slave sugar fell dramatically. Around this time,

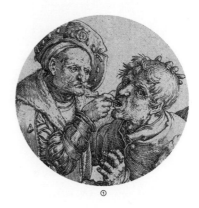

①

PAGE 40 | A carved oak English armchair from *c*. 1620, with panel and frame back. ① Detail from a line engraving by Lucas van Leyden (1523), in which a tooth-drawer extracts a tooth while his patient is being pick-pocketed. ② Detail from a portrait of Louis XIV (1701), by Hyacinthe Rigaud, with mouth closed so as not to reveal his tooth loss. ③ Prologue illustration in *Gargantua and Pantagruel* by François Rabelais.

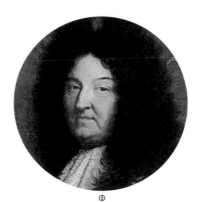

②

③

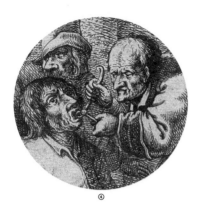

④

④ Detail from an etching by Carel Allard after Adriaen Brouwer, in which a tooth-drawer extracts a tooth from a patient as his worried wife looks on. ⑤ In *Portrait of Elizabeth I* (c. 1595), from the studio of Marcus Gheeraerts the Younger, the queen's lips remain closed to conceal her bad teeth. ⑥ Detail from *Gargantua at the Table* by Gustave Doré in Rabelais' *Gargantua and Pantagruel*, edition published in 1854.

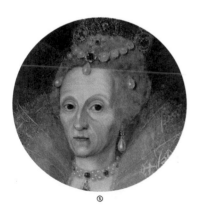

⑤

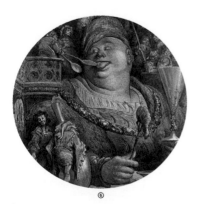

⑥

another product of the slave plantations – tobacco – also became a European vice, adding a smoky note to the foul breath of the rich.

Bad teeth caused all kinds of practical problems – nagging pain, difficulty eating, consequent indigestion and problems with speaking or even breathing – and in genteel and aristocratic circles they could be a source of shame and social exclusion. In his bawdy novels, the sixteenth-century French writer François Rabelais had explored the rich comic potential of the mouth and the anus: both could stink, both could (in a manner of speaking) speak, both could be made to seem hilariously independent of the body in which they dwelt. But courtly and, increasingly, bourgeois behaviour demanded what the British historian Colin Jones has called 'the systematic policing of the orifices'.[1] In public, one's own body should be unobtrusive and under control; it should not offend the senses of one's companions and, importantly, one should not draw attention to it. Ears and noses should not be probed, neither buttocks nor genitals scratched, and, above all, teeth must not be picked.

By far the most widely read Renaissance book on comportment – and one with a great deal to say on the husbandry of the mouth – was *Il Libro del Cortegiano (*The Book of the Courtier), written by the Italian courtier Baldassare Castiglione in 1528. Drawing heavily on Classical precedents, Castiglione sought to advance his readers by setting new boundaries on their behaviour, and especially what they did with their mouths. Rabelaisian laughter, in Jones' words, 'turned men into beasts', and open-mouthed, helpless laughter, especially in women, was the very height of lascivious vulgarity. Within the sharpened piety of Counter-Reformation Catholic Europe, laughter seemed ungodly: Christ was portrayed as the Man of Sorrows, but never a man of mirth. An ideal courtier would say little, laugh less, keep his lips sealed (not least to conceal black teeth or stinking breath) – in short, ensure that he was entirely in control of what came out of his mouth.

With this culture of genteel comportment came a new concern with techniques for maintaining a fresh and fragrant mouth. Early modern books of manners hectored their readers on the cardinal importance of sweet, or at the very least inoffensive, breath. Some

offered recipes for deodorizing mouthwashes, as in this example from *The English Man's Treasure* (1613) by Thomas Vicary:

TO TAKE AWAY THE STINKING OF THE MOUTHE — WASH MOUTHE WITH WATER AND VINEGAR AND CHEW MASTICKE THEN WASH MOUTHE WITH THE DECOCTION OF ANNIS SEEDS, MINTS AND CLOVES SODDEN IN WINE.

From the early sixteenth century, publishers churned out practical guides to maintaining the teeth. Particularly popular among English readers was *Useful Instructions on the Way to Keep Healthy, to Strengthen and Reinvigorate the Eyes and Sight with Further Instructions on the Way of Keeping the Mouth Fresh, the Teeth Clean, and the Gums Firm*, a 1544 translation of a text by the German apothecary and notorious plagiarist Walther Hermann Ryff. Toothpicks of chased silver or gold adorned the dressing cases and chatelaines of the aristocracy. During his exile in France in the mid-1640s, the English Parliamentarian politician Sir Ralph Verney received a letter from a friend asking if he could obtain a Continental novelty: 'the little brushes for making cleane of the teeth, most covered with sylver and some few with gold and sylver twiste, together with some petits bouettes to put them in.'

① In this satirical engraving by Coryn Bol after David Teniers, monkeys and other animals represent the practitioners and patients in a busy barber-surgeon's shop. ② Detail of an apothecary, from *Antidotaire; Collectorium Chirurgicum* (1461) by Bernard de Gordone and Guy de Chauliac. ③ A late sixteenth-century German mouth gag, used to open or hold open the jaw.

If the state of their teeth demanded more than a herbal mouthwash or a scrub with a silver-handled brush, who would these courtiers consult? The taboos erected by medieval and early modern physicians against the stigma of working with their hands meant that most doctors would not have deigned to concern themselves with the treatment of the teeth. Physicians in this period were not particularly concerned with the loss of teeth: like hair loss or deafness, it was part of the process of ageing, and there was little that could be done to stop it. Surgeons – a diverse group, ranging from local blood-letting barbers to the professors at the great Italian universities – took a closer interest in matters dental. Although the fourteenth-century French surgeon Guy de Chauliac argued that the treatment of the teeth should be recognized as a separate speciality, with its own techniques and body of learning, most Renaissance and early modern surgical authors made no distinction between dental work and the rest of their practice.

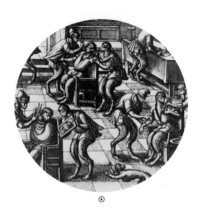

④

④ This satirical engraving (c. 1570) depicts the duties of a barber-surgeon: blood-letting, pulling teeth and treatment of wounds, for example. ⑤ 'The tooth-puller, the bagpipe player and the wood collectors', detail from the central panel of *The Haywain Triptych* (c. 1515) by Hieronymus Bosch. ⑥ The mechanism of this mouth gag meant that considerable force could be applied if necessary.

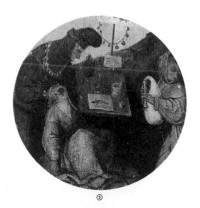

⑤

⑥

In order to understand toothache, these surgeons drew on the theories of Classical Greek and Roman writers, refracted through the prism of Islamic Renaissance scholars such as Ibn-Sīnā and Al-Zahrāwī (Latinized as Avicenna and Albucasis, respectively). Most endorsed the tooth worm theory of decay, and the Elizabethan courtier Sir John Harington's verse translation of the *Regimen Sanitatis Salernitanum* (The Salernitan Rule of Health), an eleventh-century Italian treatise, describes one of the standard remedies:

IF IN YOUR TEETH YOU HAP TO BE TORMENTED, BY MEAN SOME LITTLE WORMES THEREIN DO BREED, WHICH PAINE (IF HEED BE TA'EN) MAY BE PREVENTED, BY KEEPING CLEANE YOUR TEETH, WHEN AS YOU FEED: BURNE FRANKINSENCE (A GUM NOT EVIL SENTED), PUT HENBANE UNTO THIS, AND ONYON-SEED AND WITH A TUNNEL TO THE TOOTH THAT'S HOLLOW, CONVEY THE SMOAKE THEREOF, AND EASE SHALL FOLLOW.

Having literally smoked out what they believed to be the cause of tooth decay, a Renaissance barber-surgeon might employ a new technique to keep the tooth worms away. In the late fifteenth century, the Italian writer Giovanni d'Arcoli described the use of finely beaten gold foil to fill cavities in the teeth, and a century or so later the Italian surgeon Giovanni da Vigo set down the principles of this new practice: remove all decayed dentine with picks and trephines, treat the exposed pulp with arsenic compounds and make sure each layer of gold is pressed firmly into the cavity. Although a well-made filling could save a tooth and last for years, it required hours of scraping and hammering, and the technique did not become widespread until the development of anaesthesia. Barber-surgeons also cleansed discoloured teeth with a rag dipped in *aqua fortis* – nitric acid. Though this whitened the teeth, it served only to erode the enamel even further. Some practitioners turned this to their advantage, claiming that they could extract teeth *sine ferro* (without iron tools) by weakening them with acid until they were so loose they could be pulled out by hand.

For most people, of course, the treatment of a toothache was not a matter of silver brushes or gold fillings but a brief and painful extraction.

Like their surgical counterparts, the earliest tools for pulling teeth were derived from those found on the workbenches of medieval craftsmen. The 'pelican' – a vicious-looking hooked lever – originated as a device for pressing iron hoops onto barrel staves. Patients sat on a low stool, their head held between the tooth-puller's knees, while he locked his pelican onto the offending tooth and sought to unseat it. The leading French Renaissance surgeon Ambroise Paré argued, nervously, that surgeons drawing teeth should take care not to inflict serious injuries:

> THE EXTRACTION OF A TOOTH SHOULD NOT BE CARRIED OUT WITH TOO MUCH VIOLENCE, AS ONE RISKS PRODUCING LUXATION OF THE JAW OR CONCUSSION OF THE BRAIN AND THE EYES, OR EVEN BRINGING AWAY A PORTION OF THE JAW TOGETHER WITH THE TOOTH (THE AUTHOR HIMSELF HAS OBSERVED THIS IN SEVERAL CASES), NOT TO SPEAK OF OTHER SERIOUS ACCIDENTS WHICH MAY SUPERVENE, AS, FOR EXAMPLE, FEVER, APOSTEMA, ABUNDANT HAEMORRHAGE, AND EVEN DEATH.

Tools like the pelican could be slung into a satchel and carried from town to town, and they were taken up by the largest single group of early European dental practitioners. Roman writers satirized the itinerant tooth-pullers called *dentatores* or *edentari*, and in medieval Europe they went by a variety of names: 'toothers' in England, *arracheurs de dents* in France, *cavadenti* in Italy. Tooth-pullers set up shop in town marketplaces and village greens, but they seem to have done most of their business at the great fairs and markets of early modern Europe. Like other quacks, they knew how to put on a show, and the tooth-pullers of the Pont Neuf in Paris became one of the sights of the city, accompanied by dancers, comedians and monkeys, and clad in outrageous costumes that frequently included festoons of extracted teeth.

These are the gaudy, knockabout charlatans who appear in Dutch genre paintings by Jan van Vliet and Theodoor Rombouts – but, as the historian Roger King has pointed out, depictions like these are easy to misinterpret. At fairs and markets, mountebanks worked the crowd alongside tooth-pullers. These quacks sold medicines that they claimed would cure any toothache – most famously *orviétan*, a French

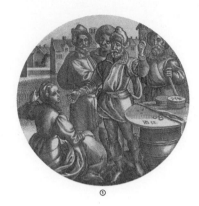

① The tooth-puller performs his operation with a flourish in *Extraction Sitting on the Street* (*c.* 1590), an engraving by J. H. Wierix. ② Detail from an etching by Jan van Vliet, in which a woman takes advantage of the patient and steals from his bag. ③ Detail from a painting after Adriaen Brouwer in which a well-dressed operator seems oblivious to his patient's distress as he extracts a tooth.

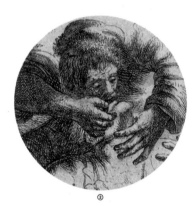

②

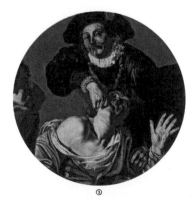

③

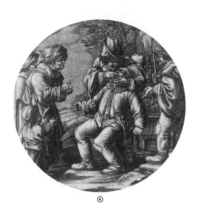

④ In 'Touch' (1630–52) from the series *The Five Senses* by Jan Both after Andries Both, peasants look on as a quack pulls out a man's tooth. ⑤ Detail from *Der Zahn-Artz* (1699), etching and engraving by Dutch book illustrator Casper Luyken. ⑥ Detail showing a table full of dental tools from *An Operator Extracting a Tooth*, a seventeenth-century oil painting after Adriaen Brouwer.

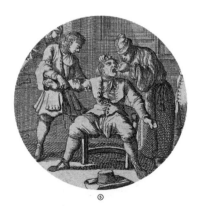

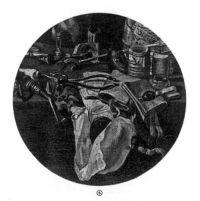

nostrum made from dozens of ingredients, including viper's flesh – and drove their message home with extravagant parodies of extractions. When artists showed teeth being levered from their sockets with swords by men on horseback, they were not depicting the tooth-pullers at work, but a savvy commercial spoof of the pain they inflicted – 'pulling legs rather than teeth'.[2]

But for many, even the lurid theatrics of the tooth-pullers could not overcome their fear of extraction, a fear that led them to endure toothaches that must have seemed interminable. In December 1578, when she was forty-five years old, Elizabeth I was 'so excessively tormented' by a toothache that for days she could not sleep. Still she refused treatment, until the aged John Aylmer, bishop of London, stepped in and:

PERSUADED HER THAT THE PAIN WAS NOT SO MUCH, AND NOT AT ALL TO BE DREADED; AND TO CONVINCE HER THEREOF TOLD HER, SHE SHOULD HAVE A SENSIBLE EXPERIENCE OF IT IN HIMSELF, THOUGH HE WERE AN OLD MAN, AND HAD NOT MANY TEETH TO SPARE; AND IMMEDIATELY HAD THE SURGEON COME OVER AND PULL OUT ONE OF HIS TEETH, PERHAPS A DECAYED ONE, IN HER MAJESTIE'S PRESENCE. WHICH ACCORDINGLY WAS DONE: AND SHE WAS HEREBY ENCOURAGED TO SUBMIT TO THE OPERATION HERSELF.

① Colin Jones, *The Smile Revolution in Eighteenth-Century Paris*, Oxford University Press, 2014, p. 34.

② Roger King, *The Making of the Dentiste, c. 1650–1760*, Ashgate, 1998, p. 11.

ꝶ INEVITABILE·FATVM

Vom Mund.

Von dem Halß.

TOP | Original manuscript with woodcut illustration of a fully toothed human skull, from *Artzneybuch köstlich für mancherley Kranckheit des gantzen Leibs* by Johann Melchior Sachse, published 1546.

BOTTOM | Original manuscript with woodcut illustration of the anatomy of the oral cavity and tongue, from Sachse's *Artzneybuch köstlich für mancherley Kranckheit des gantzen Leibs*.

D. Plures radices disiunctæ quibus molaribus insunt, &
quæ qualesve eæ sunt.

F. Plures radices non prorsus disiunctæ, sed earum aliquæ
ubique coniunctæ, quibus molaribus insunt.

F. Plures

F. Plures radices non prorsus disiunctæ, sed earum vel om-
nes, vel aliquæ alicubi coniunctæ, quibus
molaribus insunt.

f 2 Dentes

Dentes molares quot nam radices habeant.

Quarto

Proportio

TOP | From the treatise 'De dentibus' in *Opuscula
anatomica* … (1564) by Bartolomeo Eustachi, these
diagrams explain the degrees of separation of the
roots in various molars.

BOTTOM | Diagrams indicating the number of
roots in the first, second and third molars (left)
and the fourth and fifth molars (right). From
Eustachi's *Opuscula anatomica* ….

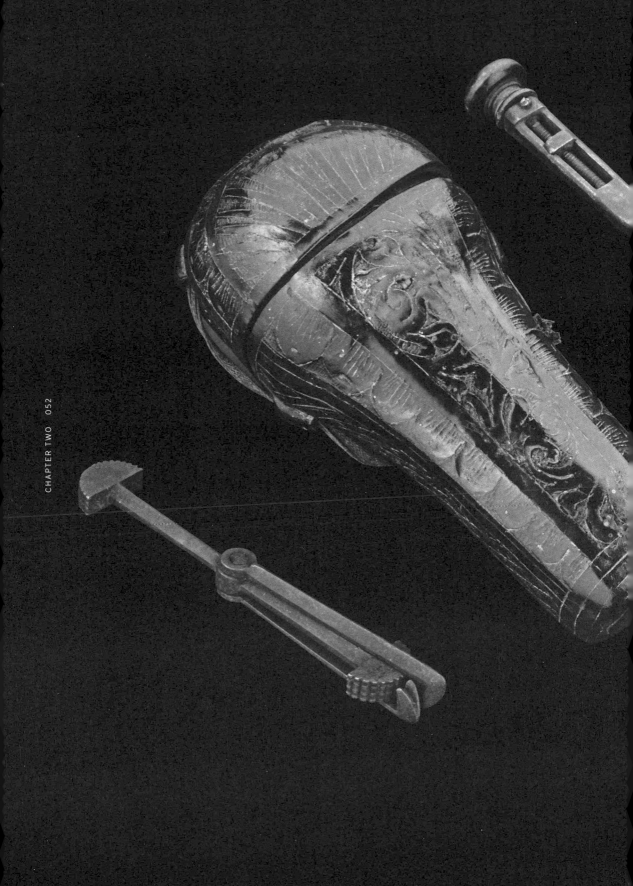

ABOVE | A French dental instrument set comprising five steel pelicans and a leather case (sixteenth–seventeenth century).

OVERLEAF | In *Interior of a Dutch House with an Operator Attending to a Man's Teeth* (*c.* 1817) by Hendrik van der Burgh, the patient knocks over his basket of eggs as he kicks out in pain when the operator digs into his gums.

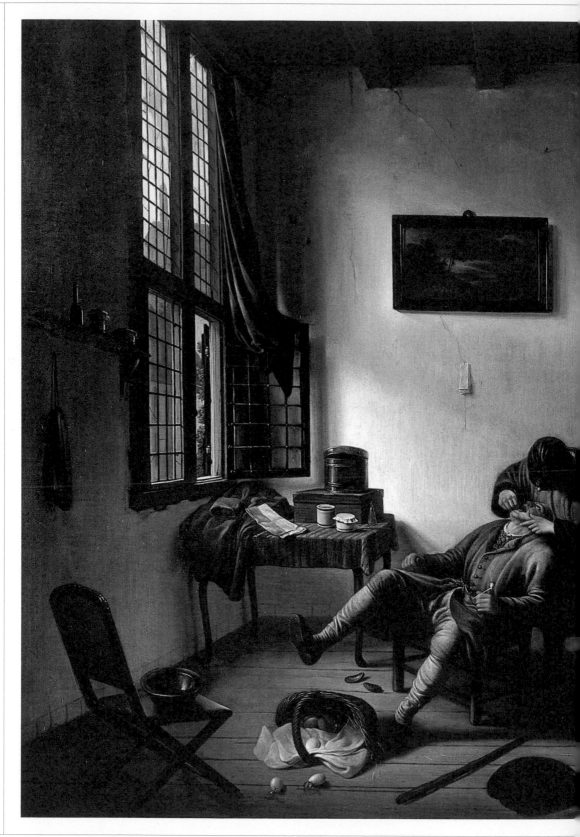

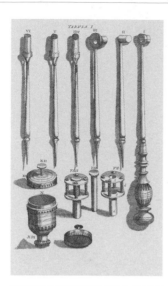

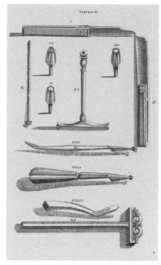

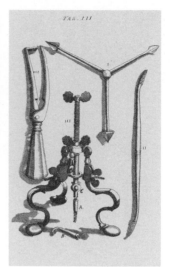

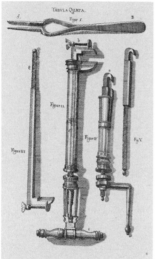

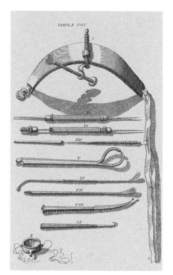

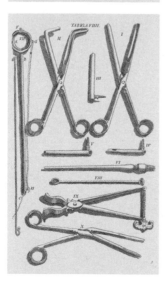

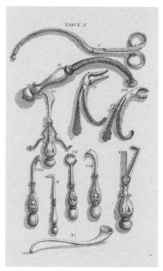

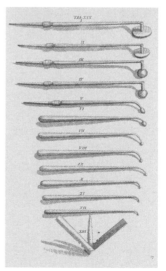

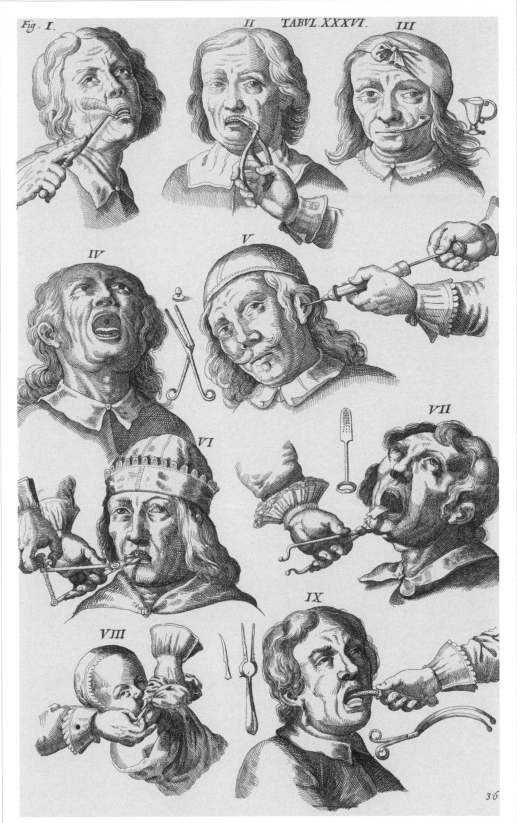

36

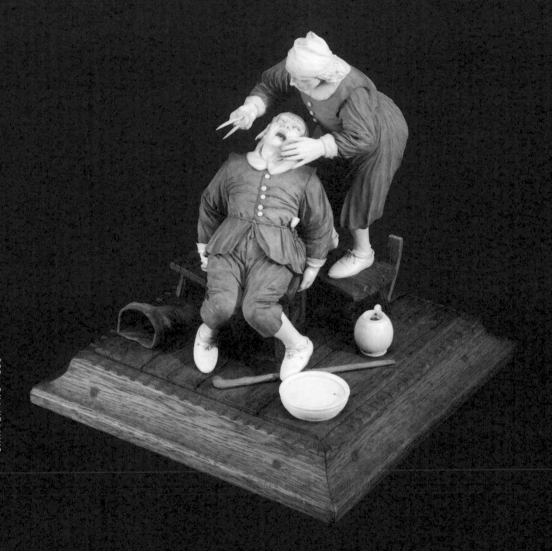

PREVIOUS LEFT | Title page and illustrations pertaining to contemporary pliers, pelicans, probes, pokers and other dental cutlery, from *Armamentarium Chirurgicum* (1655) by Johannes Scultetus.

PREVIOUS RIGHT | A page from German physician Scultetus' *Armamentarium Chirurgicum* depicts the usage of surgical instruments in dentistry and other ailments of the ear, nose and throat.

THIS PAGE | Removing a tooth in the 1600s was a painful and sometimes physically damaging process with, at best, only alcohol or herbal concoctions to numb the pain. This wood and ivory statue (and detail) depicts a tooth-pulling scene from the time.

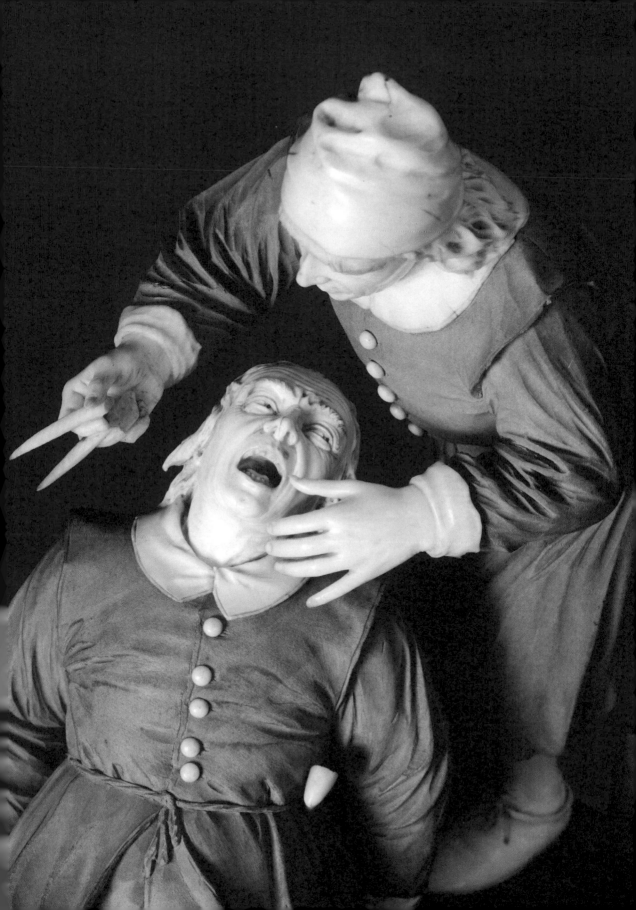

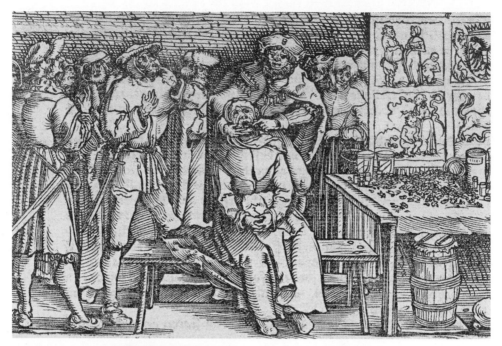

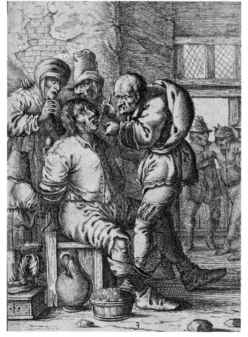

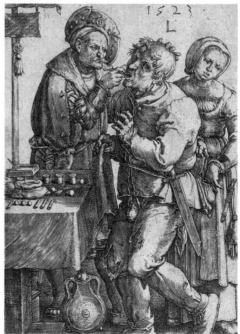

TOP | This woodcut illustration (1531) designed by German Renaissance artist Hans Weiditz shows a busy medieval dentist at work on a patient. The image appears in Francesco Petrarca's book *Trostspiegel in Glück und Unglück*.

BOTTOM LEFT | In this etching by Carel Allard after Adriaen Brouwer, the wary patient is tied to the chair.
BOTTOM RIGHT | A line engraving by Lucas van Leyden (1523), in which the pick-pocket highlights the vulnerability of the patient.

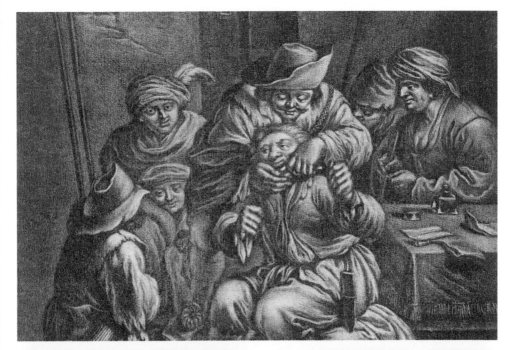

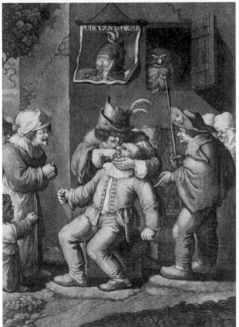

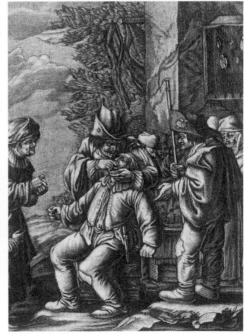

ABOVE | Three versions of 'Touch' from the series *The Five Senses* by Andries Both. Top by Johannes van Somer (*c.* 1640), bottom left by Petrus Schenk (*c.* 1690) and bottom right by Georg Christoph Kilian (*c.* 1750).

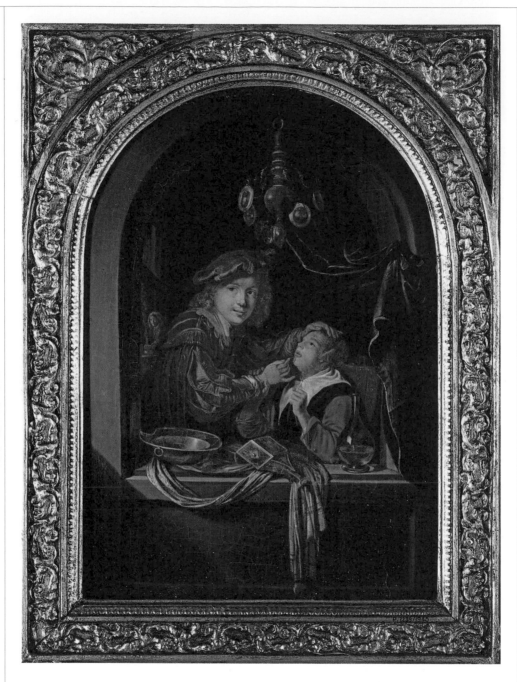

Two examples of dental art after seventeenth-century Dutch artist Gerrit Dou. ABOVE | A young man uses a dental probe to examine his patient's mouth. OPPOSITE | A patient is doubled over in pain as his tooth is extracted without pain relief.

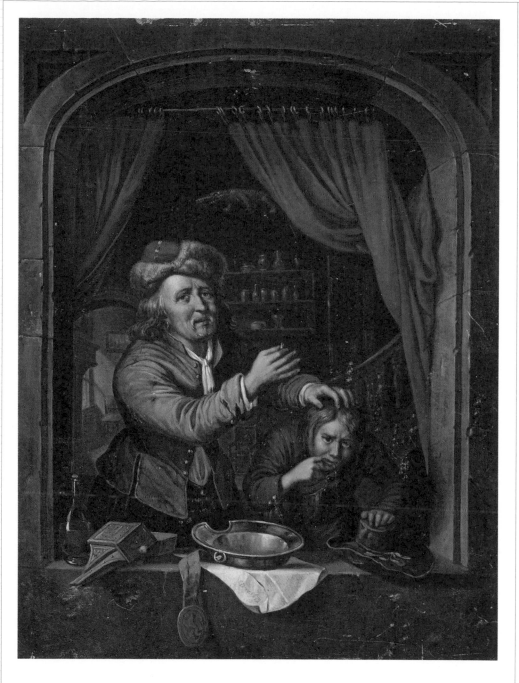

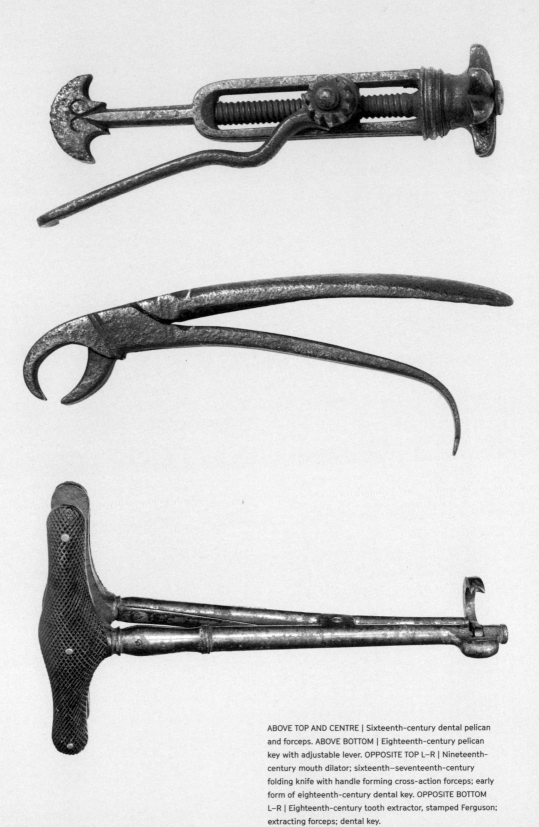

ABOVE TOP AND CENTRE | Sixteenth-century dental pelican
and forceps. ABOVE BOTTOM | Eighteenth-century pelican
key with adjustable lever. OPPOSITE TOP L–R | Nineteenth-
century mouth dilator; sixteenth–seventeenth-century
folding knife with handle forming cross-action forceps; early
form of eighteenth-century dental key. OPPOSITE BOTTOM
L–R | Eighteenth-century tooth extractor, stamped Ferguson;
extracting forceps; dental key.

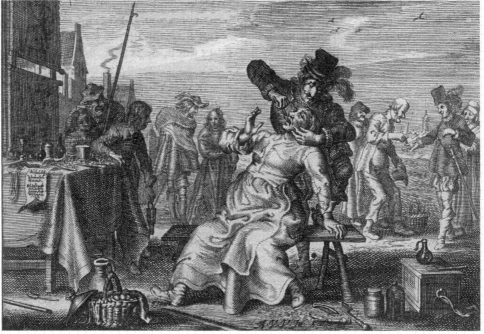

TOP | This anonymous engraving titled *Der alte Teutsche Zahnbrecher* (The Old German Tooth-Breaker, 1632) shows the 'dentist' practising his trade in a busy marketplace.

BOTTOM | In *Pulling Teeth in the Market* (1658) by Adriaan van de Venne, the ill-advised tooth-drawer uses considerable physical strength to remove the tooth.

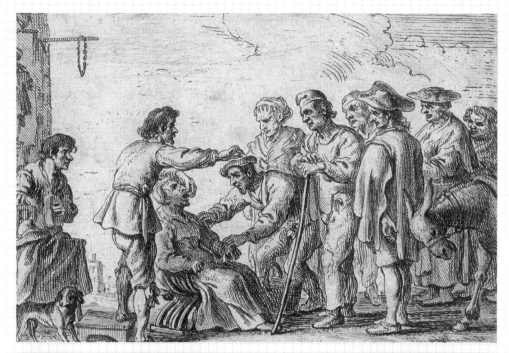

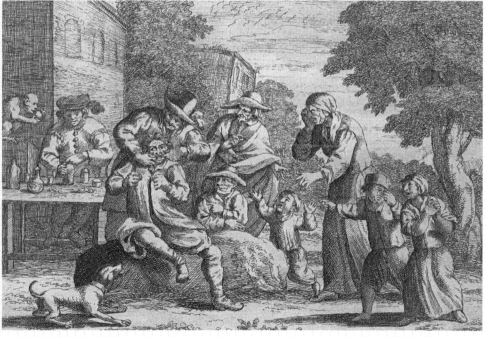

TOP | In this etching by Cornelis de Wael, it is
likely that some of the figures are 'stooges' of the
operator, pretending to demonstrate the operation
to impress the onlookers.
BOTTOM | *Extraction Under Family Supervision*
(*c.* 1675), after Pierre Gallays, portrays the
extraction of a tooth as a dramatic family event.

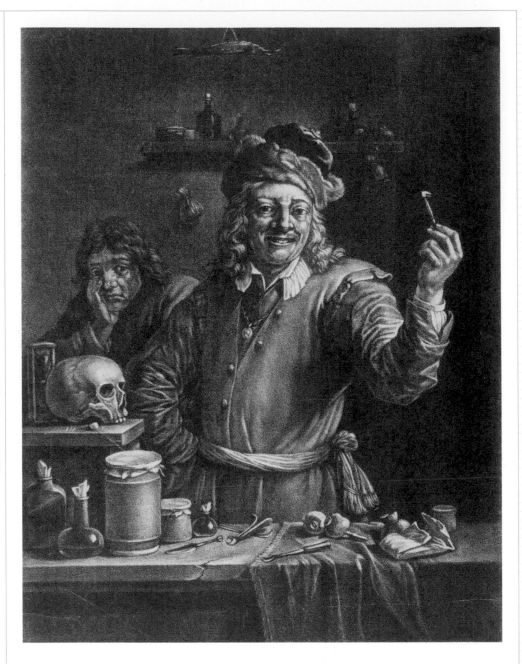

A Belgian tooth-drawer proudly holds up a tooth
that he has just extracted from his miserable-
looking patient. Seventeenth-century mezzotint
by Jan van der Bruggen after David Teniers.

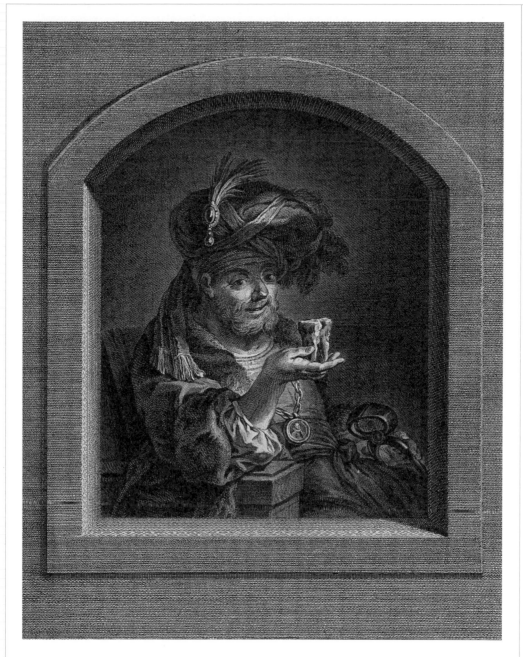

A French tooth-drawer wears a turban and pretends
to be Turkish in order to attract clients. He holds
a large tooth and an enormous tooth extractor.
Engraving by Nicolas Dupuis after François Eisen.

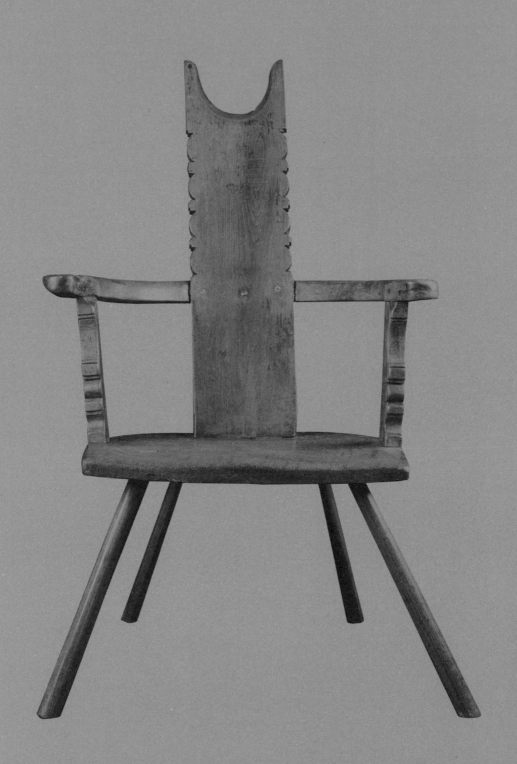

FAUCHARD

AND

THE

DENTISTES

3

Jean Thomas – *Le Grand Thomas*, 'Terror of the Human Jaw' – stands like an actor on a proscenium stage with the traffic of the Pont Neuf behind him. He is a monstrous figure, more than twice the size of the ragged-looking apprentice who crouches on a stool in front of him. With his right hand, Thomas grips the boy's head, firmly but kindly, and between the thumb and forefinger of his outstretched left hand he holds a molar, which seems to glow faintly against the sky. The caption of this 1729 engraving calls him *la perle des Charlatans*, and it seems churlish to disagree. From the 1710s until his death in 1757, Thomas was the most flamboyant of the Parisian tooth-pullers. His motto was *Dentem sinon maxillam* (the tooth, and if not, the jaw) and another engraving shows him on his lavishly appointed cart, with a large tooth – 'Gargantua's awesome molar' – suspended in a corner.[1]

Myths multiplied around this Rabelaisian figure: he weighed as much as three men, he ate as much as four, and if a tooth proved obdurate he would lock his pelican onto it, lift his client off the ground and allow their own weight to perform the extraction. He was celebrated and mocked, affectionately, in poems, caricatures and pageants, but *la perle des Charlatans* was not all he seemed. Beneath the scarlet military coat and plumed hat, Thomas was a master surgeon of the College de St Cosme, one of the most eminent surgical guilds in Europe. He was a canny businessman and he died rich and famous, but for a new and ambitious group – the *dentistes* – he embodied everything they wished to sweep away.

Emerging from the new landscape of French surgery at the beginning of the eighteenth century, the *dentistes* tailored themselves and their practice to meet the demands of a self-consciously stylish Parisian elite. They claimed to combine a new kind of theoretical knowledge with practical expertise, offering less painful and more effective treatment based on conservation and maintenance of the teeth, with extraction as an undesirable last resort. They were genteel and discreet, dressing in the latest fashions and working in private clinics or the houses of their wealthy patients. In their writings, they depicted *Le Grand Thomas* and the charlatans as fakers and butchers and, most of all, as yesterday's men – fit, perhaps, for a medieval world of sieges and plagues, but hardly appropriate for the well-

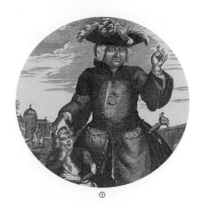

PAGE 68 This barber's chair (1700s), made from English ash and elm, has been modified for dental extractions. The neck rest has been added to support the head. ① Detail from an anonymous engraving of *Le Grand Thomas, la perle des Charlatans* (*c.* 1729). ② Pietro Longhi's *The Dentist* (*c.* 1750) focuses on the showmanship of the tooth-puller. ③ Portrait of Pierre Fauchard, engraved by J. B. Scotin after J. Le Bel. From *Le Chirurgien-Dentiste*.

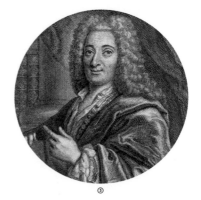

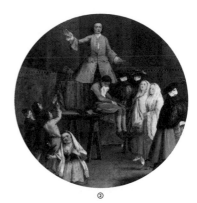

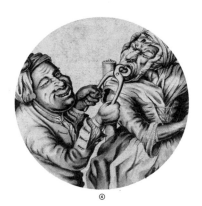

④

④ A tooth-drawer needs both hands to operate the enormous pincers he is using to extract a tooth from an old woman. Detail of a pen drawing after caricaturist John Collier (1773). ⑤ Detail from *The Pharmacist* (1752) by Pietro Longhi, in which a lady receives a swift dental examination in the drugstore. ⑥ Frontispiece from Fauchard's seminal work *Le Chirurgien-Dentiste* (The Surgeon Dentist, 1728).

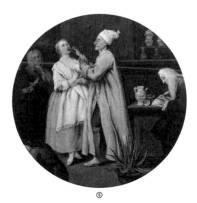

⑤

LE CHIRURGIEN
DENTISTE,
o v
TRAITE' DES DENTS.

OU L'ON ENSEIGNE LES MOYENS
de les entretenir propres & faines , de les
embellir , d'en réparer la perte & de re-
medier à leurs maladies , à celles des Gen-
cives & aux accidens qui peuvent furvenir
aux autres parties voifines des Dents.

vec des Obfervations & des Reflexions
plufieurs cas finguliers.

⑥

educated Parisians of the Enlightenment. The first practitioner to call himself a *dentiste* – Pierre Fauchard – intended it to be a term of distinction in both senses: a celebration, but also a decisive break with the past. But the line between the *dentistes* and the charlatans was never clear-cut. Fauchard himself began his career as an itinerant tooth-puller, and the triumph of the *dentiste* was in great part a matter of skilful rhetoric and sharp professional boundary work.

Intellectually, the major context for the emergence of the *dentistes* was the transformation of French surgery in the late seventeenth and early eighteenth centuries. Surgeons sought to transcend their established role as skilful but lowly craftsmen, and to gain equality with the physicians. In order to do so, they reinvented themselves as learned specialists who based their practice on a strong, autonomous tradition of anatomical knowledge. Traditionally, tooth-pullers had occupied an equivocal position within the surgical hierarchy. As explained in Chapter Two, dental work was an acknowledged part of surgical practice, but tooth-pullers languished on 'the lowest rungs of the surgical ladder'.[2] Outside the cities, many were simply local blacksmiths who occasionally turned their pincers to extraction.

Routes into Parisian practice were more complex. A minority with time and money to spare undertook a long apprenticeship under the aegis of the Paris Medical Faculty. Those who had pulled the king's teeth practised with the cachet of an *artisan suivant la cour* (artisan following the court), and others obtained a royal grant of privilege for selling patent medicines such as *orviétan*. From 1699 the College de St Cosme began to award the title of *expert* to those who could satisfy the guild masters in a two-day examination, and some tooth-pullers began to practise as *experts pour les dents* – though they were forbidden to call themselves surgeons.

To understand the *dentistes* and their thirst for respectability, we can turn to their clients: the grandees of the court of Louis XIV. Medieval monarchs rewarded their followers for prowess on the battlefield or the tiltyard, but the Sun King's courtiers used conspicuous consumption to jostle for favour. They commissioned sumptuous *hôtels* in Paris, they drove to Versailles in gilded coaches and most of all they ornamented themselves with fine clothes, jewelry, wigs, beauty spots, perfumes

and cosmetics. For these aristocrats, a mouthful of straight, gleaming teeth was a political asset, and a good *dentiste* could be a great aid to advancement.

Louis XIV himself was no stranger to the suffering that a bungling tooth-puller could cause. In 1685 his premier physician, Antoine Daquin, had ordered an 'operator for the teeth' to extract the few molars that remained in the king's upper right jaw. These proved to be well-anchored, and by the end of the procedure the operator had ripped away a great deal of the patient's upper jaw, knocking a hole through his palate and into his nasal passages. The wound healed but, as Daquin noted, 'every time that the king drank or gargled, the liquid came up through his nose, from where it issued forth like a fountain'. The monarch's premier surgeon, Charles-François Félix, was summoned, and Louis gave him a stern warning: 'Get on with it, and don't treat me as a king; I want to be cured as though I were a peasant.' In what must have been a horrendous ordeal, Félix used a glowing iron cautery to close up the hole.

In his *Le Chirurgien-Dentiste* (The Surgeon Dentist, 1728) – a textbook for aspiring *dentistes*, but also a manifesto for their ambitions – Fauchard remarked on a paradox with which the Sun King might readily have sympathized:

> THE TEETH IN THE NATURAL CONDITION ARE THE MOST POLISHED AND THE HARDEST OF ALL THE BONES OF THE HUMAN BODY; BUT AT THE SAME TIME THEY ARE THE MOST SUBJECT TO DISEASES WHICH CAUSE ACUTE PAIN AND SOMETIME BECOME VERY DANGEROUS.

Born in 1678 in the Loire, Fauchard gained early experience as a tooth-puller and served in the French Navy under the surgeon Alexandre Poteleret. After a few years at the University of Angers, he came to Paris in 1719, apparently with a strong sense of what he wanted to accomplish. *Le Grand Thomas* had the acclaim of the mob, but Fauchard knew where power and money were to be found and he built up a practice among smart Parisians as he worked on the eight-hundred-page manuscript of *Le Chirurgien-Dentiste*. Fauchard wanted this compendious text to be a complete guide to enlightened dentistry, but he also set out to define a new public role for himself and his colleagues, and to exclude those who failed

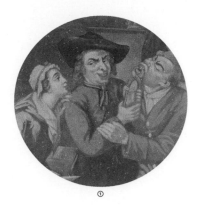

①

① *The Farrier Turned Tooth Drawer* (1792), hand-coloured mezzotint attributed to John Dixon and James Wilson. ② In this satirical etching after James Gillray, the patient is in such pain that he pulls off the tooth-drawer's wig. ③ A London dentist extracts a tooth from a patient; her female companion and the dentist's black servant-boy look on. Coloured mezzotint by caricaturist Robert Dighton (1784).

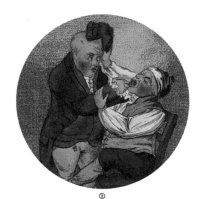

②

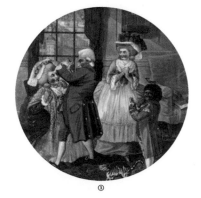

③

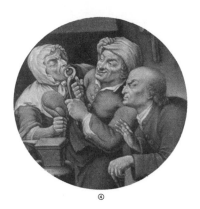

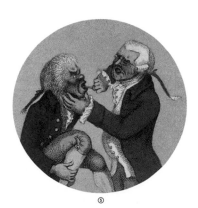

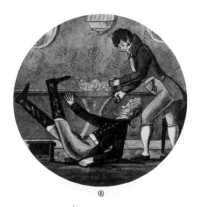

④ *The Blacksmith Turned Tooth Drawer* (1792), hand-coloured mezzotint attributed to John Dixon and James Wilson. ⑤ Two bewigged gentlemen endure the battle of tooth extraction. Coloured stipple engraving by James Gillray (1796). ⑥ Humorous depiction of an extraction in which the vigour of the dentist causes the wealthy patient to fall over. Watercolour by James Gillray (1790).

to match up to it. He was at his most passionate when denouncing the fraudulent practices of the charlatans:

PAID PRETEND SUFFERERS COME UP FROM TIME TO TIME TO THE OPERATOR, WHO HOLDS IN HIS HAND A TOOTH ALL READY WRAPPED IN A VERY FINE SKIN WITH THE BLOOD OF A CHICKEN OR SOME OTHER ANIMAL. HE INTRODUCES HIS HAND INTO THE MOUTH OF THE PRETEND SUFFERER, AND DROPS INTO IT THE TOOTH WHICH HE IS HOLDING. THEN HE HAS ONLY TO TOUCH THE TOOTH WITH A POWDER OR A STRAW OR THE POINT OF HIS SWORD: HE HAS ONLY, IF HE WISHES, TO RING A BELL IN THE EAR OF THE PRETENDED PATIENT, WHO THEN SPITS OUT THAT WHICH HE HAS IN HIS MOUTH—THE BLOOD AND THE BLOODY TOOTH WHICH WAS PLACED THERE.

If a patient with a genuine toothache presented themselves for extraction, the charlatan would make his excuses: ' ... that the fluxion is too great, that he must have patience for a few days, or that this tooth is an eye tooth which must not be drawn, because (as the empirics pretend) these teeth are connected with the eye, which they say will be lost if the teeth are drawn.' Fauchard also presented a series of examples in which tooth-pullers had made grievous mistakes: for example, the gruesome case of Henri Amarton of Nonette in the Auvergne. Amarton had visited a tooth-puller and asked him to extract a rotten molar, but the tooth simply would not come out. Rather than admit failure, the tooth-puller hammered the tooth up into Amarton's maxillary sinus and told him he must have swallowed it. Within a few days, Amarton's face had become grossly swollen and he suffered terrible pain from what was now a potentially fatal sinus abscess. A surgeon eventually worked out what had happened and managed to extract the tooth and save Amarton's life, at the cost of another invasive operation. In Fauchard's view, the only way to avoid incidents like these was to attend a *dentiste* and shun all tooth-pullers, particularly those who mistook possession of the tools for skill and experience:

SO MANY MEDDLE IN WORK ON THE TEETH ALTHOUGH THEY ARE OF ANOTHER PROFESSION,

THAT I THINK PRESENTLY THERE WILL BE MORE
DENTISTS THAN PEOPLE WITH TOOTHACHES.
THERE ARE INDEED CERTAIN CUTLERS WHO
MEDDLE WITH EXTRACTION OF THE TEETH.
APPARENTLY THE INSTRUMENTS WHICH THEY
MAKE GIVES THEM AN ITCH TO TRY THEM. I HAVE
KNOWN ONE IN THIS TOWN WHO PASSES IN HIS
QUARTER AS A TOOTH-DRAWER. THIS PARTICULAR
MAN WHO HAD SEEN SEVERAL CHARLATANS
OPERATE, THINKING THAT IT WOULD BE AS EASY
TO DRAW TEETH AS TO MAKE KNIVES, HAS JOINED
THE RANKS AND DOES NOT DEFER WHEN THE
OPPORTUNITY OFFERS TO PUT HIS PRETENDED
SKILL INTO PRACTICE, AND HIS INSTRUMENTS
OF THE PROOF; AND IF HE DOES NOT ALWAYS
TAKE OUT THE TOOTH WHOLE HE DOES MANAGE
TO TAKE A PIECE OF IT.

Fauchard's claim to originality rested on two
innovations. He would preserve his clients' teeth,
rather than resorting to extraction as a cure-all, and
he would make them more beautiful, cleaning and
straightening existing teeth and bridging gaps with
well-made dentures. A *dentiste* would fill cavities
with gold in the Italian manner and fix crooked teeth
with braces of gold and silk or, if an immediate result
was required, a special orthodontic pelican. Realistic
false teeth, carved from ivory or bone, could be held
in place with delicate silver springs. *Le Chirurgien-
Dentiste* included forty-two pages of illustrations
showing new tools for making dentures and
prostheses, drawn from the workshops of jewellers
or watchmakers. Rather than enduring cauterization,
as Louis XIV had, patients could block holes in their
palates or conceal the attritions of syphilis with an
obturator – a sponge attached to a gold or silver
plate, painted to match the skin.

Alongside these technical innovations, the
new *dentistes* also had a new demeanour, one that
embodied Enlightenment virtues of sensibility and
politesse. Discarding the oversized personalities and
overwhelming physical strength of the charlatans,
they offered sensitivity to their clients' anxiety and
suffering, and a hand that was (in Fauchard's words)
'light, steady and skilful'. Metal instruments should
be warmed before use, to avoid intensifying the
shock to delicate tissues, and patients given time
to collect their emotions after painful procedures.

① Dental prosthesis from *Recherches et
observations sur toutes les parties de l'art
du dentiste* (1786) by M. Bourdet. ② This
instrument (1701–1850) would have been
used to carve marks in ivory dentures
to create the appearance of individual
teeth. ③ An advertisement for surgeon
dentist W. Morgan's tooth powder, from
Dental Memoranda by Theodosius Purland,
published 1702 to 1878.

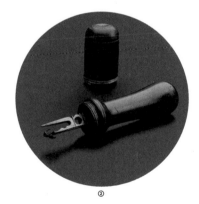

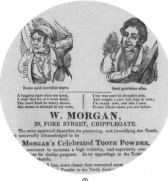

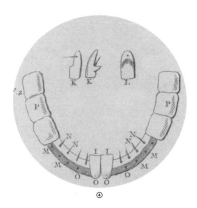

④ Detailed diagram of a prosthesis from Bourdet's seminal work. ⑤ This denture was carved from hippopotamus ivory and would have been expensive. Ivory was difficult to clean and over time the denture would begin to deteriorate and smell quite unpleasant. ⑥ Printed advertisement for an anodyne necklace, from Purland's *Dental Memoranda*. Hand-written date 1766.

Rather than forcing their clients into uncomfortable and undignified postures, *dentistes* should learn to work around a patient reclining on a sofa. Just as the new courtly culture of Versailles reflected the growing influence of consumer capitalism, so a *dentiste* was also an entrepreneur, using his social contacts and advertisements to drive home the necessary (and lucrative) connections between good teeth, beauty and success.

Seen from one perspective, Fauchard and the *dentistes* were simply tooth-pullers on the make, riding the coat-tails of the French surgical revolution and finding their fortunes in the mouths of the Parisian *haute bourgeoisie*. But they were also the first generation of dental practitioners to be consulted by people who were not necessarily suffering acute pain. Much of what the *dentistes* promised would be entirely familiar to the patients of any modern orthodontist: the perils of the ugly mouth in a society obsessed with surfaces, the suffering endured in pursuit of a beautiful smile, the joys of *la bouche ornée*.

① For a vivid and thought-provoking analysis of Thomas' image, see Colin Jones, 'Pulling Teeth in Eighteenth-Century Paris', *Past and Present* No. 166, 2000, pp. 100–145.
② Roger King, *History of Dentistry: Technique and Demand*, Wellcome Unit for the History of Medicine, 1997, p. 4.

OVERLEAF | Pages from Pierre Fauchard's *Le Chirurgien-Dentiste* (1728):
LEFT PAGE | Dental prosthesis – artificial teeth with springs (top left); complete set of dentures with springs (top right); dental tools used in prosthodontics (bottom left and right).
RIGHT PAGE | Dental ligature pliers used for teeth restoration (top left); a pair of dental forceps (top right); pointed dental forceps (bottom left); dental pelican for tooth extraction (bottom right).

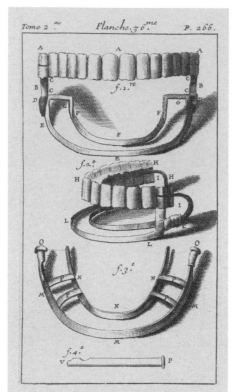

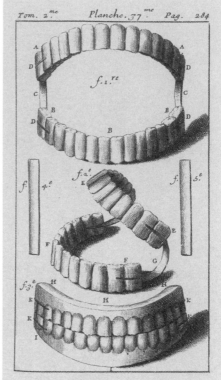

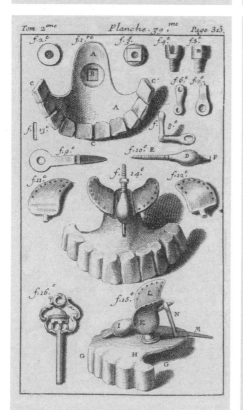

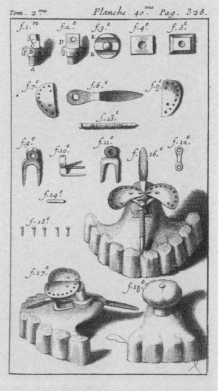

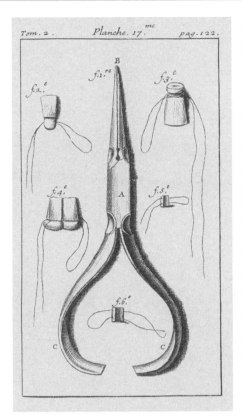

Tom. 2. *Planche. 17.*^{me} *pag. 122.*

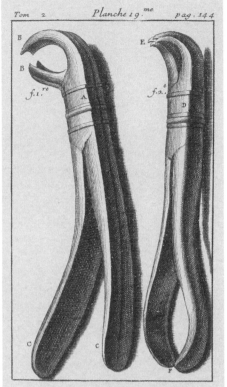

Tom 2 *Planche 19.*^{me} *pag. 144.*

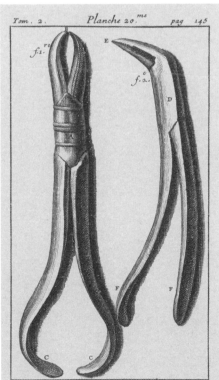

Tom. 2. *Planche 20.*^{me} *pag 145*

Tom 2 *Planche 25.*^{me} *pag 200*

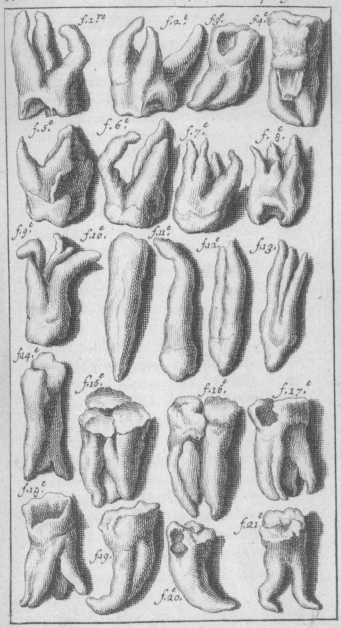

Tom. 2. Planche 27.me pag. 202.

f.1.re f.2.e f.3.e f.4.e

f.5.e f.6.e f.7.e f.8.e

f.9.e f.10.e f.11.e f.12.e f.13.

f.14.e f.15.e f.16.e f.17.e

f.18.e f.19. f.20.e f.21.e

ABOVE | Drawings of teeth in the upper and lower jaw, from Fauchard's *Le Chirurgien-Dentiste*.

OPPOSITE | Plates from a German textbook on dentistry, *Abhandlung von den Zähnen des menschlichen Körpers und deren Krankheiten* (1756) by Philipp Pfaff, showing dental instruments used for creating artificial teeth (top) and dental burnishers, used during teeth restoration, and an assortment of other dental instruments (bottom).

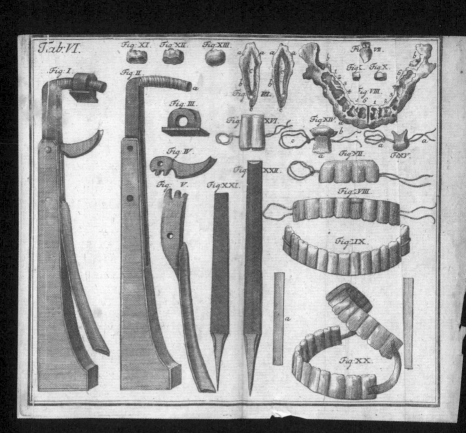

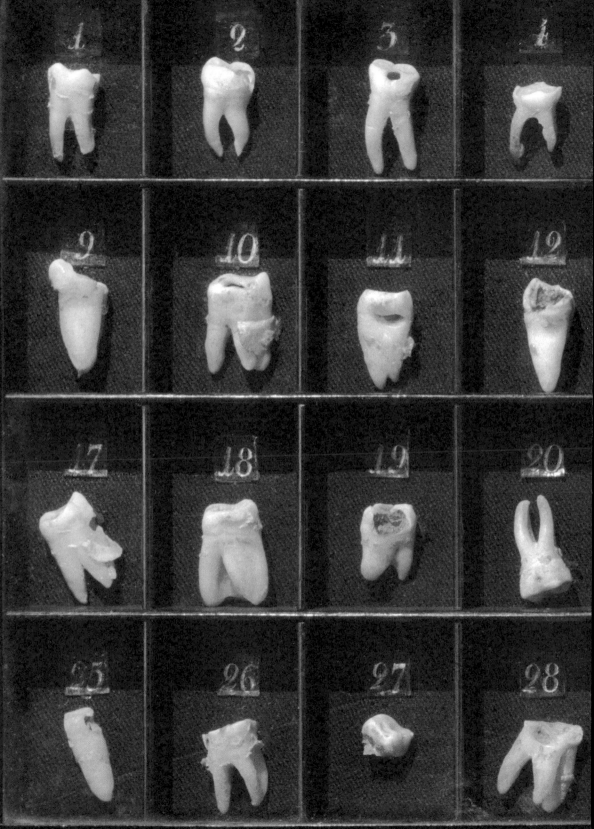

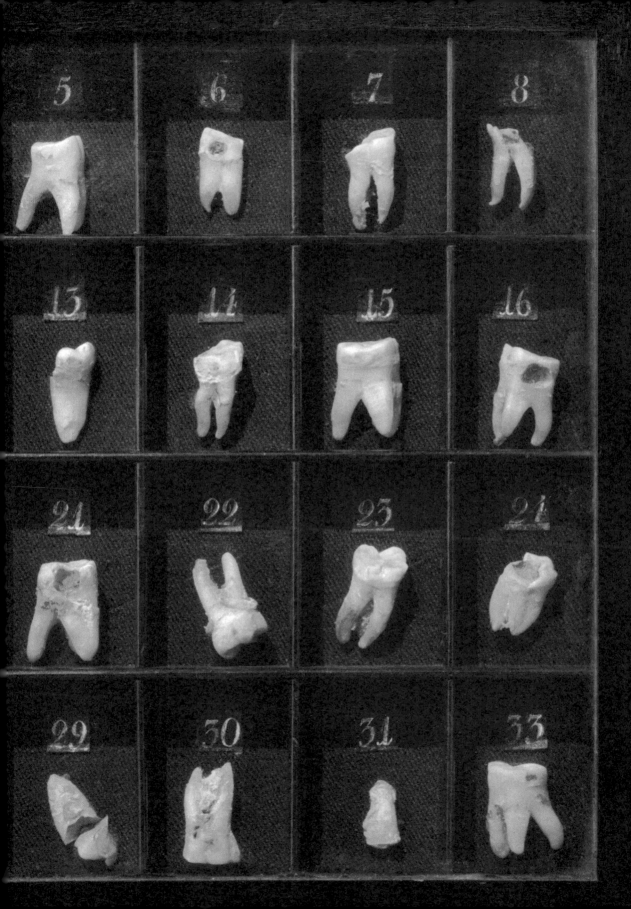

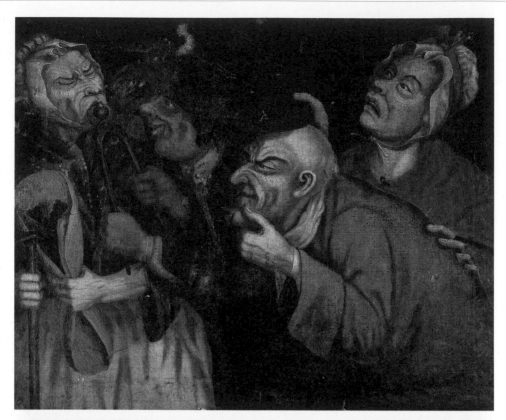

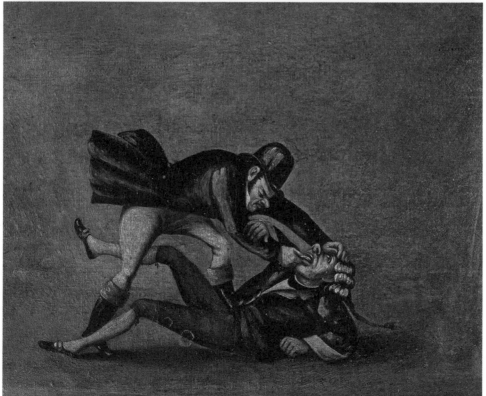

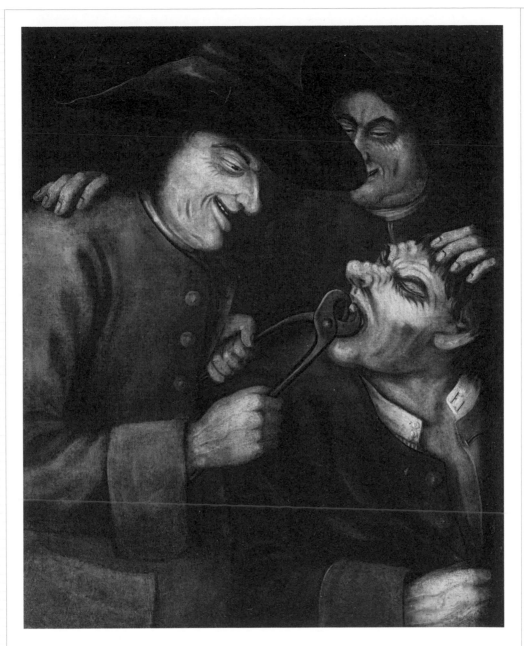

PREVIOUS | Teeth belonging to various different people that were pulled and collected by Peter I, also known as Peter the Great, Emperor of Russia (1672–1725).

OPPOSITE AND ABOVE | Eighteenth-century oil paintings in the style of John Collier, known as 'Tim Bobbin'. The blacksmith-cum-dentist appears content to use giant pincers to remove the teeth of his distraught patients (opposite top and above); a patient falls to the ground in his struggle to avoid an over-enthusiastic tooth-puller (opposite bottom).

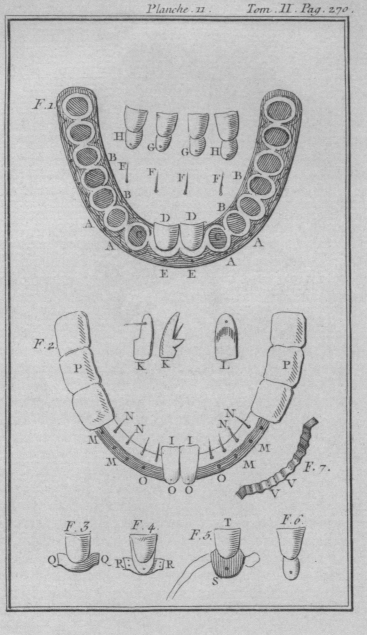

Pages from Bourdet's *Recherches et observations*
sur toutes les parties de l'art du dentiste.
ABOVE | Diagrams of dental prostheses.
OPPOSITE | Dental burnishers used during
teeth restoration (top left); dental prosthetics
(top right); dental probes (bottom left);
dental keys (bottom right).

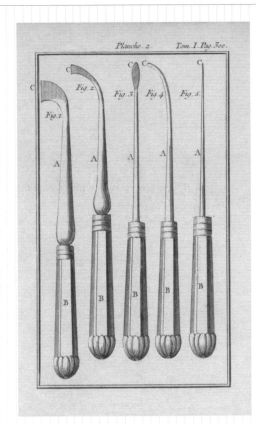

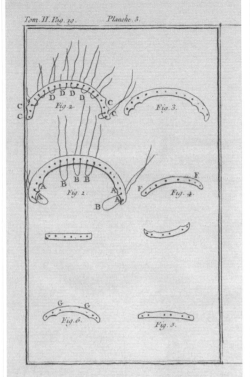

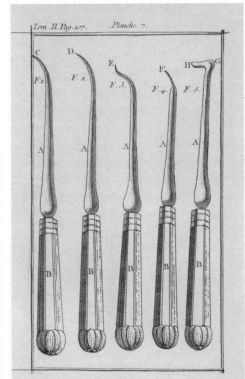

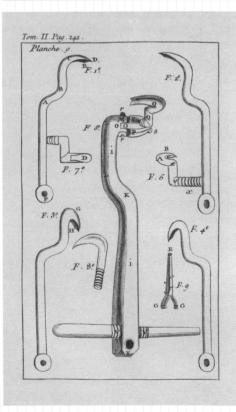

ENLIGHTENED

EXTRACTIONS

4

The most famous false teeth in history rest on a brass cradle in a glass case at the Mount Vernon Estate in Virginia. In another setting they could be a pair of castanets imagined by Francis Bacon – a ghastly, disembodied grin that might pursue you, gnashing, through your dreams. These dentures once belonged to George Washington, first president of the United States, and – as almost every writer on the subject has observed – they are not made of wood. The lower set are human teeth, the upper set most likely carved from elk molars, and the hinged dental plates are tarnished lead. Another surviving set, a lower plate, is made from what John Greenwood, Washington's dentist, called 'seahorse teeth' – walrus ivory.

Washington suffered with his teeth throughout his life. After losing several in his early twenties, he tried partial dentures and artificial teeth wired to his remaining dentition, which seem to have contributed to his short temper and mercurial moods during the Revolutionary War. At the time of his inauguration in 1789, he had one remaining tooth, and for the rest of his life he struggled with uncomfortable full dentures. Enduring long presidential dinners, he said and ate little, retiring to his private apartments afterwards to gum his way through platefuls of soft pickled tripe. Washington's false teeth have had a lasting effect on his image: his portrait on the US dollar bill, painted by Gilbert Stuart in 1796, shows him wearing Greenwood's false teeth, his cheeks plumped out with cotton wool – one reason, perhaps, why he looks so glum.

The tale of Washington's false teeth captures the three-cornered tension between aspiration, capability and reality that lay at the heart of Enlightenment dentistry. Greenwood was a renowned New York dentist and no charlatan. His dentures were carefully designed and beautifully crafted, made from materials that embodied the global spirit of the age. Greenwood's clients might have had in their mouths the teeth of a dead Russian soldier, ivory from an African elephant or an Arctic walrus, and South American gold. A porcelain set from the French entrepreneur Nicolas Dubois de Chémant cost one thousand livres, perhaps three times the annual salary of a workman at the time. But they were still uncomfortable, barely functional, abysmally smelly if not properly maintained – better than nothing, evidently, but only just.

①

PAGE 86 An early adjustable dental chair. As a specialized piece of furniture, it is representative of the emergence of the dentist as a separate profession.
① A partial denture belonging to George Washington, with real and false teeth.
② *A Man Whose Face Expresses Moderate Pain* (c. 1770) by William Hebert after Charles Le Brun. ③ Detail from a set of caricatures of facial expressions (1824), lithograph by Louis Boilly after François Séraphin Delpech.

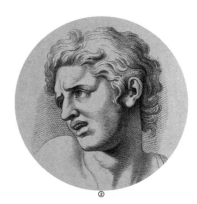

②

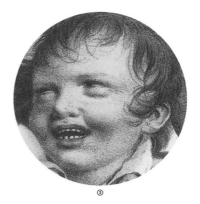

③

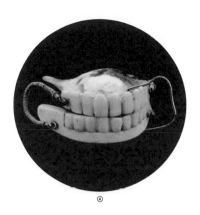

④

④ George Washington's denture with hinged attachment to a lead dental plate. ⑤ *A Bearded Man Whose Face Expresses Horror* (c. 1770). The lettering below reads *L'effroy* (terror or fright). Etching in the crayon manner by William Hebert after Charles Le Brun. ⑥ Detail from a caricature by Louis Boilly after François Séraphin Delpech (1827). A faint-looking woman (seen here) is supported by a companion as the doctor applies leeches to her neck.

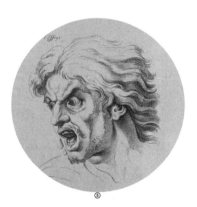

⑤

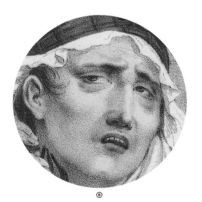

⑥

As explained in Chapter Three, the *dentistes* and their Parisian clientele invented the idea that one should visit a dentist for reasons other than the relief of pain: to improve one's looks or rank or marriageability. As this notion spread across Europe and the United States, we also start to see – in the case of Washington and Greenwood, for example – the parallel idea of a running relationship with one's dentist over years and decades. For practitioners and their wealthy patients, dentistry represented a route to self-advancement in a culture increasingly content to define itself through consumption and appearance.

Washington's uncomfortable expression on the dollar bill points, inadvertently, towards the continuing importance of artistic and cultural forces in determining what counted as a well-made smile. Eighteenth-century attempts to represent and understand pain, in art and medicine, focused around the face and especially the mouth. Painters, sculptors, physicians and physiognomists debated the possibility of a universal language of human emotion, a vocabulary of expressions common to all humans, from the most courteous Parisian fop to the Pacific islanders encountered by Captain Cook. One of the first attempts to delineate this language came in a series of lectures given by the French court painter Charles Le Brun in the 1670s. Drawing on Descartes' theory that emotion originated in the soul, before passing into the body via the pineal gland beneath the brain, Le Brun argued:

IF THERE BE A PART, WHERE THE SOUL MORE IMMEDIATELY EXERCISES HER FUNCTIONS, AND IF IT BE THE PART MENTIONED, IN THE MIDDLE OF THE BRAIN, WE MAY CONCLUDE THAT THE FACE IS THE PART OF THE BODY WHERE THE PASSIONS MORE PARTICULARLY DISCOVER THEMSELVES.

In the middle of the eighteenth century, the Irish writer and statesman Edmund Burke noted that there was, as it were, a sublime grimace, one common to all experiences of overwhelming fear, pain and terror. Enlightened mouths could speak the sweetest reason or express the deepest horror. Fifty years after Burke, in his *Essays on the Anatomy of Expression in Painting* (1806), the anatomist and artist Charles Bell characterized the expression associated with

'extremity of pain': 'the teeth strongly fixed, the lips drawn so as to expose the teeth and gums'. Bell rooted his view in an anatomical theology, arguing that God had created the human mouth to express uniquely human emotions, and throughout the preceding century most artists and critics would have agreed with him. In art, as in decent company, open mouths and bared teeth indicated superstitious ecstasy, bestial madness or plain vulgarity.

As Colin Jones has observed, though, there is more to be said about the meaning of the eighteenth-century mouth than this. Smiles in late seventeenth-century poems, plays and novels were 'forced, disdainful, bitter, mocking, proud, sardonic, ironic', but by the 1750s they had become 'sweet, good, agreeable, friendly, virtuous'.[1] Jones connects this shift with the mid-eighteenth-century cult of sensibility: a literary movement, but also a style of feeling and a new model for love and friendship. The French taste for sensibility emerged in the late 1720s with a new theatrical genre, the *comédie larmoyante* or 'tearful comedy'. By presenting ordinary characters in emotionally wrenching predicaments, the authors of these successful tearjerkers sought to touch the conscience of their audience and lead them towards virtue. But the *comédies larmoyante* also gained a political edge, offering bourgeois Parisian audiences an alternative to the stiff, unemotional manners of the French court. Parisians devoured the sentimental novels of the English writer Samuel Richardson – *Pamela* (1740), *Clarissa* (1748), *The History of Sir Charles Grandison* (1753) – and Jean-Jacques Rousseau took up the theme of smiles and tears in *Julie, ou la nouvelle Hélouise* (Julie, or the New Heloise, 1761).

Under the influence of sensibility, and in parallel with the rise of the *dentistes*, well-heeled Parisians adopted the warm, white-toothed smile as a mark not of coarseness but of sympathy, sensitivity and intelligence. As the acknowledged leaders of Enlightenment fashion, they inspired imitation in cities all over Europe. From the 1750s, English tooth-pullers began to call themselves 'dentists' (just as English man-midwives had adopted the French *accoucheur*) – a pretension mocked by the *London Chronicle* in 1764:

EVERY TOOTH-DRAWER WHO PRETENDS TO DRAW WITH A TOUCH, IS AN OPERATOR FOR THE TEETH

① *Ecstasy of Saint Teresa* (detail, 1647–52) by Gian Lorenzo Bernini, white marble, Church of Santa Maria della Vittoria, Rome. ② *Portrait of a Lady* (c. 1730–35) by Joseph Highmore. ③ A label for Camphorated Tooth Powder from the Stanley and Co. chemist shop in Leamington. Other products on sale included Eau de Cologne, Carbonate of Soda, Castor Oil, Aromatic Stomach Powder and Old Lavender Watere.

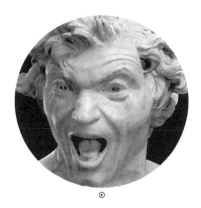

④ *Anima Dannata* (Damned Soul, 1619) by Gian Lorenzo Bernini, white marble, Spanish Embassy, Rome. ⑤ *Portrait of the Duchess of Beaufort* (c. 1775–80) by Thomas Gainsborough. The subject holds her mouth slightly open to reveal her white-toothed smile. ⑥ The label for Odoriferous Dentifrice, from the Stanley and Co. chemist shop in Leamington, highlights the virtues of the product.

AT LEAST; THE RENOWNED CHEVALIER IS INDEED THE ONLY IMPERIAL, ROYAL AND PONTIFICIAL OPHTHALMIATER IN THE WHOLE WORLD; MR PAUL JULLION THE ONLY RECTIFIER OF DEFICIENT HEADS; BUT OCCULISTS AND DENTISTS ABOUND IN EVERY COUNTRY TOWN; AND I CANNOT HELP SMILING AT THE RUSTIC BARBER-SURGEON, WHO JOINED BOTH TOGETHER AND STILED HIMSELF ON HIS SHOP-BOARD, *OCCULIST FOR THE TEETH*.

Americans, too, began to adopt Parisian attitudes to the teeth. In 1776 the dentist Benjamin Fendall argued that no self-respecting colonial gentlewoman could afford to neglect the state of her mouth:

THE FOULNESS OF THE TEETH BY SOME PEOPLE IS LITTLE REGARDED; BUT WITH THE FAIR SEX, WITH THE POLITE AND ELEGANT PART OF THE WORLD, IT IS LOOKED ON AS A CERTAIN MARK OF FILTHINESS AND SLOTH; NOT ONLY BECAUSE IT DISFIGURES ONE OF THE GREATEST ORNAMENTS OF THE COUNTENANCE, BUT ALSO BECAUSE THE SMELL IMPARTED TO THE BREATH BY DIRTY ROTTEN TEETH, IS GENERALLY DISAGREEABLE TO THE PATIENTS THEMSELVES, AND SOMETIMES EXTREMELY OFFENSIVE TO THE OLFACTORY NERVES IN CLOSE CONVERSATION.

Here, we can see the double face of Enlightenment consumer culture: a voracious appetite for all kinds of exotic commodities, but also a demand for devices and techniques to remedy the stained, rotten teeth resulting from overindulgence in tea, coffee, chocolate, sugar, tobacco or Turkish delight. Eighteenth-century journals and newspapers were crammed with advertisements for tooth powders, tooth whiteners, mouthwashes, breath sweeteners, toothpicks, tongue scrapers and toothbrushes. Some, such as this example from the *Daily Courant* in 1717, came straight from the patter of a medieval charlatan:

IT AT ONCE MAKES THE TEETH AS WHITE AS IVORY, THO' NEVER SO BLACK OR YELLOW, AND EFFECTUALLY PRESERVES THEM FROM ROTTING OR DECAYING, CONTINUING THEM SOUND TO EXTREME OLD AGE. IT WONDERFULLY CURES THE SCURVY IN THE GUMS, PREVENTS RHEUM

OR DEFLUXIONS, KILLS WORMS AT THE ROOT OF THE TEETH, AND THEREBY HINDERS THE TOOTHACHE. IT ADMIRABLY FASTENS LOOSE TEETH, BEING A NEAT AND CLEANLY MEDICINE OF A PLEASANT AND GRACEFUL SCENT.

Scurvy – a weakening of connective tissue associated with vitamin C deficiency, symptoms of which are loose teeth and bleeding gums – was most commonly associated with long sea voyages and was typically the province of surgeons, although numerous dentists and dental products claimed to treat it. In an advertisement in the New York *Daily Advertiser* in 1790, John Greenwood – maker of Washington's dentures – offered to 'cure the Scurvy, and ulcerated gums, and by your observance of his directions, the Scurvy will never return'. His near contemporary, the Irish-American dentist John Baker, sold 'Baker's Antiscorbutic Dentifrice, a certain Cure for all Disorders of the Teeth, Gums and Foul Breath'. Others began to look elsewhere for the cause of rotten teeth. In 1768 Thomas Berdmore, dentist to George III, published *A Treatise on Disorders and Deformities of the Teeth and Gums*. Berdmore warned his readers that a sugary diet was the major cause of tooth decay and that some tooth powders and dentifrices would do more harm than good. Experimenting with several brands, he found that they whitened the teeth by abrading the enamel and could, therefore, completely destroy a sound mouth within weeks.

Extraction, then, was still a wearisomely common part of eighteenth-century dentistry, and dentists had a new tool at their disposal: the toothkey. Resembling a cross between a corkscrew and a door key, the toothkey could be clipped firmly onto a troublesome tooth, causing less damage to the gums than the older pelican. Once teeth had been extracted, though, dentist and client faced the same old question: how to replace them? One solution, almost as ancient, was to make and fit a set of dentures, but (as Washington discovered) dentures could be chronically uncomfortable and almost useless for actually chewing food. If they were made from a material that, like ivory, deteriorated in the mouth, or if they were not cleaned regularly of food residue, they could cause appallingly bad breath. Sets held in place by powerful springs forced the

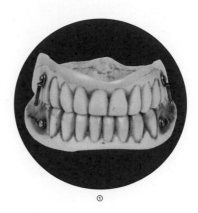

①

① A full set of top and bottom dentures, hand-carved from ivory. ② These porcelain dentures were possibly made by Nicolas Dubois de Chémant between 1795 and 1814. He learned about porcelain from Alexis Duchâteau who had developed porcelain dentures to replace his own stained ivory set. ③ A pouch with two iron dental keys and a pair of iron dental forceps, made 1800–50.

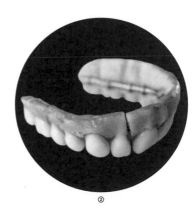

②

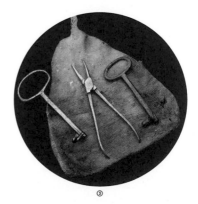

③

④

④ Early sets of dentures were held together with springs, in order to keep them in position when the mouth was open. ⑤ These early nineteenth-century Waterloo teeth are set in ivory and secured by pins. ⑥ This animal tooth was carried as an amulet in a pink and blue bag in order to cure toothache. It was hoped that the pain would be transferred from the person to the amulet (1901–10).

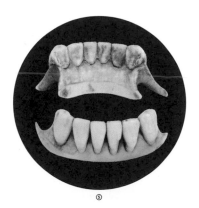

⑤

⑥

mouth into unattractive shapes, or flew out when the owner began to speak, and badly matched partial dentures stood out jarringly from surviving teeth. When the French dentist Sieur Roquet advertised his services in the Boston *Independent Advertiser* in 1749, his description tells us less about his skill in making dentures and more about the hopes of his clients:

> ... HE ALSO CURES EFFECTUALLY THE MOST STINKING BREATHS BY DRAWING OUT, AND ERADICATING ALL DECAYED TEETH AND STUMPS, AND BURNING THE GUMS TO THE JAWBONE, WITHOUT THE LEAST PAIN OR CONFINEMENT; AND PUTTING IN THEIR STEAD, AN ENTIRE SET OF RIGHT AFRICAN IVORY TEETH, SET IN A ROSE-COLOUR'D ENAMEL, SO NICELY FITTED TO THE JAWS, THAT PEOPLE OF THE FIRST FASHION MAY EAT, DRINK, SWEAR, TALK, SCANDAL, QUARREL, AND SHEW THEIR TEETH, WITHOUT THE LEAST INDECENCY, INCONVENIENCE OR HESITATION WHATEVER.

For the makers of dentures, the biggest problem was obtaining a close, comfortable fit. Although materials such as lead or gold allowed a certain amount of remoulding, hand-carved ivory plates had to be based on crude paper templates of the jaw, and usually demanded several adjustments. One dazzlingly costly way around this was the use of porcelain dentures, developed in the late eighteenth century by the French *dentiste* Nicolas Dubois de Chémant. His early experiments highlighted problems with shrinkage and surface cracking during firing, but Chémant's sets were praised by the Académie des Sciences and the Paris Medical Faculty, and in 1788 he received a royal patent. His showroom in the stylish Palais-Royal did excellent business until the Revolution, and in 1792 he moved to London. Working with the Wedgwood factory, he resumed production and by 1804 claimed to have sold more than twelve thousand sets. Although Chémant's dentures were not made to fit individual mouths, they came in a variety of sizes, with gums tinted pink after firing, and the toothy couple in Thomas Rowlandson's *A French Dentist Shewing a Specimen of his Artificial Teeth and False Palates* (1811) certainly look delighted with their investment.

For those whose purses did not run to a set of hand-painted porcelain false teeth, other grislier possibilities presented themselves. Throughout the eighteenth and early nineteenth centuries, many denture wearers ate, smiled and spoke through mouths studded with the teeth of the dead. 'Waterloo teeth', as they have become known, were teeth pulled from the jaws of dead soldiers – or so clients were led to believe. Strong, healthy teeth from fit young men were in demand: 'Oh, Sir, only let there be a battle and there'll be no want of teeth,' says a body snatcher quoted in Bransby Cooper's biography of his uncle, the eminent English surgeon Sir Astley Paston Cooper. 'I'll draw them as fast as the men are knocked down.' But with teeth from a putrid body just as useable as those torn from a fresh battlefield corpse, most of the sets sold as Waterloo teeth were most likely stolen from morgues and graves. Although they were much cheaper than porcelain dentures, human teeth still commanded a high price, as this 1781 price list from the London dentist Paul Jullion shows:

CONSTRUCTING AND FITTING AN ARTIFICIAL [IVORY] TOOTH WITH SILKEN LIGATURES, 10S 6D.
FITTING A HUMAN TOOTH (ON THE SAME CONSTRUCTION AS AN ARTIFICIAL ONE) WITH SILKEN LIGATURES £2 2S.
CONSTRUCTING AND FITTING AN UPPER OR AN UNDER ROW OF ARTIFICIAL TEETH WITHOUT FASTENINGS, £10 10S.
FITTING AN UPPER OR UNDER ROW OF HUMAN TEETH, WITHOUT FASTENINGS, £31 10S.

Waterloo teeth were not the only option for those who sought a realistic substitute for a missing tooth. In the 1760s, the surgeon John Hunter, fascinated by the anatomical and physiological similarities between humans and animals, began to experiment with transplantation.[2] After successfully grafting the heel spur of a cockerel onto its comb, and exchanging testes and ovaries between cockerels and hens, he implanted a human tooth into a cockerel's comb (the result of which is preserved in the Hunterian Museum at the Royal College of Surgeons of England). Convinced that the tooth had taken, Hunter began to work with human patients, and noted techniques for transplanting teeth between different mouths in his

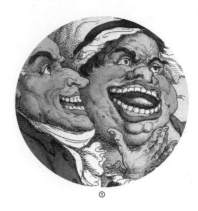

①

① This detail from a caricature by Thomas Rowlandson (1811) portrays a wealthy couple enamoured with their new dentures. ② From *The Natural History of the Human Teeth: Explaining their Structure, Use, Formation, Growth and Diseases* (1771) by John Hunter. ③ Syphilitic malformations of permanent teeth, from *A Clinical Memoir of Certain Diseases of the Eye and Ear as a Consequent of Inherited Syphilis* (1863) by Jonathan Hutchinson.

②

③

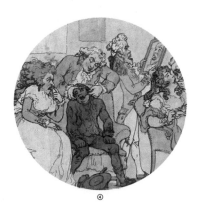

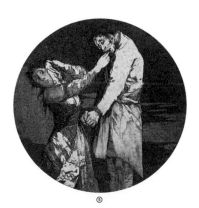

④ In a fashionable dentist's practice, healthy teeth are being extracted from poor children to create dentures for the wealthy (detail), by Thomas Rowlandson (1787). ⑤ A woman covers her eyes as she steals the teeth of a hanged man (detail), by Francisco Goya (c. 1797). ⑥ A patient at the Royal Free Hospital displays diseased tissue on the tongue and broken teeth. Watercolour by Christopher D'Alton (1874).

The Natural History of the Human Teeth (1771) and *A Practical Treatise on the Diseases of the Teeth* (1778). He acknowledged the practical difficulties of fitting an extracted tooth back into a different socket, and suggested that transplantation sessions should be arranged with several donors and recipients, so that if a tooth did not fit one jaw it would not go to waste, but could be tried in others.

Following Hunter's work, a small but vigorous market in live human teeth began to emerge. The French dentist Jean-Pierre Le Mayeur moved to New York in 1781 and ran a regular advertisement in the city's newspapers: 'Any person disposed to part with their FRONT TEETH may receive Two guineas for each Tooth, on applying to No. 28 Maiden-Lane.' Back in London, scurrilous gossip claimed that the young and impecunious Emma Hart, later Lady Hamilton and Lord Nelson's mistress, had been on her way to a dentist to sell her front teeth and with them her celebrated beauty, but had encountered a madam who talked her out of it and into a brothel. Most controversial was the fact that donors tended to be poor, while recipients were, by definition, wealthy enough to pay ten or twenty guineas for new teeth. Rowlandson's *Transplanting Teeth* (1787) skewered the harsh reality of this trade: well-dressed clients fuss over their appearance and flirt with the dentist, while a young chimney sweep has his teeth yanked out, and rag-clad children leave with a few coins and raw, bleeding mouths. Another chimney sweep, in Helenus Scott's picaresque novel *The Adventures of a Rupee* (1782), set out the lifelong consequences of making such a bargain:

> [M]Y SISTER ... HAS HAD NOTHING BUT HER NAKED JAWS SINCE SHE WAS NINE YEARS OF AGE. IT IS BUT POOR COMFORT TO HER THAT HER TEETH ARE AT COURT, WHILE SHE LIVES AT HOME ON SLOPS, WITHOUT ANY HOPE OF A HUSBAND.

Even when a suitably sized tooth could be found, transplants rarely survived more than a year or two. And while wealthy clients were quite happy to buy teeth from paupers, they worried over the risk of catching diseases such as syphilis. In a 1785 case report in the *Medical Transactions*, Sir William Watson, vice president of the Royal Society, concluded that at least one young woman had died in this way:

THINGS PASSED WELL BUT AFTER A MONTH
HER MOUTH BECAME PAINFUL ... THE CHEEKS
AND THROAT, WERE CORRODED BY LARGE,
DEEP, AND FOETID ULCERS. THE GOOD EFFECTS
OF THE MERCURY WERE VERY APPARENT ... BUT
SHE CONTINUED DANGEROUS. HER STRENGTH
GRADUALLY LESSENED, UNTIL DEATH PUT AN
END TO HER SUFFERINGS ... THE PROGRESS OF
THIS PUTRID DISEASE NOT BEING IMPEDED BY
THE MOST POWERFUL ANTISEPTICS, IN LIBERAL
DOSES, AND GIVING WAY TO MERCURIALS
EVEN IN SMALL ONES, CANNOT BUT SUGGEST
THE TAINT WAS VENEREAL.

By the time of the French Revolution (1787–99), the new dentistry pioneered by Pierre Fauchard was practised wherever the influence of French fashion was felt. *Dentistes* worked all over Europe and had also crossed the Atlantic to New York and Boston. They brought with them a vision of what strong, beautiful teeth could do for their well-to-do clients, and a new sense of what dentistry might become, intellectually and professionally. It is all the more puzzling that in Paris, the birthplace of the *dentiste*, this new dentistry had all but died out by the end of the eighteenth century. Under a revolutionary law of 1791, any French citizen was free to pursue any trade, dentistry included, but the revolutionary *écoles de santé* established at Paris, Montpellier and Strasbourg in 1794 made no space in their curricula for dentistry. Revolutionary leaders, many from the French provinces, seem to have detected a whiff of *ancien régime* decadence in the work of the Parisian *dentistes*, and the new medical and surgical establishment refused to take them seriously as learned professionals.

In other parts of the world, the new dentistry continued to flourish, but most ordinary folk, urban or rural, could not afford the attentions of a *dentiste*, and toothache and extraction remained harsh facts of life for the poor. Dentists, meanwhile, were still deeply divided over their relationship to medicine and surgery. Should they submit to supervision by the great clinical colleges, in the hope that this would bring respectability and advancement? Or should they fight to establish their own niche in the medical marketplace? Most of all, what could they do about their ancient association with pain and suffering?

①

① The engraved title page from the first book-length treatise on dentistry published in the United States (1814).
② In *Toothache* (nineteenth century) by Scottish artist Erskine Nicol, the patient attempts to soothe his pain with alcohol.
③ Fully prepared clove oil from a chemist in Coventry. The oil could be used to soothe toothache temporarily and as a mouthwash.

②

③

④

Patients feared the pain of fillings, transplants and extractions as much as they hated the long agony of toothache, and some would go to extraordinary lengths in search of relief. In *Confessions of an English Opium-Eater* (1821), Thomas De Quincey acknowledged that this great work of Romanticism had begun with a rotten molar:

> MOST TRULY I HAVE TOLD THE READER, THAT
> NOT ANY SEARCH AFTER PLEASURE, BUT
> MERE EXTREMITY OF PAIN FROM RHEUMATIC
> TOOTHACHE – THIS AND NOTHING ELSE IT WAS
> THAT FIRST DROVE ME INTO THE USE OF OPIUM.

④ A man being shot in the mouth by demons, representing the start of toothache. Wood engraving by George Cruikshank after Horace Mayhew. ⑤ *Toothache* (nineteenth century) by Cosola Demetrio shows a young child attempting to alleviate toothache. ⑥ Dispensing pot of 'Blue Pills' (1880–1930), used for a range of ailments including toothache. The pills contained mercury and were potentially toxic.

⑤

⑥

① On the Parisian 'smile revolution', see Colin Jones, *The Smile Revolution in Eighteenth-Century Paris*, Oxford University Press, 2014.
② Ruth Richardson, 'Transplanting Teeth: Reflections on Thomas Rowlandson's "Transplanting Teeth"', *Lancet*, 354, 1999, p. 1740.

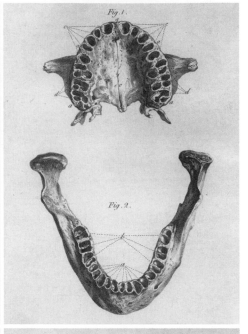

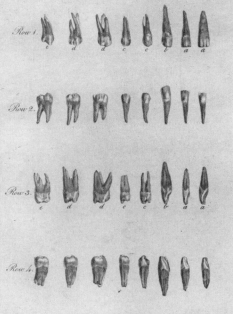

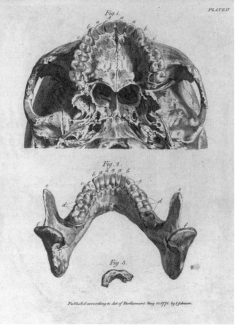

Pages from *The Natural History of the Human Teeth: Explaining their Structure, Use, Formation, Growth– and Diseases* (1771) by John Hunter. TOP LEFT | Title page. TOP RIGHT | Underside of the upper jaw and the upper part of the lower jaw, showing tooth sockets.

BOTTOM LEFT | Base of the skull showing the upper jaw with full set of teeth, the lower jaw viewed from above and behind with full set of teeth, and the moveable cartilage of the joint in the lower jaw. BOTTOM RIGHT | Teeth from the upper and lower jaw, plus side views.

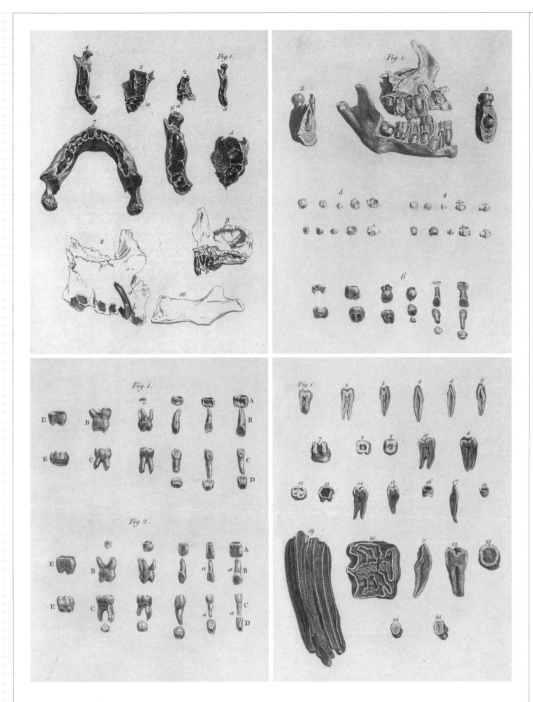

TOP LEFT | Illustration showing the various stages
of development in infants of the upper and lower
jaws: from newborn baby to seven to eight-month-
old baby. TOP RIGHT | The upper and lower jaws of
an eight to nine-year-old child, with five teeth in
various stages of advancement.

BOTTOM LEFT | Plate showing the teeth of a five
to six-year-old child (Fig. I) and a seven-year-old
child. BOTTOM RIGHT | Cross-section of the canal
or cavity of various human and horse teeth. Fig. XIX
shows a horse's tooth slit down its length, Fig. XX
the grinding surface of a horse's molar.

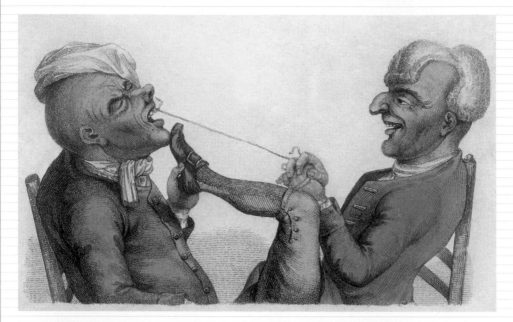

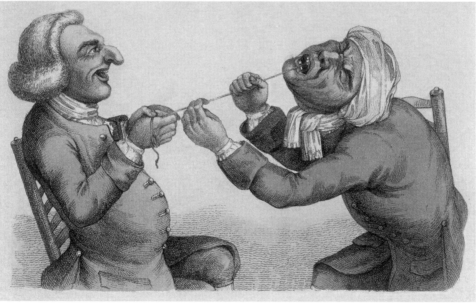

In this series of hand-coloured caricatures by the artist known as
Tim Bobbin (1773, edition 1810), the tooth-pullers are depicted using
increasingly over-the-top methods to extract the patients' teeth.
TOP | *Laughter & Experiment*. BOTTOM | *Acute Pain*.
OPPOSITE TOP | *Mirth & Anguish*. OPPOSITE BOTTOM | *Fellow Feeling*.

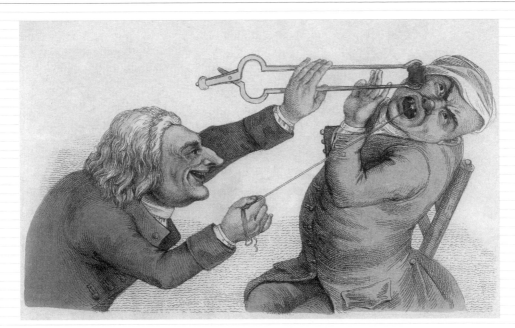

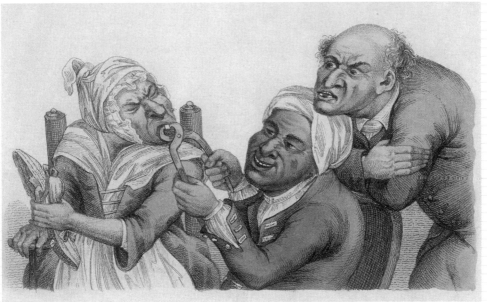

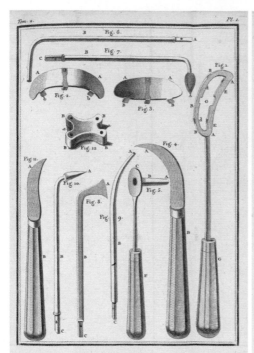

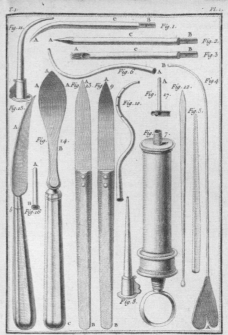

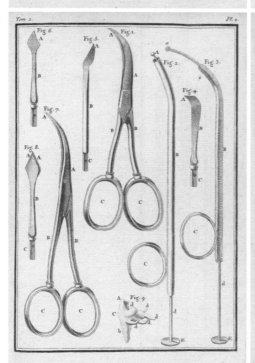

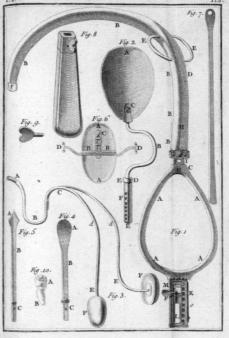

Plates illustrating instruments for treating diseases of the maxilliary sinus and various surgical tools, including scalpels and cauterization tools, from *Traité des maladies et des opérations réellement chirurgicales de la bouche* (1778) by Anselme Louis Bernard Bréchillet Jourdain.

Pl. 3.

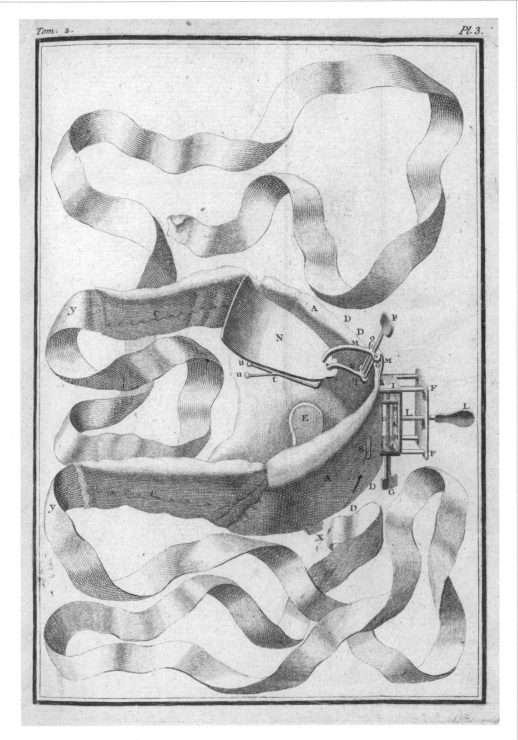

This plate from Jourdain's book shows a chin strap
designed to staunch bleeding after a dental operation.
The device is fastened around the patient's chin and
is especially useful for patients who do not have a top
set of teeth.

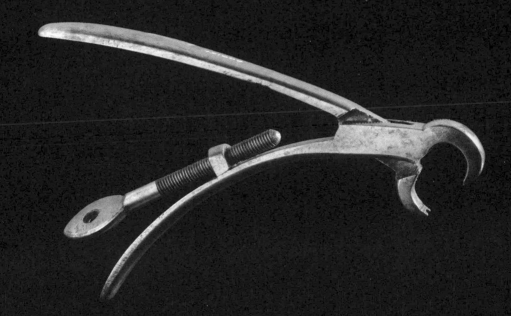

TOP | Dental key (1725–80). These tools were introduced in the early 1700s and were notorious for causing injury. The claw was placed over the top of the tooth and the bolster, the long metal rod to which the claw is attached, was placed against the root of the tooth. The key was then turned as if the user were opening a lock and the tooth would hopefully be removed.

BOTTOM | These forceps (1701–1800) are known as 'crow's bill' forceps because of their shape, and they are among the oldest instruments used for tooth-pulling. The screw can be turned to adjust the pressure on the tooth. This type of forceps would have been utilized to remove the roots of teeth that had rotted or been damaged, possibly by a previous tooth-puller.

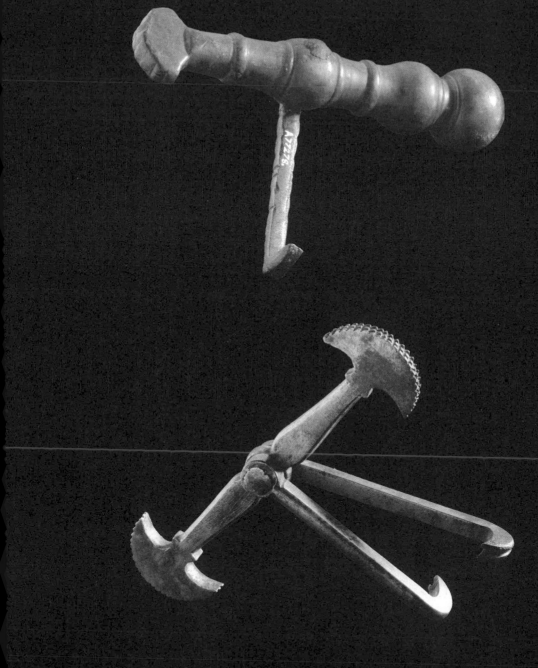

TOP | Dental pelican with wooden handle (1550–1750).
BOTTOM | Steel dental pelican (1701–1800).
Used for pulling teeth, dental pelicans are so-
called because they resemble a pelican's beak.
The claw was placed over the top of the tooth
and the fulcrum, the semi-circular piece of metal
at the end, was placed against the gum. The
pressure from the lever would remove the tooth.

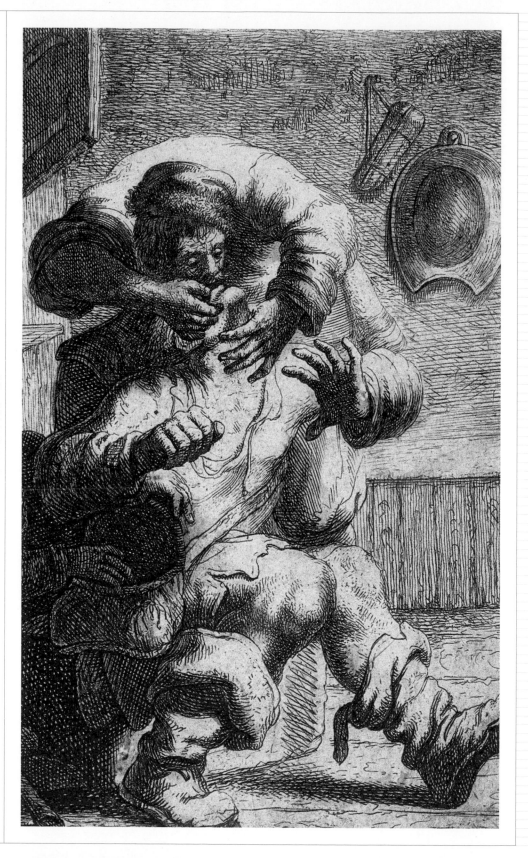

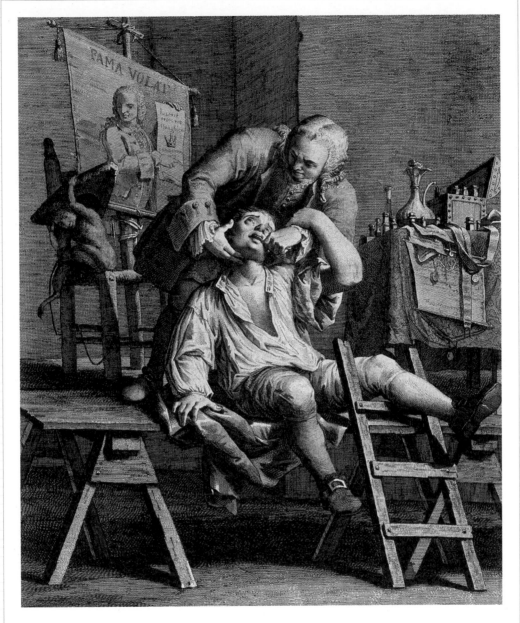

OPPOSITE | A tooth-drawer extracts a tooth from
a seated patient while a woman steals from his
bag. Detail from an etching by Jan van der Vliet.
It was not uncommon for a distressed patient to be
taken advantage of by an unscrupulous bystander.

ABOVE | A flamboyant travelling dentist advertises
his trade with the words 'Fama volat' (Fame flies).
Engraving by Giovanni Volpato after Francesco Maggiotto.
OVERLEAF | A set of ornate dental instruments in
a wooden case from the late nineteenth century.

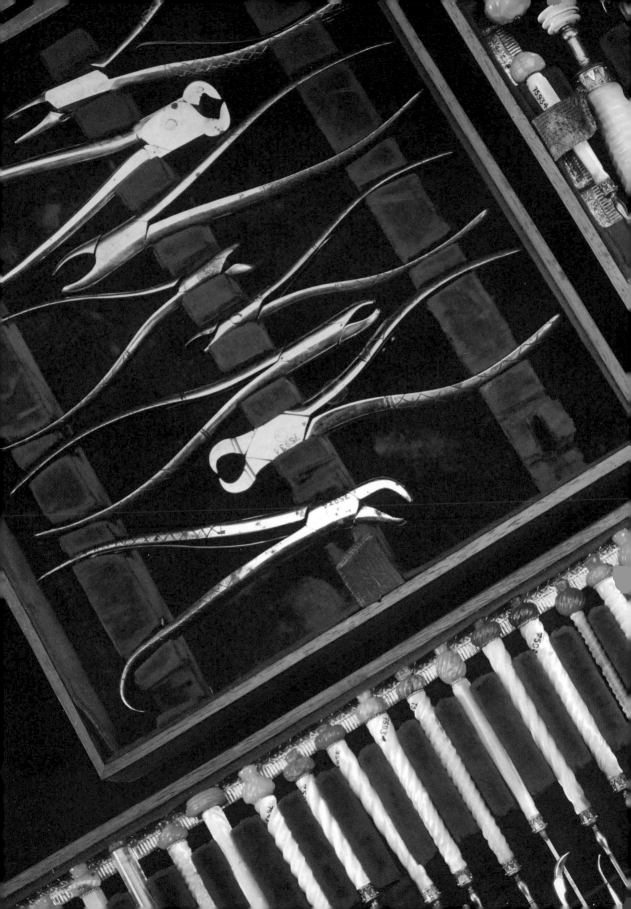

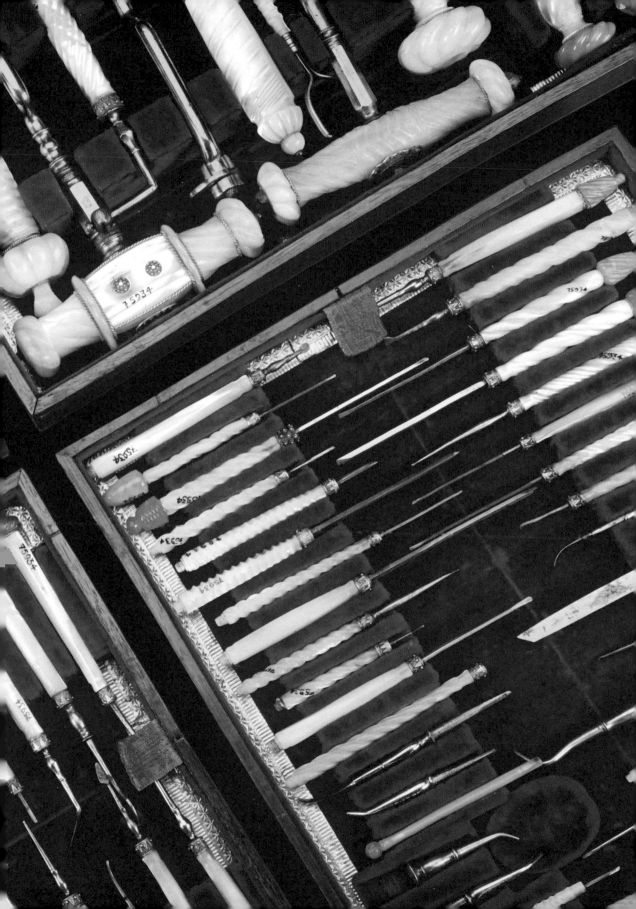

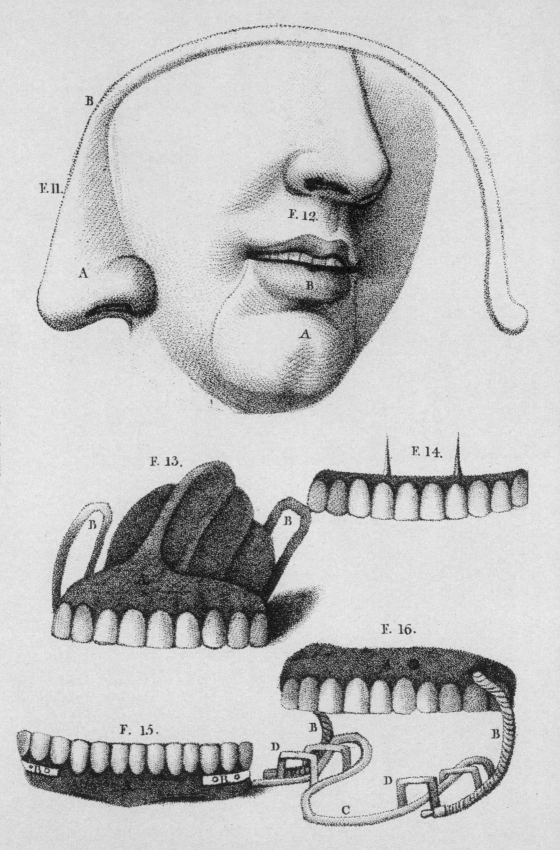

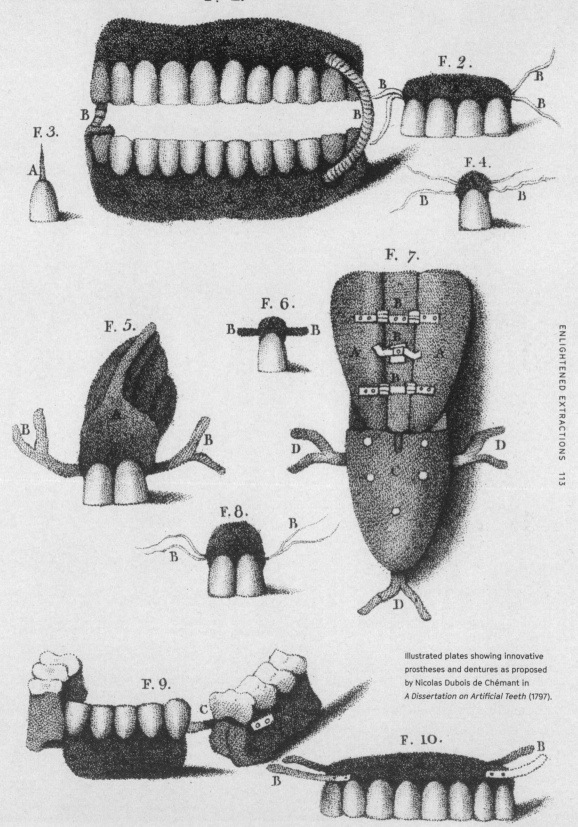

Illustrated plates showing innovative prostheses and dentures as proposed by Nicolas Dubois de Chémant in *A Dissertation on Artificial Teeth* (1797).

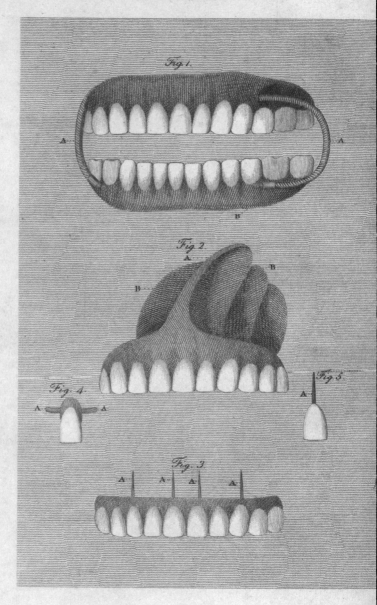

Published by Mr. Dubois de C

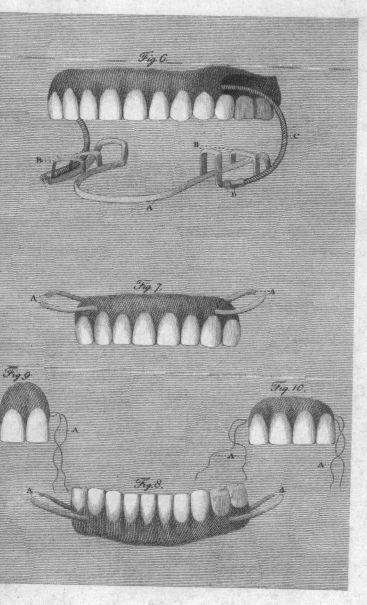

Fig 6.

Fig 7.

Fig 9.

Fig. 10.

Fig 8.

Surgeon Oct.ʳ 1.ˢᵗ 1802.

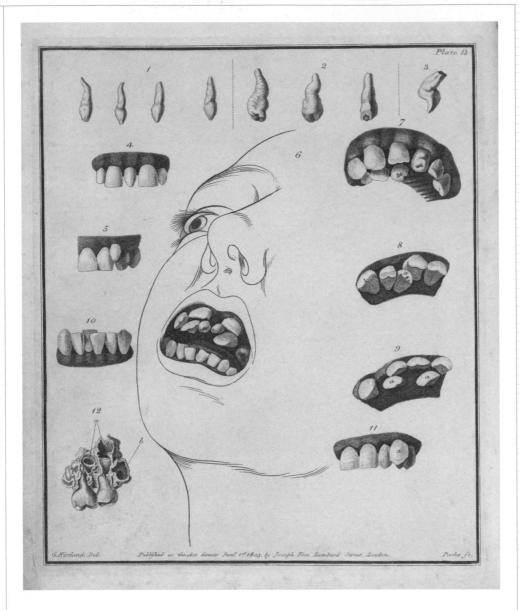

PREVIOUS | 'Mineral Paste Teeth' – types of dental
prostheses published in Chemant's *A Dissertation
on Artificial Teeth*.

ABOVE | This page from the second edition of *The
Natural History and Diseases of the Human Teeth*
(1814) by Joseph Fox shows hyperdontia: the condition
of having an excess number of teeth. The additional
teeth are referred to as supernumerary teeth
and can occur in any part of the dental arch.

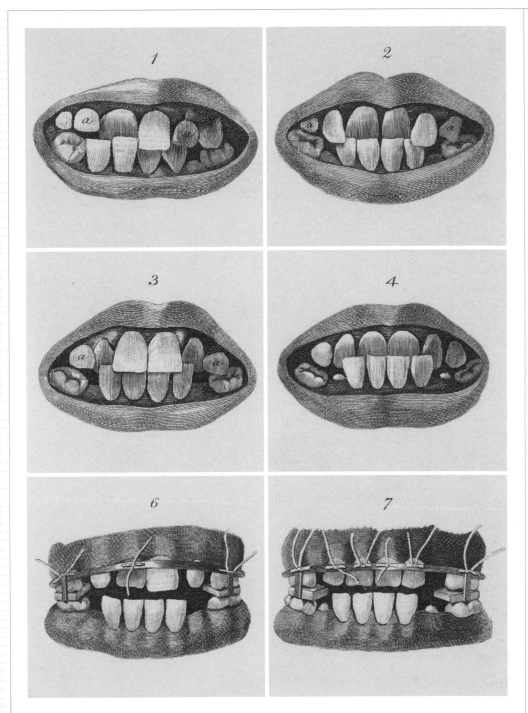

ABOVE | Fox's *The Natural History and Diseases of the Human Teeth* illustrates a selection of irregularly placed teeth and how a brace can be applied for correction.

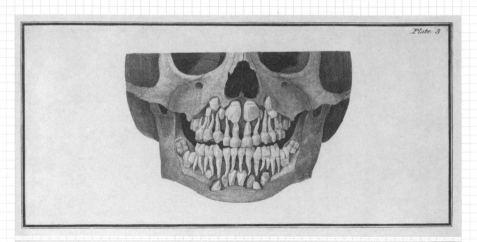

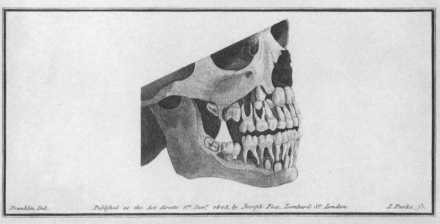

Plate 3

Franklin. Del. Published as the Act directs 1.st Jan.y 1803, by Joseph Fox, Lombard St. London. I. Parks. S.c

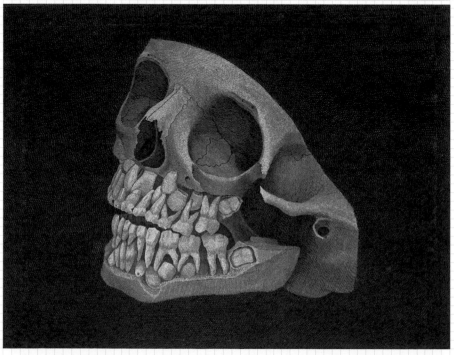

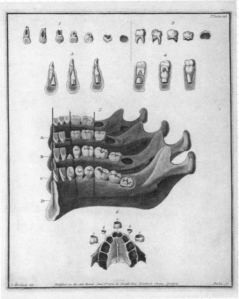

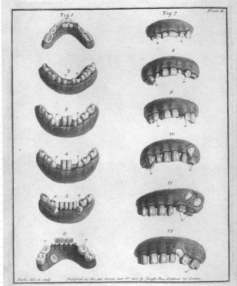

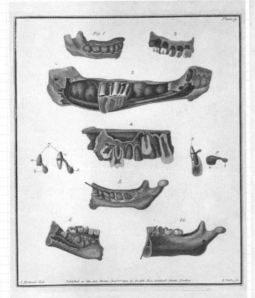

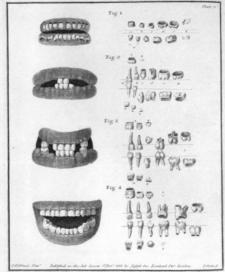

OPPOSITE TOP AND CENTRE | Front and side view of the teeth of a child between four and five years of age. Engraving by I. Parks in Fox's *The Natural History and Diseases of the Human Teeth*.
OPPOSITE BOTTOM | Jaw and part of skull of an animal. Engraving by I. Parks after George Kirtland (*c.* 1805) in Fox's *The Natural History*

ABOVE | From Fox's *The Natural History* Changes that take place during different periods of growth (top left). Examples of permanent teeth with irregular growth (top right). The development of teeth from birth, showing the vascular membranes (bottom left). The development of teeth from birth to two to three years old (bottom right).

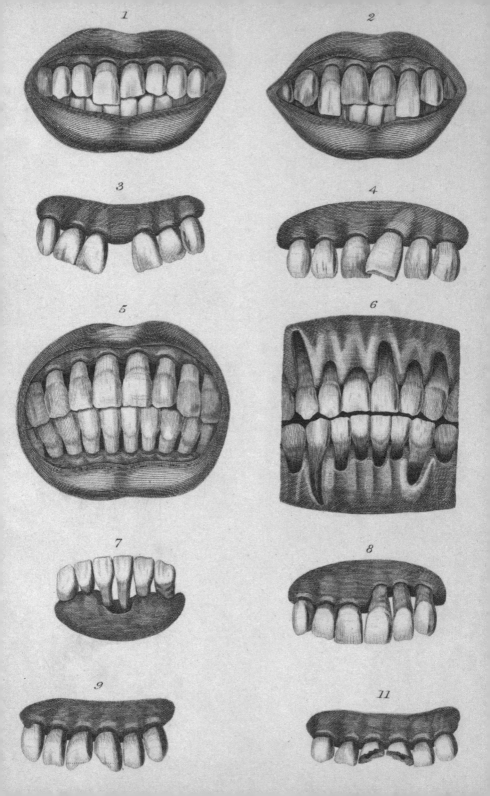

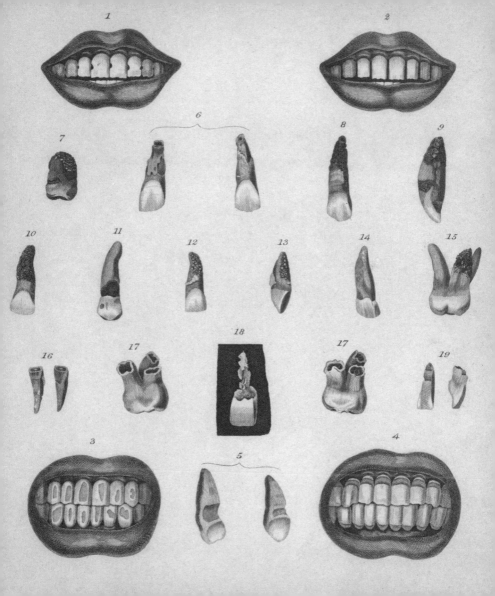

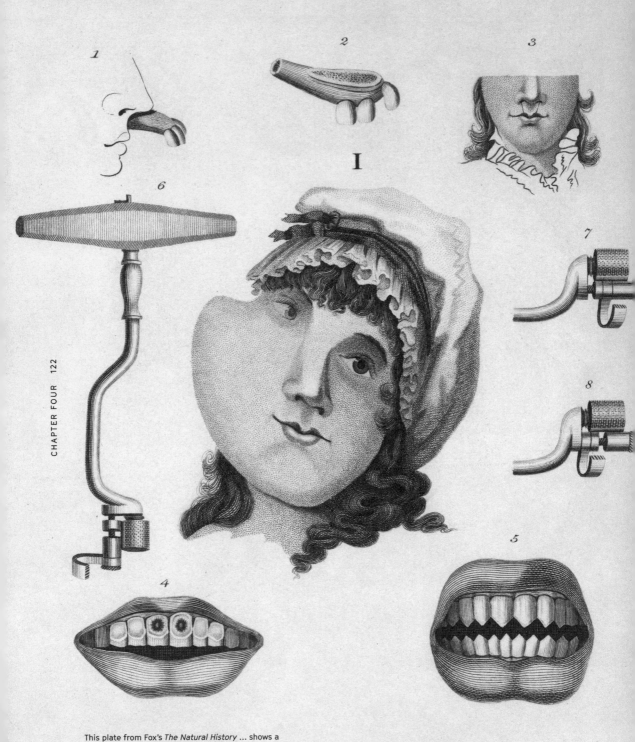

This plate from Fox's *The Natural History* ... shows a
woman with a facial tumour in the right antrum, the
profile of a young man who has a distorted growth
of the upper jaw combined with cleft lip, filed and
pointed teeth, and various claw positions adopted
when using a dental key for extraction.

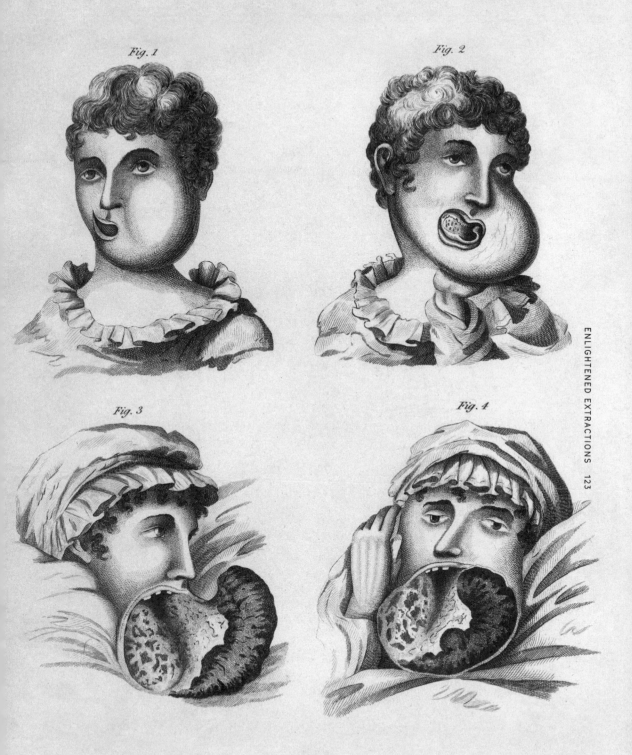

Fig. 1 *Fig. 2*

Fig. 3 *Fig. 4*

The progression of an aggressive facial tumour
in a thirteen-year-old female patient admitted
to Guy's Hospital, London, can be seen in this
plate from Fox's *The Natural History*

Row 1

Row 2

Fig. 1

Row 3

Row 4

Copperplate engravings from the second edition of Fox's *The Natural History* ... ABOVE | Cross-sections of the teeth and lower jawbone.

OPPOSITE | The temporary teeth of the upper jaw (Row 1) and the lower jaw (Row 4). The permanent teeth of the upper jaw (Row 2) and the lower jaw (Row 3).

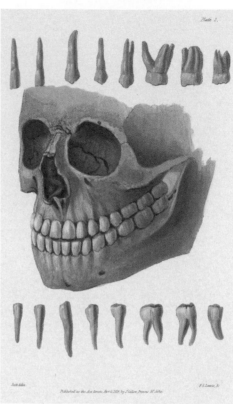

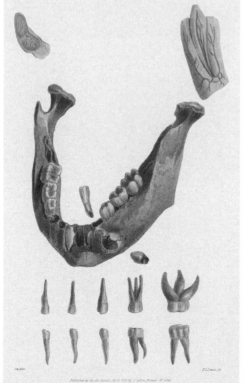

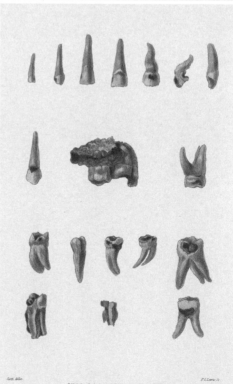

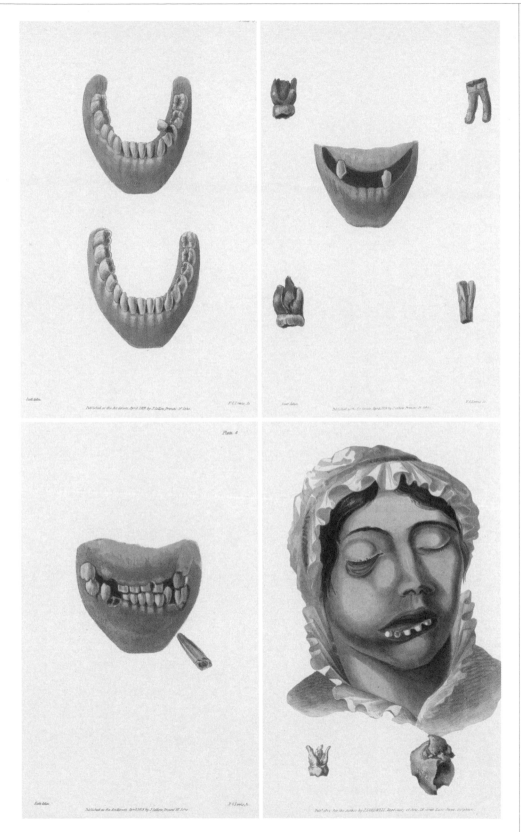

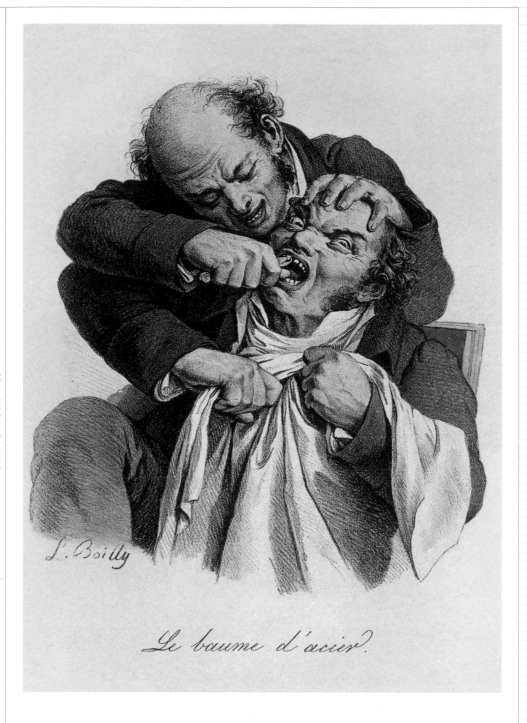

Le baume d'acier.

PREVIOUS | Plates from *Opinions on the Causes and Effects of Diseases in the Teeth and Gums* (1819) by Charles Bew. The woman (right) died at the age of thirty-five from a cancerous swelling of the mouth and face. The malady was caused by an unsuccessful attempt to remove a molar from the upper jaw.

ABOVE | A tooth-drawer extracts a tooth from a grimacing patient. Nineteenth-century coloured lithograph by D. Alexander after Louis Boilly. The title *Le baume d'acier* translates.as 'Steel Balsam', 'balsam' being an archaic term for a balm or treatment.

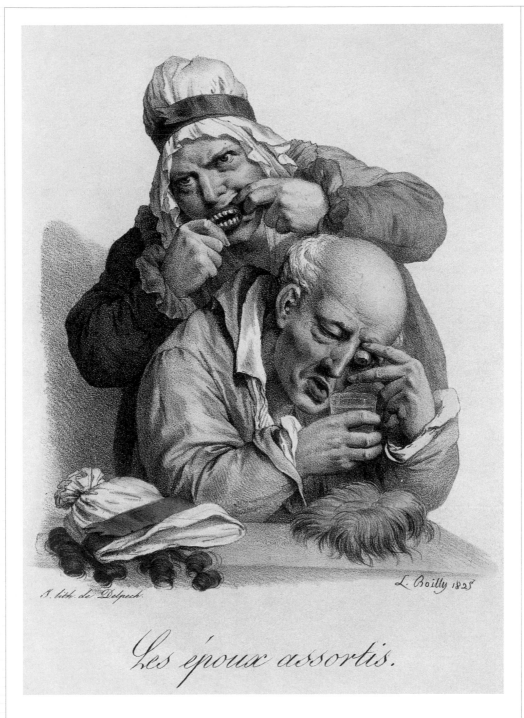

J. lith. de Delpech.

L. Boilly 1825

Les époux assortis.

ABOVE | A couple remove their various false body parts. Both having taken off their wigs, the husband pops out his glass eye into some water while his wife removes her dentures. Coloured lithograph by François Séraphin Delpech after Louis Boilly (1825).

OVERLEAF | This page from *Traité complet de l'anatomie de l'homme comprenant la médecine opératoire* (1831–54) by Jean-Baptiste Marc Bourgery shows the maxillary and mandibular dental arcades. The various teeth in Figs. 7 to 16 illustrate congenital dental anomalies and dental pathologies.

3

2

4

Fig.6.

7

7

Fig.9.

8

8

1

Fig.3.

1

7

Fig.16.

7'

Fig.4.

8

4

Fig.5.

8

7

5

7

5

Fig. 1.

Fig. 12.

Fig. 13.

Fig. 8.

Fig. 10.

Fig. 11.

Fig. 2.

Fig. 14.

Fig. 15.

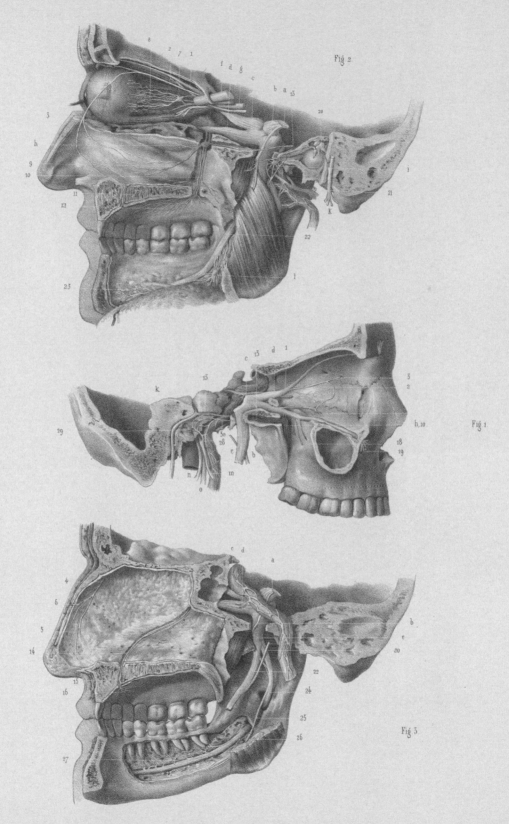

Fig 2

Fig 1

Fig 3

N.H. Jacob direxit

Imp. Lemercier, à Paris.

Dessiné d'après nature par Roussin.
préparation par Ludovic.

Fig. 1 Fig. 2

These pages from Bourgery's *Traité complet de l'anatomie de l'homme* ... show the cranial nerves, the trigeminal nerve, the maxillary nerve and the mandibular nerve (opposite) as well as the anatomy of the oral cavity (above and below).

Fig. 4 Fig. 3

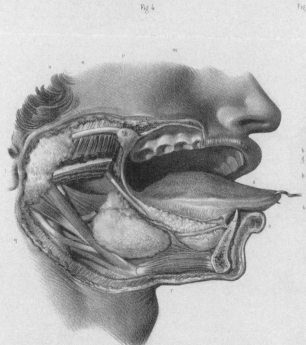

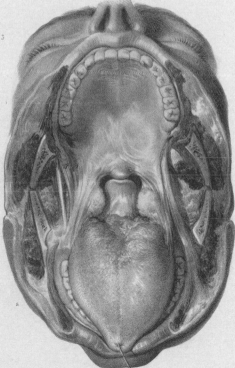

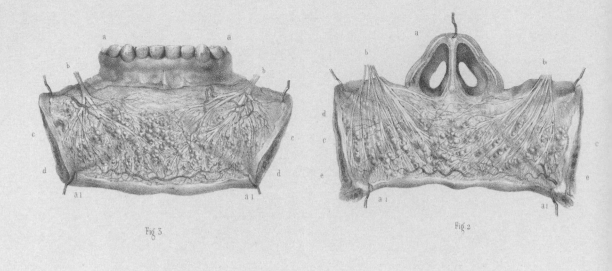

Fig 3

Fig 2

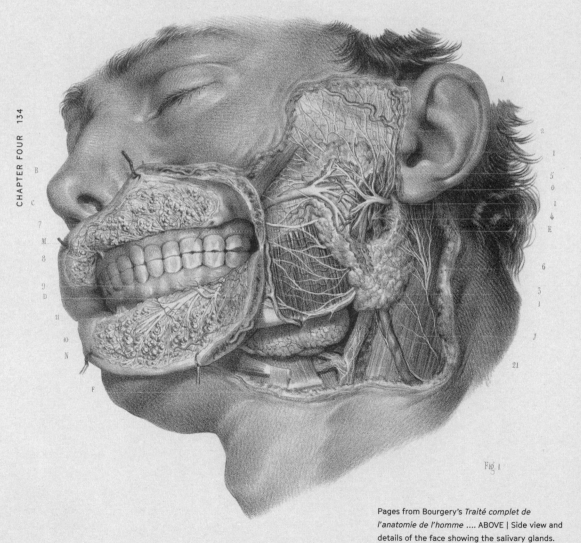

Fig 1

Pages from Bourgery's *Traité complet de l'anatomie de l'homme* ABOVE | Side view and details of the face showing the salivary glands. OPPOSITE | Nerves of the oral cavity and the tongue.

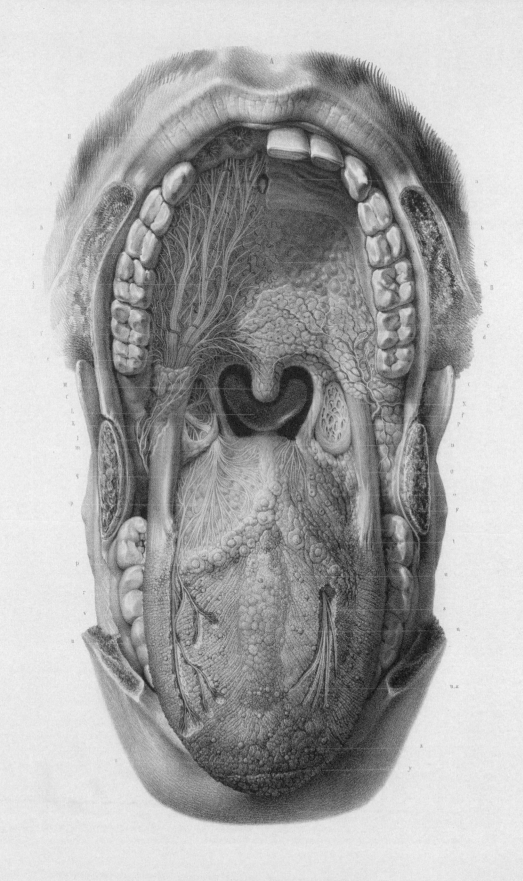

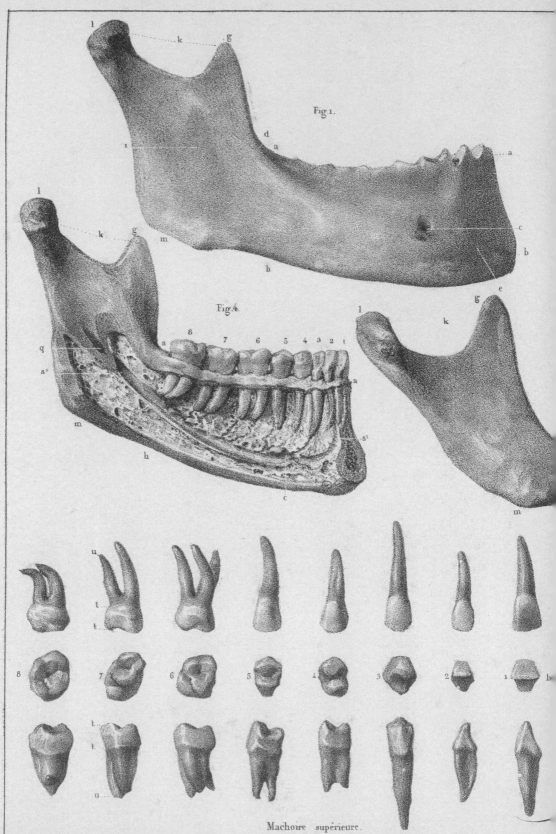

Fig 1.

Fig.4.

Machoire supérieure.

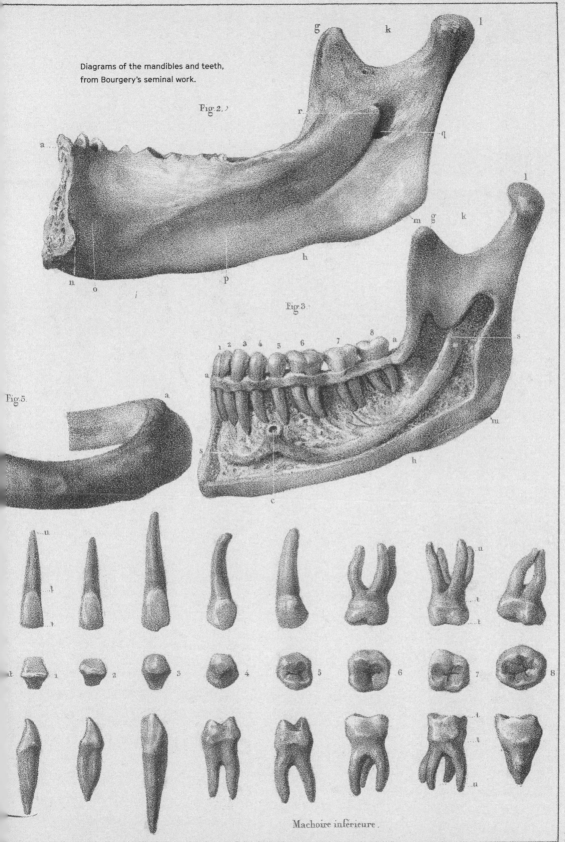

Diagrams of the mandibles and teeth,
from Bourgery's seminal work.

Fig. 2.

Fig 3.

Fig. 5.

Machoire inférieure.

Pl. 29.

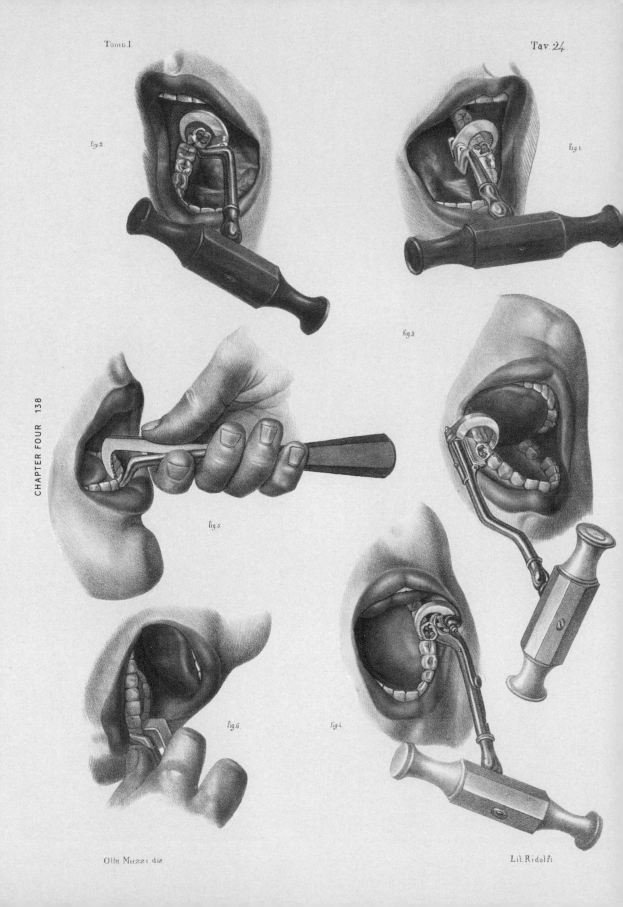

fig. 2.

fig. 1.

fig. 3.

CHAPTER FOUR 138

fig. 5.

fig. 6.

fig. 4.

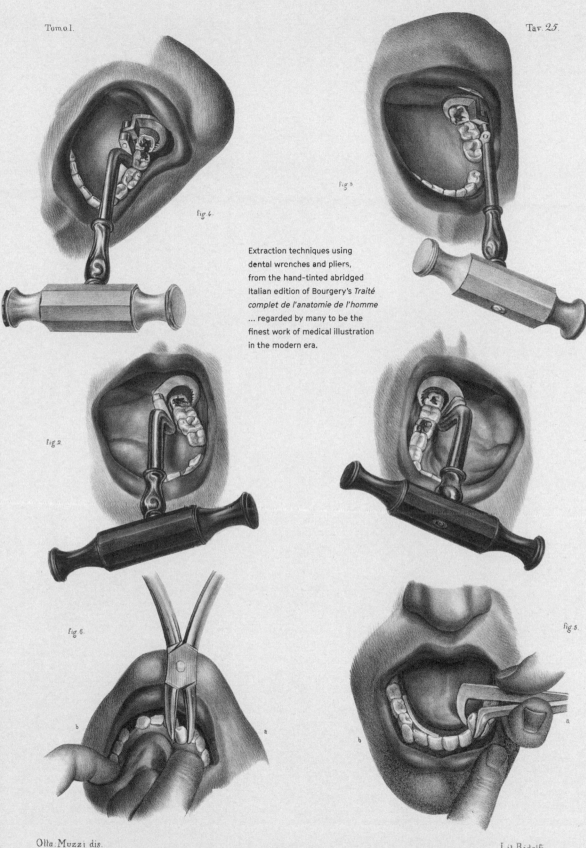

Tomo I.

Tav. 25.

fig 4.

fig 3

Extraction techniques using
dental wrenches and pliers,
from the hand-tinted abridged
Italian edition of Bourgery's *Traité
complet de l'anatomie de l'homme*
... regarded by many to be the
finest work of medical illustration
in the modern era.

fig 2

fig 6.

fig 5.

Otta.Muzzi dis.

Lit Ridolfi.

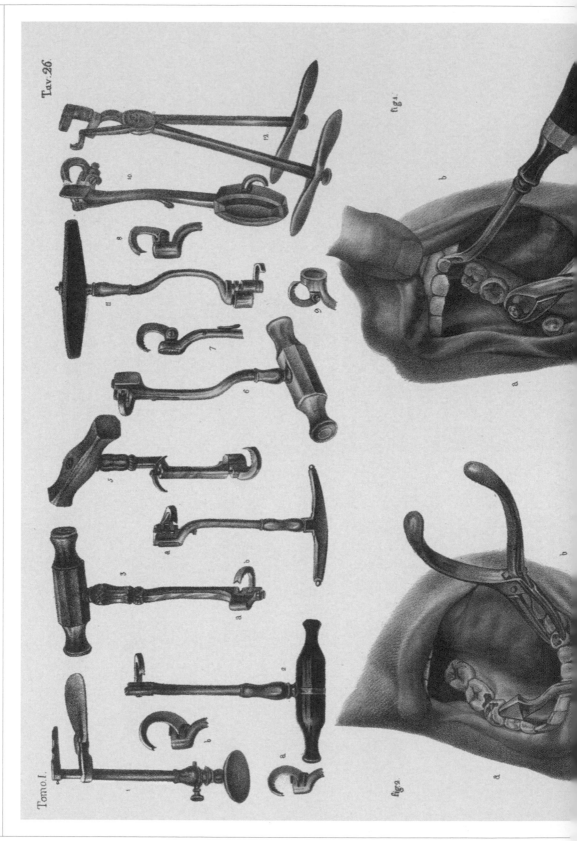

Tav.26.

Tomo.I.

Otta Muzzi dis:

Lit: Ridolfi.

13. 14. 17. 15. 18. 16. 21. 19. 20. 22. 24. 23. 25. 26.

27. 28. 29. 30.

PREVIOUS | These pages from Bourgery's *Traité complet de l'anatomie de l'homme ...* show two processes: a tooth extraction with forceps and a luxation of a root with a dental elevator, and a luxation of a carious double root with a dental pelican. The dental instruments include an oral speculum, toothkeys and cutting pliers.

THIS PAGE | Clockwork picture of an itinerant dentist performing an extraction in a rural French hamlet (*c.* 1800–50). He is accompanied by a bandman to drown out the patients' cries.

Illustration of dental prosthetics, brushes and
instruments. From *Il Dentista Istruito* (1834)
by J. C. F. Maury.

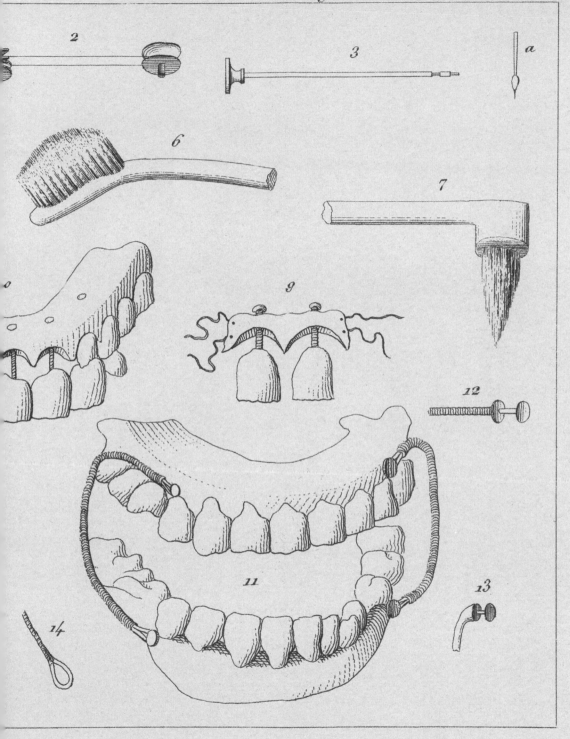

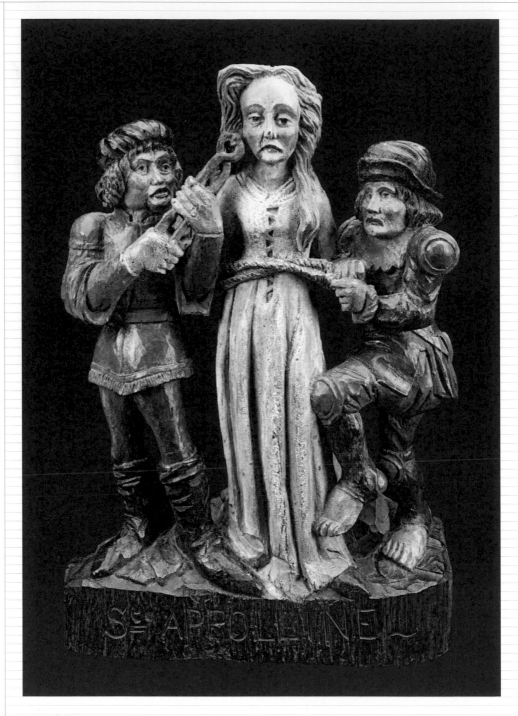

ABOVE | Wooden statue of St Apollonia and two tormentors (nineteenth century). It shows the very painful way in which Apollonia was martyred. Her teeth were broken and pulled out one by one using pliers. For this reason, she is revered as the patron saint of toothache and of dentists. This statue is a copy of the original, which is in the Chapelle de la Houssaye in Pontivy, France.

OPPOSITE | Plaque depicting dental and surgical operations (1801). Carved from oak, it shows a painful extraction in progress while another man undergoes a surgical treatment to the head. OVERLEAF | Dental tools for tooth extraction, including toothkeys, forceps, dental keys, dental pelicans and dental forceps. From *Armamentarium chirurgicum* (1835–36) by German surgeon Albert Seerig.

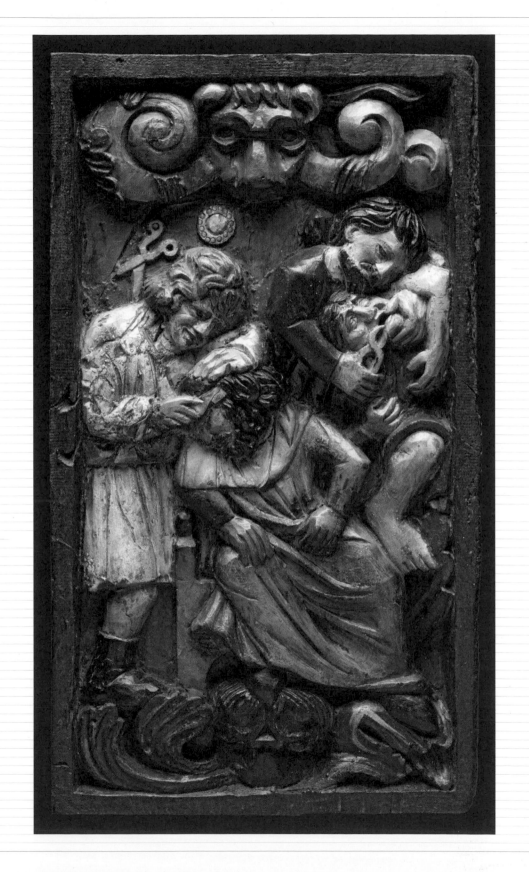

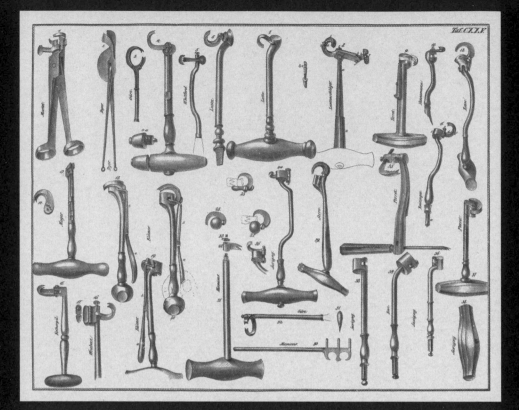

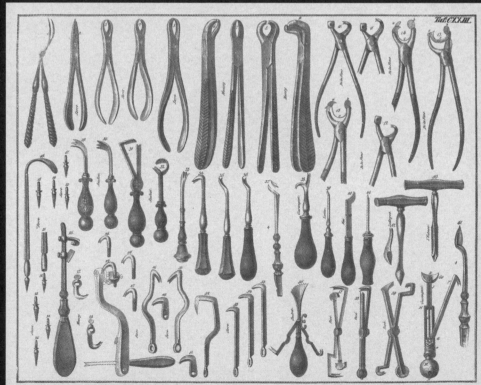

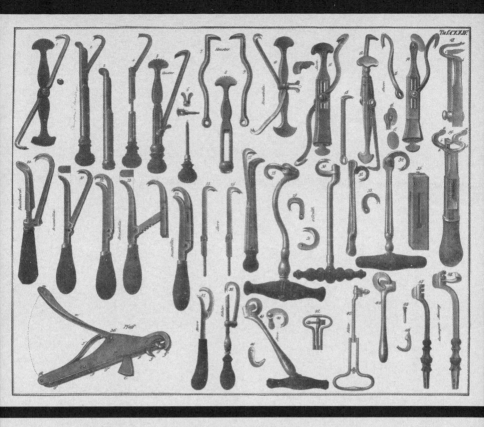

Tab.CXXXIV.

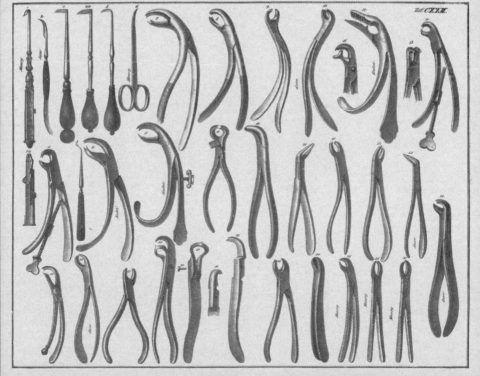

Tab.CXXXV.

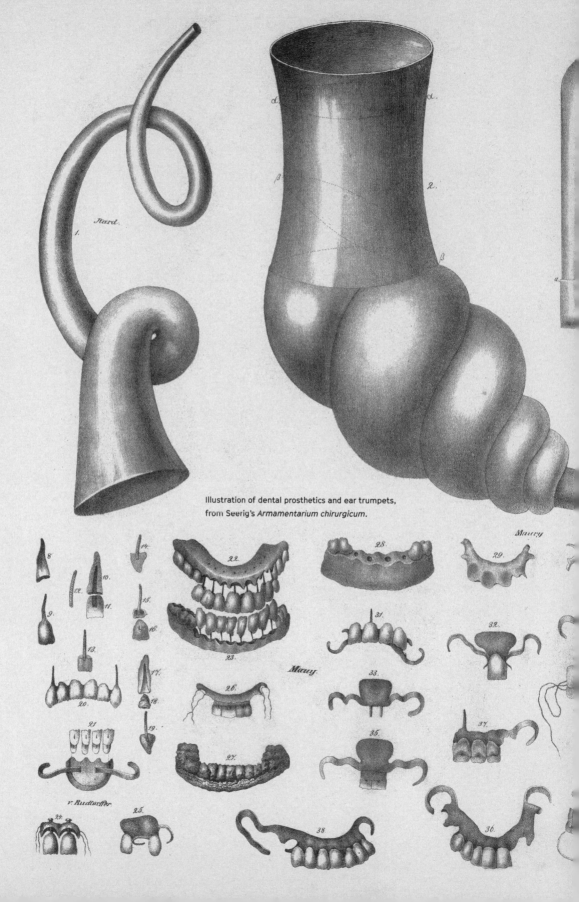

Illustration of dental prosthetics and ear trumpets,
from Seerig's *Armamentarium chirurgicum*.

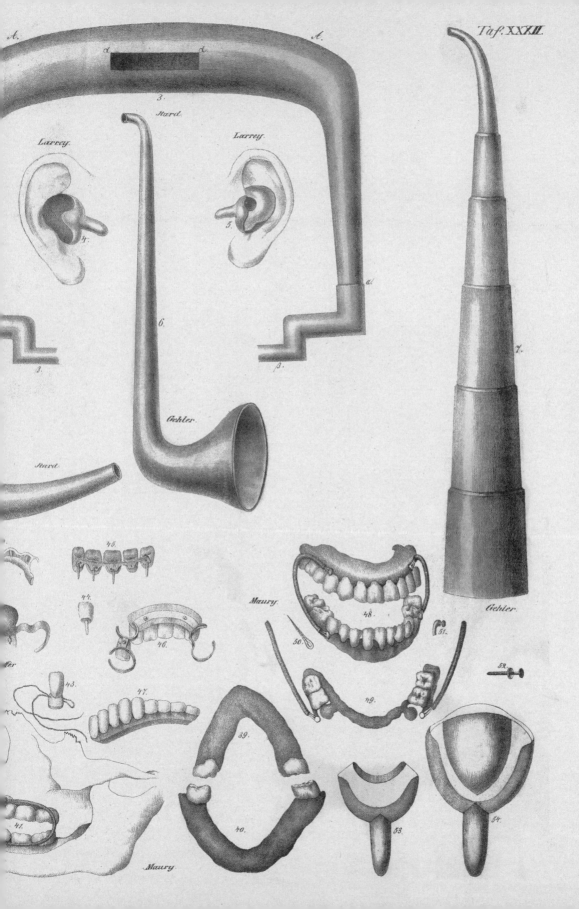

Lithograph by J. Basire illustrating the various forms of human teeth (*c.* 1837).

Fig. 3

A

B.

Fig 5.

C

D

Fig. 7.

c

c

a

a

nog:

PLATE VII.

Fig. 5.

Fig. 1.

D A

B

D

D C

Fig. 3.

Fig. 6.

Fig. 4.

Fig. 2.

B

A

C

Fr. Schenck, Lith.

OPPOSITE | Illustration by William Alfred Roberts showing apparatus for arresting haemorrhage after the extraction of teeth, from the *Monthly Journal of Medical Science* (1846). ABOVE | Two profiles of a woman, the first with teeth and the second without, from the second edition of *The Surgical, Mechanical and Medical Treatment of the Teeth* (1846) by James Robinson.

OVERLEAF | Forty-five different scenes telling the tale of a man with toothache, his various attempts at trying to cure himself and his final recourse to the dentist. Wood engraving by George Cruikshank after Horace Mayhew.

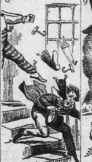

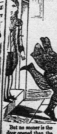

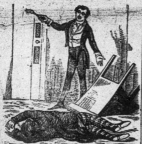
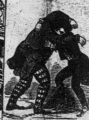

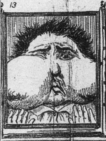

not give you … some creosote

After trying the 240 Infallible cures for the Tooth-ache you go to bed again, and enjoy a few moments of quiet rest

But the evenings amusement scarcely bears the mornings reflection. - Every attempt to shave is hopeless upon the face of it

You console yourself with a poultice

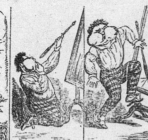

brought in …reams

The first thing in the morning you try another infallible remedy

But instead of destroying the nerve, you only succeed in burning your fingers

Having heard of some most wonderful cases of tooth-ache being effectually cured by Steam you inhale it for half an hour

But stupidly pausing to take breath, you are completely overwhelmed by the consequence

Being told by an old woman that filling your mouth with cold water and sitting on the hob till it boils is a certain cure, you take your seat and act accordingly, but want the firmness and coolness to persevere

You rush to the Dentists once more, and plunge head-long in

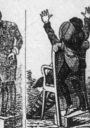

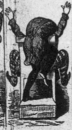

with his … requested

You resign yourself boldly to your fate

Once in the hands of the Dentist the time seems interminable

This is the first quarter of an hour !

The second quarter of an hour ! !

The third quarter of an hour ! ! !

The fourth quarter of an hour ! ! ! !

…ACHE

…AYHEW.

…KSHANK.

1s. 6d. Plain.

And you go home, dine, sleep well, and the next morning are delighted to find that you are none the worse for the Tooth-ache

The end of the Tooth-ache, "All's well that ends well."

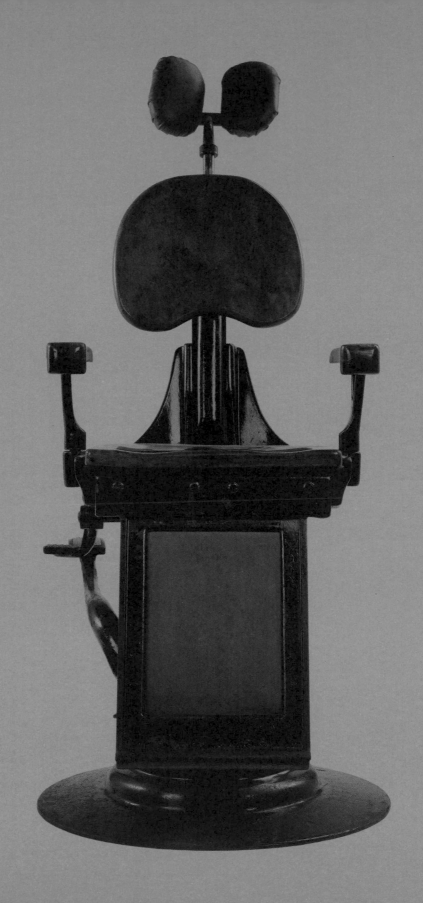

A
NEW ERA
IN
TOOTH-
PULLING
5

In the summer of 1799, Humphry Davy, a young laboratory superintendent at Thomas Beddoes' Pneumatic Institution in Bristol, was distracted from his experiments by his impacted wisdom teeth – a 'great pain, which equally destroyed the power of repose, and of consistent action'. One of Davy's tasks was to determine the effect of inhaling various vapours and gases, and some time in August, 'on the day when the inflammation was most troublesome':

[HE] BREATHED THREE LARGE DOSES OF NITROUS OXIDE. THE PAIN ALWAYS DIMINISHED AFTER THE FIRST FOUR OR FIVE INSPIRATIONS; THE THRILLING CAME ON AS USUAL, AND UNEASINESS WAS, FOR A FEW MINUTES, SWALLOWED UP IN PLEASURE.

Writing up his experiences in his *Researches, Chemical and Philosophical, Chiefly Concerning Nitrous Oxide* (1800), Davy recalled that this curious effect was only temporary, and 'I once imagined that the pain was more severe after the experiment than before.' We might take this experiment as the first page in the story of modern anaesthesia, but Davy's work raises more questions than it answers. If he had recognized the anaesthetic qualities of nitrous oxide in 1799, why did it take half a century for anaesthesia to become widely acknowledged? And why were the first general anaesthetics administered not in the laboratories of British natural philosophers but in the offices of American dentists, with American showmen administering the gas?

The emergence of anaesthesia was closely connected with the ambitions of dentists, that characteristically nineteenth-century mix of humane curiosity and ruthless commercial nous. A vast and prosperous industrial middle class, concerned – as their eighteenth-century counterparts had been – with success and respectability, were willing to pay higher fees for reputable, painless dentistry. Increasingly, they looked to the state and the universities to guarantee a certain level of competence, through diplomas and professional registers. Dentists, in turn, gained standing and wealth, and picked up older arguments over the most appropriate way to consolidate their position. This century of transformation also witnessed the emergence of much that we would now recognize as modern dentistry: the dental drill, the dental chair,

①

PAGE 156 Hydraulic dental chair, for use with children, by The Dental Manufacturing Co. (1910–30). ① Mercurial air-holder and breathing machine. Plate from *Research 1: Concerning the Analysis of Nitric Acid and Nitrous Gas and the Production of Nitrous Oxide* (1800) by Humphry Davy. ② Photograph of the first demonstration of surgical anaesthesia, Boston, 16 October 1846. ③ Nitrous oxide cylinder (1840–68).

②

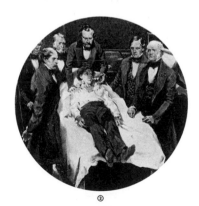

③

④

④ A Colton card promoting nitrous oxide as sideshow entertainment (c. 1846). ⑤ Administering nitrous oxide gas, from L. W. Nevius' *The Discovery of Modern Anaesthesia* (1894). ⑥ Anaesthetic apparatus (1880–1910). Joseph Clover used both nitrous oxide and ether and claimed that his apparatus quickly anaesthetized patients, was good value for money and could administer a controlled dosage easily.

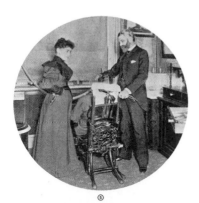

⑤

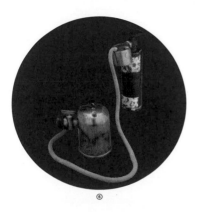

⑥

a certificate or licence on the wall and, most of all, the prospect of fillings and extractions without pain.

In the first half of the nineteenth century, most encounters with nitrous oxide took place on stage, in the form of 'frolics' put on by travelling lecturers and charlatans. We can get some sense of their wild, near-psychedelic atmosphere from the poster for 'A Grand Exhibition of the Effects Produced by Inhaling Nitrous Oxide, Exhilerating [sic], or Laughing Gas!' in New York in 1845:

MEN WILL BE INVITED FROM THE AUDIENCE TO PROTECT THOSE UNDER THE INFLUENCE OF THE GAS FROM INJURING THEMSELVES OR OTHERS. THIS COURSE IS ADOPTED SO THAT NO APPREHENSION OF DANGER MAY BE ENTERTAINED. PROBABLY NO ONE WILL ATTEMPT TO FIGHT.

In December of the previous year, the Boston dentist Horace Wells had witnessed a laughing gas frolic given by American anaesthetist Gardner Quincy Colton in Hartford, Connecticut. He was struck deeply by the antics of one participant, who breathed the gas and vaulted around the stage, bouncing off the furniture but evidently feeling no pain. The dentist invited Colton to 'bring a bag of gas to his dental office', and the following morning Wells himself underwent the first recorded tooth extraction under anaesthesia. His tooth came out with no difficulty, and on regaining his faculties the patient reportedly shouted, 'A new era in tooth-pulling! It did not hurt me more than the prick of a pin.'

Wells carried out a few more extractions with nitrous oxide, but things went terribly wrong when a former student, William Thomas Green Morton, arranged a demonstration for the Dental Society of Boston at the Massachusetts General Hospital in 1845. Worried about the risks of overdosing, Wells gave only a few breaths of gas to his burly student patient before trying to pull a rotten tooth. An audience member recorded the consequences:

THE PATIENT STARTED YELLING HIS HEAD OFF AND GESTICULATING WILDLY, NEARLY KNOCKING DR WELLS ON THE FLOOR. THE TWO DENTISTS TRIED VAINLY TO RESTRAIN HIM, BUT HE WAS TOO STRONG FOR THEM, AND PUSHING ASIDE THE CHAIR AND INSTRUMENTS SCATTERED ON

THE FLOOR, HE WENT FOR WELLS, BENT ON
REVENGE FOR THE HOAX THAT HAD BEEN PLAYED
ON HIM. AND THE AUDIENCE FOLLOWED SUIT.
'HUMBUG, SWINDLE,' THEY SHOUTED, 'THROW
HIM OUT. THIS IS A UNIVERSITY AND NOT A CIRCUS.'

This episode – which effectively ended Wells' career
as a dentist – illustrates the main difficulty facing
all early experiments with nitrous oxide. The success
of the frolics had been built on the unpredictable
and raucous effects of laughing gas in those
who breathed it, and this made dosage extremely
hard to estimate – particularly when the gas was
administered from a large rubber bag. The major
breakthrough in dental anaesthesia came when
Morton began to experiment with a different
substance. In 1844 he had attended lectures given
by the physician Charles Thomas Jackson at Harvard
Medical School. Jackson had demonstrated the power
of ether to cause unconsciousness and was also in
the habit of using drops of ether to numb the pain of
toothache. Borrowing this idea, Morton convinced one
of his patients, Eban Frost, that ether was a better
bet than mesmerism for a painless extraction. On the
evening of 30 September 1846, Morton asked Frost
to breathe ether vapour from a silk handkerchief. In
a testimonial, the patient recalled that after a minute
or so he was 'lost in sleep', but 'in an instant more
I woke and saw my tooth lying on the floor. I did
not experience the slightest pain whatsoever.'

Morton moved quickly to secure his claim to the
proceeds from ether anaesthesia. He and Jackson
filed a patent, and he entered a lucrative new
partnership with the dentist Nathan Cooley Keep,
offering painless extractions to the people of Boston.
By the end of the year, Morton had received his
patent, and news of his discovery rang around the
world. In London the American physician Francis Boott
received a letter from a friend, Jacob Bigelow, who had
witnessed Morton's demonstration. Boott passed the
description to his neighbour, society dentist James
Robinson, and on 19 December Robinson carried
out the first British general anaesthetic, pulling a
decayed molar from the jaw of one Miss Lonsdale.

Although Morton was successful in obtaining
credit for the discovery of ether, his attempt to make
a fortune from it proved fruitless. Many surgeons
opposed his patent, arguing that they should be

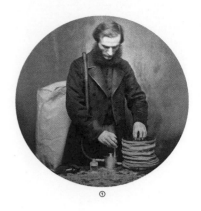

① Portrait of Joseph Clover preparing his
chloroform inhaler (c. 1862). ② An early
inhaler for ether anaesthesia (1847–48).
Ether-soaked sponges were placed in the
glass jar and flexible tubing connected
the valve to the face mask so the patient
could inhale the gas. ③ One of the first
operations to use ether as an anaesthetic
agent, performed at the Massachussetts
General Hospital. Daguerrotype (1897).

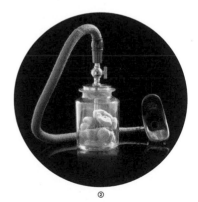

②

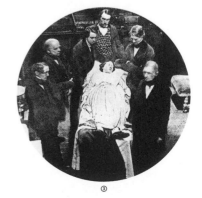

③

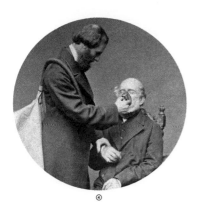

④

④ Portrait of Joseph Clover demonstrating his chloroform inhaler (*c.* 1862). ⑤ The Richardson spray (1866–84) was used originally to spray ether to give a local anaesthetic, especially during tooth extraction. The air is pushed through using the hand pump, which forces the liquid ether out of the nozzle. ⑥ A modification of Mason's gag for use in operations within the mouth and nose (1922).

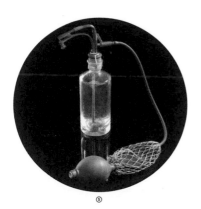

⑤

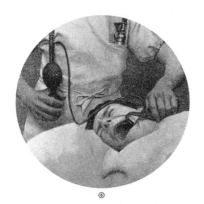

⑥

free to use this powerful new technique without paying royalties. Their view gained ground when it emerged that what Morton had been marketing as 'letheon' was nothing more than scented ether. A Congressional prize of $100,000 for the inventor of anaesthesia came to nothing after it proved impossible to disentangle the stories of competing claimants, who included not only Morton, Wells and Jackson, but also the Georgia surgeon Crawford Long, who had been carrying out amputations under ether as far back as 1842. Wells, by this point a chloroform addict, committed suicide in prison after throwing vitriol over two women in the street, and Morton died in 1868 at the age of forty-eight, near-destitute and his reputation ruined by litigation.

The anaesthetics revolution – in which a staple of travelling sideshows was remade, in less than a year, as a great humanitarian innovation and a prompt for bitter struggles over precedence and profit – mirrored the upheavals facing dentistry in the mid-nineteenth century. On one hand, dentists were more successful and more numerous than ever. But the refusal of physicians and surgeons to take anaesthesia seriously while it remained the province of mere dentists reflected the shaky standing of dentistry as a profession. In the years around Morton's work on ether anaesthesia, dentists on both sides of the Atlantic began to campaign for greater recognition. But this movement was riven with divisions. Should dentists accept regulation from the established colleges of medicine and surgery? And would clinical elites be prepared to rub shoulders with practitioners whom they commonly dismissed as uneducated tradesmen?

In Britain the movement for reform split into two opposing groups. 'Memorialists' wanted dentistry to become part of surgery, with a fellowship qualification overseen by the Royal College of Surgeons (RCS); 'Independents' sought to establish a separate and autonomous structure. A majority of ordinary British dentists seem to have favoured the Independents, but the Memorialists had powerful friends in Parliament, and the Medical Act of 1858 empowered the RCS to offer a qualification in dentistry. By 1863 the Independents had admitted defeat.

In 1878 the Dentists Act established a Dental Register, on the lines of the Medical Register, and put British dentistry under the official supervision

of the General Medical Council. The British Dental Association, established two years later, reflected the continuing influence of surgery, with a governing council drawn mostly from the senior membership of the Odontological Society and the RCS. But for the British Dental Association's members, the great irony of this generational struggle for recognition was that they had become, in the words of the historian Christine Hillam, 'a colony of a medical profession which not only had no interest in it but considered it as some inferior trade'.[1]

By the time the Dentists Act came into force in Britain, American dentists had been demanding reform for forty years or more. American author James Wynbrandt noted that the year 1839 has a good claim to be the 'birth year of organized dentistry' in the United States, with the creation in Baltimore of the world's first dental college, the publication of the *American Journal of Dental Science*, the first dental journal, and the foundation of the American Society of Dental Surgeons, the first national organization for dentists.[2] American dentists followed what their British contemporaries would have called an 'Independent' line: the American Dental Association (ADA), established in 1859, campaigned for legal regulation of dental practice while asserting the right of American dentists to practise without interference from the medical establishment.

Whatever their professional allegiances, late nineteenth-century dentists found themselves practising new techniques in new spaces: premises that reflected the expectations of patients and the texture of life in the new industrial cities. Traditionally, as we have seen, tooth-pullers knelt or sat to perform their duties, while patients of the *dentistes* lay on a chaise longue. By the early nineteenth century, dental offices were equipped with high-backed armchairs, and in 1850 the S.S. White Dental Manufacturing Company, based in Philadelphia, began to market the first mass-produced adjustable dental chairs. Furthermore, the look of dental practices was beginning to change, as dentists, like surgeons, drew on the ideas and the rhetoric of aseptic surgery. The surgery of a progressive-minded dentist at the end of the nineteenth century would have resembled a laboratory: all white tiles, stainless steel and sterilized smocks.

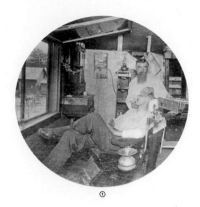

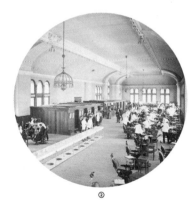

① A dentist works on a patient in a well-equipped surgery in Jacksonville, Oregon, in the early 1890s. ② The Dental Hall at University of Pennsylvania (seen here in *c.* 1904) opened in 1895 as a result of the expansion of the dental programme. ③ Dental work is carried out at the company hospital of Hood Rubber Company, Cambridge, Massachusetts. It was only the second US firm to offer an on-site dentist.

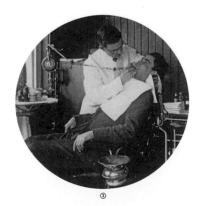

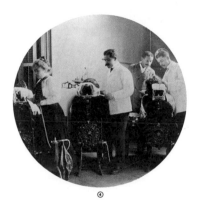

④

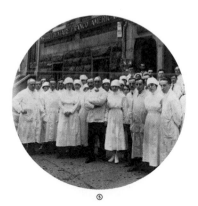

⑤

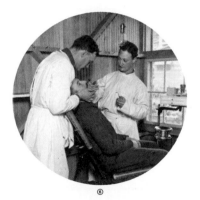

⑥

The dentists who worked in these spotless spaces spent a great deal of their time measuring, making and fitting dentures. Industrial mass production meant that realistic porcelain sets no longer cost a king's ransom, and anaesthesia made patients less willing to put up with rotten teeth and aching jaws. Even these hygienic dentures required good care, though, a point made by John Tomes in his *Instructions in the Use and Management of Artificial Teeth* (1851):

IT IS OF GREAT IMPORTANCE THAT YOU SHOULD KNOW HOW TO PRESERVE FALSE TEETH, FOR IN THE ABSENCE OF PROPER ATTENTION THEY ARE SOON DESTROYED, AND STILL SOONER BECOME OFFENSIVE. THE WEARER OFTEN SEEMS SINGULARLY UNCONSCIOUS OF THE OFFENSIVE ODOUR THAT ARISES FROM NEGLECTED TEETH – NOT SO, HOWEVER, THE BYSTANDER; HE IS ALMOST POISONED BY THE OFFENSIVE BREATH OF HIS NEIGHBOUR ... THE WEARER SHOULD PAY GREAT ATTENTION TO THIS POINT. THE SURFACES OF THE TEETH ... SHOULD BE WELL BRUSHED WITH A LITTLE PRECIPITATED CHALK, ONCE OR TWICE A DAY; AND AFTER BRUSHING, RUBBED WITH A DRY SOFT TOWEL.

Nineteenth-century industries also offered an answer to the oldest difficulty facing those who wore false teeth. Eighteenth-century sets held in place by springs could leap from the mouth or lacerate the cheeks and gums if they broke. But as ivory, gold and porcelain gave way to vulcanized rubber – a technique perfected by the American inventor Charles Goodyear in the early 1840s – dental plates could be moulded precisely to fit the contours of the jaws and palate. Vulcanite dentures were far more comfortable to wear, did not need springs and could be coloured to match the patient's gums; they became standard in Britain until the development of acrylic after the First World War. Until 1879 American dentists had to contend with aggressive litigation by the Goodyear employee Josiah Bacon, who had gained personal control of the vulcanization patents. After suing dozens of dentists who had made vulcanite plates, Bacon was shot dead by one of his victims in a hotel room in San Francisco.

The new dental surgeries had their own characteristic sound: the metallic whir of a drill.

Devised by Charles Merry in 1858, powered by a foot treadle and mounted on a long flexible cable, the dental drill allowed dentists to excavate cavities far more rapidly, thereby replacing the older and excruciating technique of hollowing out a decayed tooth with spoon-shaped excavators. Around this time, germ theory led dentists and scientists to work out the details of the relationship between sugar, bacteria and tooth decay. By digging all the decayed dentine out of a cavity and sealing it with an inert, resistant substance, a dentist could eliminate the germs and the acidic environment they created, and could also save the tooth – a new rationale for the old practice of filling a tooth with gold. Cheaper mercury-amalgam fillings began to appear in the late eighteenth century, although in their first incarnation they provoked a vicious controversy.

Initially in France, then in Britain and finally in the United States, a family calling themselves the Crawcours filled hundreds of teeth with their 'Royal Mineral Succedaneum', a paste of mercury and filings from silver coins. In their advertisements, they claimed that their fillings required no painful excavation; in practice, this meant that their patients were left with abscesses because cavities continued to fester beneath the fillings. Worse, Royal Mineral Succedaneum had a nasty habit of expanding as it set, cracking teeth and making them harder to extract. In the 1830s, dentists in New York established a society to oppose the work of the Crawcours, and when the family returned to Europe they left an abiding suspicion of amalgam fillings among American dentists.

The great change in attitudes towards fillings came with the development of local anaesthesia in the late nineteenth century. Ether, and later chloroform, had proved invaluable for simple extractions, but neither technique worked well for longer, more involved procedures in which the patient's airway might become obstructed. In 1860 the German chemist Albert Niemann had extracted an alkaloid from the leaves of the coca plant, and a number of German clinicians began to experiment with what Niemann had named cocaine. Carl Koller, an ophthalmic surgeon, announced in 1884 that he had used it successfully for eye surgery, and shortly afterwards the New York surgeon William Halsted carried out

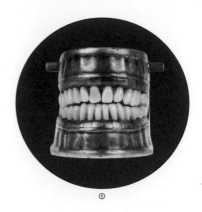

①

① This dental model of a full set of teeth was made by Vecabé in the 1920s. The teeth are enamel and they have been precisely crafted to present an accurate model. ② These dentures are made from aluminium plates. The teeth are a mixture of porcelain and human teeth (1858–80). ③ An entry from Claudius Ash & Sons' trade catalogue (1908) advocates Ash's Imperial Amalgam as the best in the market.

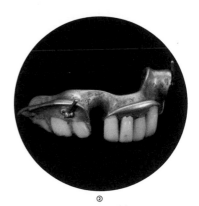

②

③

④

④ Each tooth in the Vecabé dental model is removable, fixed to the jawbone with a brass pin. The teeth fit together neatly in an anatomically correct position.
⑤ This upper denture comprises a moulded vulcanite plate fitted with porcelain teeth.
⑥ An American advertisement for cocaine toothache drops prepared by the Lloyd Manufacturing Company and available from all druggists (1885).

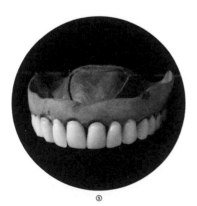

⑤

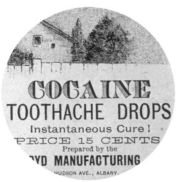

⑥

a series of violent experiments on a dentist whose jaw he had numbed with an injection of cocaine:

IN THREE MINUTES THERE WAS NUMBNESS AND TINGLING OF THE SKIN ... IN SIX MINUTES, THERE WAS COMPLETE ANAESTHESIA OF THE LEFT HALF OF THE LOWER LIP ... A PIN THRUST COMPLETELY THROUGH THE LIP CAUSED NO SENSATION WHATEVER ... HARD BLOWS UPON THE TEETH WITH THE BACK OF A KNIFE CAUSED NO SENSATION.

Just as general anaesthesia had rendered extraction less fearsome for patients, so local anaesthesia made fillings a more attractive option for those who wanted to conserve their natural dentition rather than replace it. At the time of the Dentists Act of 1878, an editorial in the *British Medical Journal* noted, haughtily, that while medicine was a profession, dentistry was a business – and at the end of the nineteenth century, business was booming. Dentists who advertised and maintained a showroom might be considered vulgar and tainted with trade, but more discreet private practitioners saw themselves on the same social level as other professional men. A respectable dental practice in a provincial British city could make £600 a year, compared with the £400 or so that a London GP might expect to pocket.

Gradually, too, the profile of dentistry was changing. In 1840 around ten per cent of the United States' 1,200 dentists were black, and although this number grew only slowly over the next half-century some dental schools – such as the College of Dentistry established in 1881 at the historically black Howard University – opened its doors to black students. Women seeking to enter dentistry faced a similar struggle. Emeline Roberts Jones, the first recorded female dentist in the United States, had to study in secret after her husband, a dentist, refused to teach her (impressed with her skill, he eventually took her on as a partner).

Even in this era of regulation and reform, the market for patent medicine and dental disposables remained as vibrant as ever. In 1869 Charles Forster established a factory in Strong, Maine, that turned out millions of uniformly tapered wooden toothpicks, while early mass-produced toothbrushes were given graceful names such as the Windsor, the Philadelphia

and the Murray. The burgeoning pharmaceutical industry both fed on and fed a global market for tooth powders, dentifrices and mouthwashes, including the very first tubes of toothpaste. In their advertisements, some companies presented their products as the necessary accoutrements of a refined lifestyle:

> DR SHEFFIELD'S CRÈME ANGELIQUE: WHITENS THE TEETH LIKE PEARLS. PERFUMES THE BREATH DELIGHTFULLY. IS MOST CONVENIENT FOR USE IN THE TOILET. CONTAINS NOTHING INJURIOUS.

Others took a more demotic tone:

> HO! THOSE TEETH OF MINE! SOZODONT PRESERVES THE TEETH, SOZODONT CLEANSES THE TEETH, SOZODONT BEAUTIFIES THE TEETH, SOZODONT IMPARTS THE MOST FRAGRANT BREATH, SOZODONT REMOVES ALL TARTAR AND SCURF FROM THE TEETH, SOZODONT ARRESTS THE PROGRESS OF DECAY. THE GUMS ARE MADE ROSY AND HEALTHY BY ITS USE, AND THE MORTIFYING DEFECT, AN UNPLEASANT BREATH, IS COMPLETELY REMEDIED BY IT. IT IS THE KING OF DENTIFRICES.

Teething infants might be dosed with Dalby's Carminative or Dr Godfrey's General Cordial, both laced with opium and alcohol, or Mrs Winslow's Soothing Syrup – a tincture of morphine sulphate that in 1911 was condemned as a 'baby killer' by the American Medical Association. And the Pratt Battery and the Oxydonor promised to eradicate dental abscesses with, respectively, electricity and oxygen.

At the end of the nineteenth century, one practitioner more than any other embodied the tension between dentistry's theatrical past and its technical future. In 1896 Edgar 'Painless' Parker announced his arrival to the residents of St John's, Canada, in terms that evoked the theatrical feats of *Le Grand Thomas*:

> TEETH EXTRACTED FREE OF CHARGE, WITHOUT PAIN, BY A PECULIAR METHOD OF HIS OWN, WITH WHIPS, SWORDS, SPOONS AND INSTRUMENTS OF HIS OWN INVENTION. AMUSING! INTERESTING! ENTERTAINING! ASTONISHING! NOTHING TO

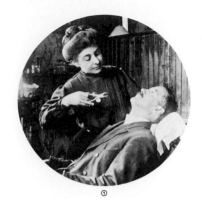

①

① Annie Praed was Australia's first female dentist. She began practising in 1899 and by 1921 had opened her own surgery. ② Magazine insert (*c.* 1885) advertising Dr Pierre's dentifrices. ③ Ever the showman, Painless Parker collaborated with P. T. Barnum, founder of the Barnum & Bailey Circus, to promote his business. It was common for a band to be present to drown out the patients' cries.

②

③

④

④ Dr C. Jesse Davis, graduate of Meharry Medical College, operates in his dental suite in the Roosevelt Bank building, Chicago, in 1925. ⑤ Charles Forster's Toothpick Mill, seen here in c. 1900. ⑥ Exterior view of a building occupied by the offices of Dr Edgar Parker in Brooklyn, New York, in c. 1895. The front of the establishment is adorned with the words 'I am positively it in painless dentistry'.

⑤

⑥

CORRUPT THE MORALS OF THE MOST REFINED
OR FASTIDIOUS PERSON IN THE CITY.

Born in New Brunswick, Canada, in 1872, Parker ran away to sea before returning to study medicine. His mother, a Christian Scientist, insisted that he visit a phrenologist, who told him that he would be more suited to dentistry. After being expelled from the New York College of Dentistry, he enrolled in the Philadelphia Dental College. On graduating Parker returned to New Brunswick and opened a dental office, where in six weeks he earned only seventy-five cents.

Affronted by his own inability to make a living, Parker set out on the road as a showman. He would roll into town at the head of a procession and entertain the inhabitants with jugglers, singers, comedians and acrobats. Despite dosing his patients with whisky and a cocaine solution, Parker performed extractions in his travelling medicine show that were not always as painless as he promised – hence his preference for brass bands. He also claimed to have pulled 357 teeth in a single day, and wore them on a string around his neck. Parker rented a building on Flatbush Avenue in Brooklyn and covered it in irresistibly alliterative slogans: 'Painless Parker, Preeminent, Par excellent, Positively Painless Perfection of Practice and Philanthropically Predisposed to Popular Prices!'

The new dental establishment hated Parker. In his own phrase, he was unethical, flagrantly breaking the ADA's prohibition on advertising. He undercut his competitors and took pride in treating as many patients as quickly as possible. He had been sued, he said, more times than he could remember, and he claimed he always won. But his franchises offered cheap, good-quality dental work at a price most ordinary folk could afford, and he encouraged all his patients to look after their teeth. When the Californian legislature passed a law insisting that all dentists practise under their real names, he changed his first name to 'Painless' and carried on. Twentieth-century dentistry would owe far more to his example than most dentists were prepared to admit.

① Christine Hillam, *James Robinson (1813–1862): Professional Irritant and Britain's First Anaesthetist*, Lindsay Society for the History of Dentistry, 1996, p. 39.
② James Wynbrandt, *The Excruciating History of Dentistry: Toothsome Tales & Oral Oddities from Babylon to Braces*, St Martin's Press, 1998, p. 126.

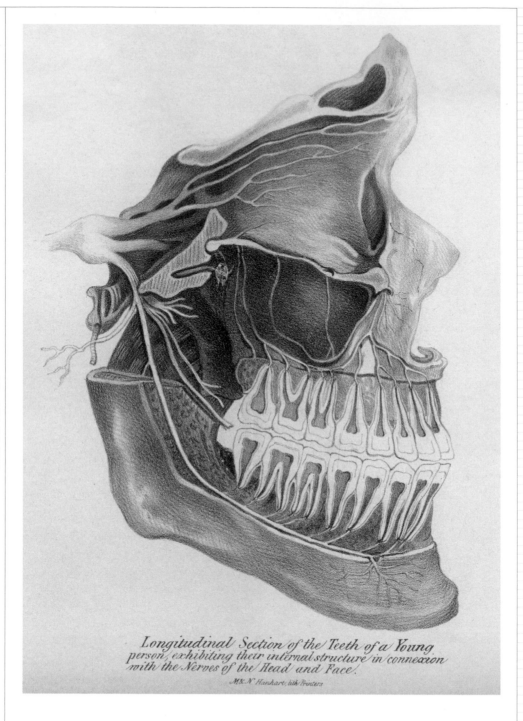

Longitudinal Section of the Teeth of a Young person, exhibiting their internal structure in connexion with the Nerves of the Head and Face.

M & N Hanhart, lith Printers.

Illustrations from *The Surgical, Mechanical and Medical Treatment of the Teeth* (1846) by James Robinson. ABOVE | Longitudinal section of the teeth of a young person exhibiting their internal structure in connection with the nerves of the head and face.

OPPOSITE | A complete set of permanent teeth. Illustration shows the development by age for each permanent tooth in the upper and lower jaw.

UPPER JAW.

Wisdom Tooth. 18 to 30 Years of Age.

MOLARES.

2ʳᵈ Molar. 12 to 14Dᵒ

1ˢᵗ Molar. 6 to 7Dᵒ

......... 10 to 12Dᵒ

2ˢᵈ Biscuspis. 8 to 9Dᵒ

BICUSPIDES.

1ˢᵗ Biscuspis. 11 to 13Dᵒ

......... 7 to 8Dᵒ

Eye Tooth. 7 to 7½Dᵒ

CUSPIDATUS.

Lateral Incisor.

Central Incisor.

INCISORES.

Centre of the Jaw.

LOWER JAW.

A COMPLETE SET
OF
PERMANENT TEETH.

١

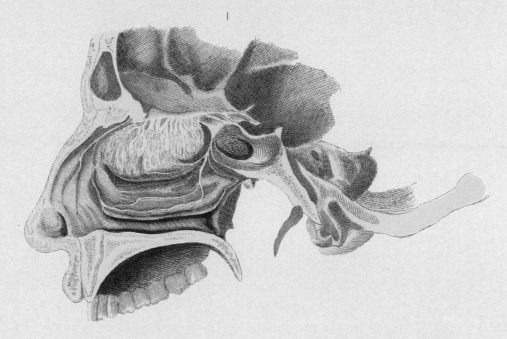

٣

Pages from *An Atlas of Anatomical Plates of the Human Body* (1849) by Frederic John Mouat. He lived and worked in India for thirty years and this volume was produced as part of his work as a teacher of medicine and a promoter of higher education.

٢

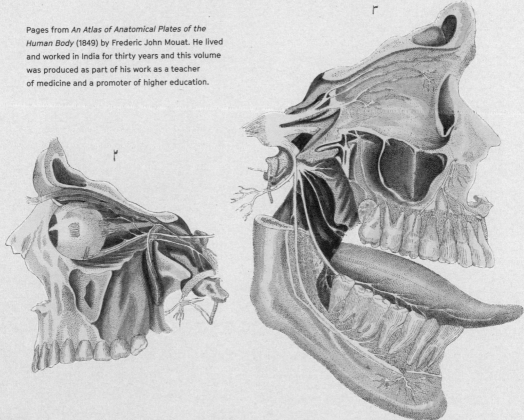

Der hohle Zahn.

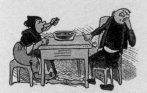

Oftmalen bringt ein harter Brocken
Des Mahles Freude sehr in's Stocken.

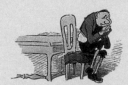

So geht's nun auch dem Friedrich Kracke;
Er sitzt ganz krumm und hält die Backe.

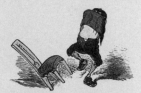

Um seine Ruhe ist's gethan;
Er biß sich auf den hohlen Zahn.

Nun sagt man zwar: Es hilft der Rauch!
Und Friedrich Kracke thut es auch;

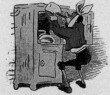

Allein schon treiben ihn die Nöthen,
Mit Schnaps des Zahnes Nerv zu tödten.

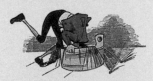

Er taucht den Kopf mit sammt dem Uebel
In einen kalten Wasserkübel.

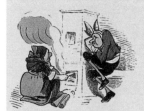

Jedoch das Uebel will nicht weichen,
Auf and're Art will er's erreichen.

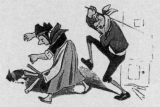

Umsonst — er schlägt, vom Schmerz bedrängt,
Die Frau, die einzuheizen denkt.

Auch zieht ein Pflaster hinter'm Ohr
Die Schmerzen leider nicht hervor.

Vielleicht — so denkt er — wird das Schwitzen
Möglicherweise etwas nützen.

Indeß die Hitze wird zu groß,
Er strampelt sich schon wieder los;

Und zappelnd mit den Beinen,
Hört man ihn bitter weinen.

These twenty-four vignettes tell the story of a man with agonizing toothache. They depict his numerous attempts at self-help before he finally resorts to visiting the dentist. Coloured wood engraving (1862) by Wilhelm Busch, a German artist well-known for his comic illustrated cautionary tales.

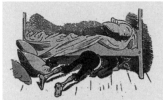

Jezt sucht er unter'm Bette
Umsonst die Ruhestätte.

Zulezt fällt ihm der Doctor ein.
Er klopft. Der Doctor ruft: Herein!

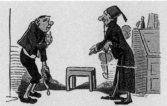

„Ei, guten Tag, mein lieber Krage!
Nehmt Plaz! Was ist's denn mit der Backe?"

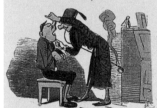

„Laßt seh'n! Ja ja! Das glaub ich wohl!
Der ist ja in der Wurzel hohl!"

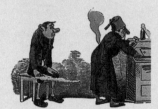

Nun geht der Doctor still beiseit.
Der Bauer ist nicht sehr erfreut.

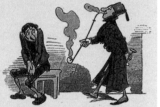

Und lächelnd kehrt der Doctor wieder.
Dem Bauern fährt es durch die Glieder.

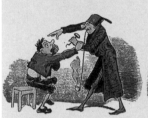

Ach! Wie erschrack er, als er da
Den wohlbekannten Haken sah.

Der Doctor, ruhig und besonnen,
Hat schon bereits sein Werk begonnen.

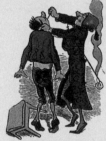

Und unbewußt nach oben
Fühlt Krage sich gehoben.

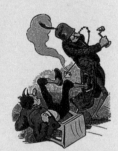

Und — rack! — da haben wir den Zahn,
Der so abscheulich weh gethan!

Mit Staunen und voll Heiterkeit
Sieht Krage sich von Schmerz befreit.

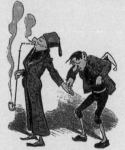

Der Doctor, würdig wie er war,
Nimmt in Empfang sein Honorar.

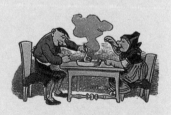

Und Friedrich Krage sezt sich wieder
Vergnügt zum Abendessen nieder.

Münchener Bilderbogen.

10. Auflage.

Nro. 330.

Kgl. Hofbuchdruckerei von Dr. C. Wolf & Sohn in München.

herausgegeben und verlegt von K. Braun und F. Schneider in München.

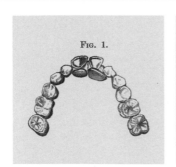

Fig. 1.

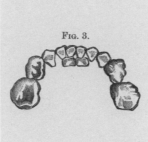

Fig. 4.

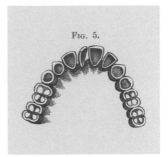

Fig. 7.

Fig. 3.

Fig. 2.

Fig. 5.

Fig. 14.

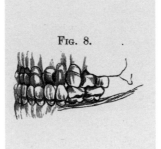

Fig. 8.

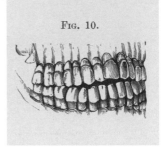

Fig. 10.

Plates from *Irregularities and Diseases of the Teeth* (1870) by Henry Sewill. ABOVE | Examples include the growth of the two front permanent teeth behind the temporary teeth in the upper jaw (Fig. 1), crowding of teeth and the overlap of the incisors (Fig. 4) and the protrusion of the central incisors, due to abnormal development of the premaxillary bone (Fig. 7).

OPPOSITE | Illustrations of Alfred Cane's specifications for dental syringes (1896), showing the improvements he has made in the instruments for plugging and filling teeth.

OVERLEAF | Cover and internal pages from the Arnold and Sons Instrument Manufactory catalogue of surgical instruments (1885).

A.D. 1896. July 9. N.º 15,265.
CANE'S Complete Specification.

(1 SHEET)

[This Drawing is a reproduction of the Original on a reduced scale]

FIG.1.

FIG.2

FIG.3ᵃ

FIG.3

FIG.3ᵇ

FIG.4

FIG. 5

FIG.6

FIG.8.

FIG.9

FIG.7.

Maltby & Sons. Photo-Litho.

CATALOGUE OF SURGICAL INSTRUMENTS

MANUFACTURED BY ARNOLD AND SONS, BY APPOINTMENT TO

HER MAJESTY'S GOVERNMENT; THE HONORABLE COUNCIL OF INDIA; THE ADMIRALTY; THE CROWN AGENTS FOR THE COLONIES; HER MAJESTY'S PRISONS; FOREIGN GOVERNMENTS; ST. BARTHOLOMEW'S HOSPITAL; THE SURGICAL AID SOCIETY; AND THE PRINCIPAL PROVINCIAL AND COLONIAL HOSPITALS, ETC. ETC.

35 & 36, WEST SMITHFIELD, LONDON.

1885.

Entered at Stationers' Hall.

274 *ARNOLD AND SONS, LONDON.*

Fig. 749.

Lower Bicuspides, right, Fig. 749 £0 7 6

Fig. 750.

Lower Bicuspides Forceps, left, Fig. 750 0 7 6

Fig. 751.

Lower Bicuspides Forceps, Fig. 751 0 7 6

Fig. 752.

Upper Bicuspides Forceps right, Fig. 752 0 7 6

Fig. 753.

Upper Bicuspides Forceps, left, Fig 753... ... 0 7 6

ARNOLD AND SONS, LONDON. 269

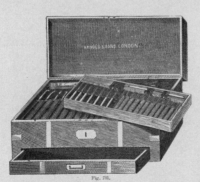

Fig. 731.

Arnold & Sons' Dental Cabinet, in rosewood, walnut, or mahogany, lined silk velvet, with Instrument Trays, etc., containing—

 Twelve Scaling Instruments, in ivory handles.
 Twelve Stopping ditto ditto.
 Twelve Excavators, steel handles.
 Twelve Drills, rose-heads, ditto.
 One Mouth Mirror.
 Spring Forceps for foil, cotton, etc.
 Bottle for Stopping.
 Bottle for Mercury.

The above set, complete £10 10 0

Arnold & Sons' Superior Dental Cabinet, in rosewood, walnut, or mahogany, lined silk velvet, with Trays and Drawers for Instruments, Gold Foil, etc., and Lower Drawer for extra Forceps, Fig. 731, containing—

 Eighteen superior Scaling Instruments, in ivory handles.
 Eighteen superior Stopping ditto ditto.

326 *ARNOLD AND SONS, LONDON.*

This instrument is intended to induce anæsthesia in part by the diminution of oxygen respired, and to regulate the strength of Æther vapour, so that it may with certainty produce the degree of quietude wanted, and not cause coughing or difficulty of respiration.

Portable Æther Inhaler (Morgan's) £1 12 0

Fig. 961.

Æther Inhaler (Ormsby's), complete, Fig. 961 1 4 0

The chief advantages of the new Inhaler are as follows :
1. Simple in construction and application.
2. Not expensive.
3. Small quantity of æther used to produce anæsthesia (average quantity 1 oz.).
4. Prevents any loss or evaporation of ether vapour.
5. Its small size and great portability.
6. Short time required to produce complete anæsthesia (average time, two minutes).
7. The great safety to the patient during administration.

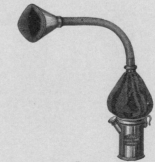

Fig. 962.

Lower Bicuspides Forceps, single joints.
Upper ditto ditto.
Curved Stump ditto ditto.
Fox's Tooth Key, with three claws.
Gum Lancet, in tortoiseshell.
Elevator.

The above set, complete £2 0 0

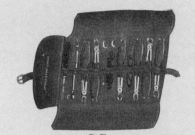

Fig. 726.

No. 3. Leather Pouch, with strap and buckle, Fig. 726,
containing—

Upper Molar Forceps, Right (circular joints).
Ditto ditto Left ditto.
Lower ditto ditto.
Upper Bicuspides ditto ditto.
Lower ditto ditto ditto.
Curved Stump ditto ditto.
Fox's Tooth Key, with three claws.
Gum Lancet, in tortoiseshell.
Bell's Elevator.

The above set, complete 3 3 0

Fig. 764.

Lower Stump Forceps, left, Fig. 764 £0 7 6

Fig. 765.

Lower Stump Forceps, right, Fig. 765 0 7 6

Fig. 766.

Upper Stump Forceps, right, Fig. 766 0 7 6

Fig. 767.

Upper Stump Forceps, left, Fig. 767 0 7 6

Fig. 970.

Chloroform Drop Bottle (Bloxam's), improved graduated,
in leather case, size 4¾ in. × 1¼ in., Fig. 970 ... £0 3 6
Ditto, in boxwood case 0 4 6

Vide *British Medical Journal,* March 11th, 1871; the *Lancet,* March 18th,
1871; *Medical Times and Gazette,* February 4th and 25th, 1871; *Medical Press
and Circular,* March 22nd, 1871.

The Graduated Chloroform Bottle is exceedingly portable and simple. No
assistant is required in the administration. The chloroform being spread over a
large surface of lint, the amount of atmospheric air is very great. It is much
safer, as you do not rely upon complicated valves. The amount of chloroform
administered can at once be ascertained by the graduated scale.

Fig. 971.

Chloroform Drop Bottle (Symons's), graduated with gilt
double cap to prevent evaporation, covered with
leather, as used at St. Bartholomew's, Fig. 971 ... 0 7 6
Ditto ditto (Skinner's), graduated, with
metal drop stopper, covered with leather 0 4 6

Hypodermic Syringe, silver mounted, with three steel
needles, in morocco case £1 5 0
Ditto ditto nickel-plated, with two steel needles 0 10 6
Ditto ditto two needles, mounted in vulcanite 0 5 6

Fig. 953.

Hypodermic Syringe, Celluloid, Fig. 953 0 12 6

This invention offers a very important advantage not possessed by any other
Syringe—viz., the *Cylinder has the transparency of glass, and cannot be broken
under ordinary circumstances.*

Hypodermic Syringe and Exploring Trocar, complete,
in case 1 10 0

Fig. 954.

Emergency Case (Pearse's), Fig. 954 0 17 6

Extract from *Lancet,* July 21st, 1883:—"This case, which is made of ebony,
resembles in form a large drawing-pencil. It contains at one end a special
hypodermic syringe, and at the other end is a series of compartments which
contain discs and perles of such drugs as are most likely to be required on
emergencies. The chief of these are Morphia, to relieve sudden and acute
pain; Apo-morphia, to excite vomiting quickly; Nitrite of Amyl, in perles, for
employment in angina, etc.; and Ether, in perles, to be used as a rapid stimulant
in cases of syncope, etc. Each compartment is labelled with the name and strength
of the drug contained. The case, which is made by Messrs. Arnold & Sons, of
London, is very compact and handy, and will be found very useful in most
emergencies."

Discs and Perles for above per set 0 12 6

Fig. 955.

Hypodermic Injector (Cousins's), Fig. 955 0 1 6

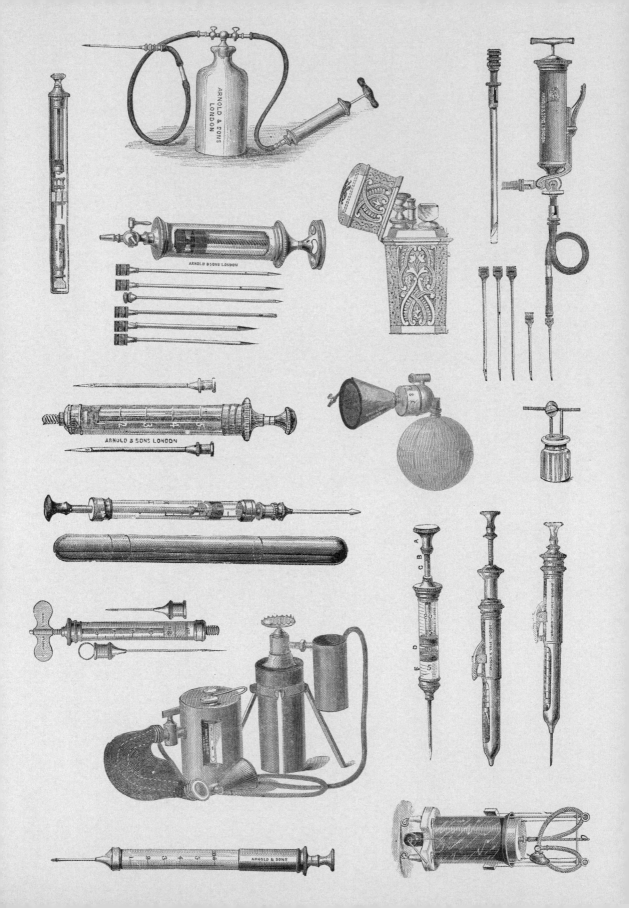

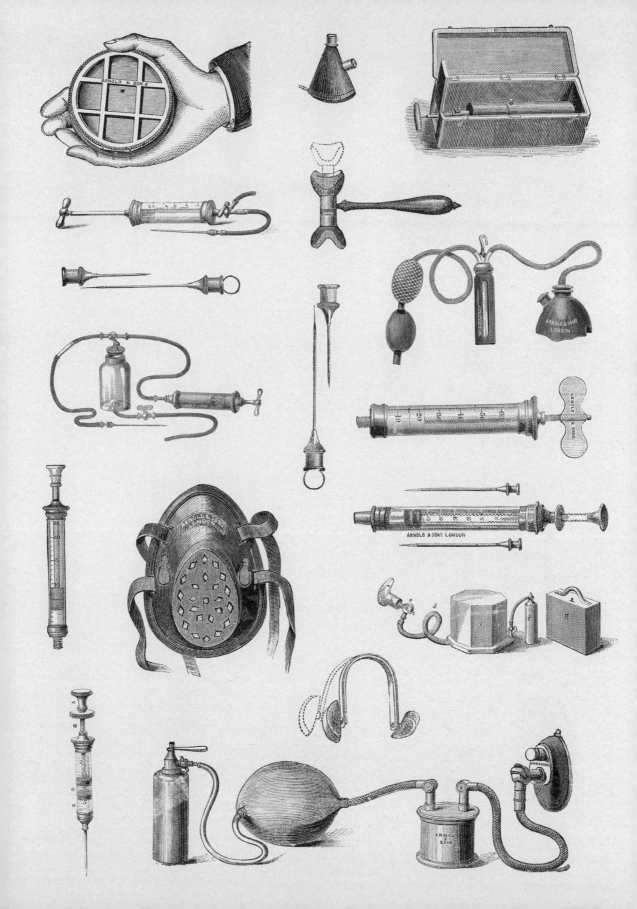

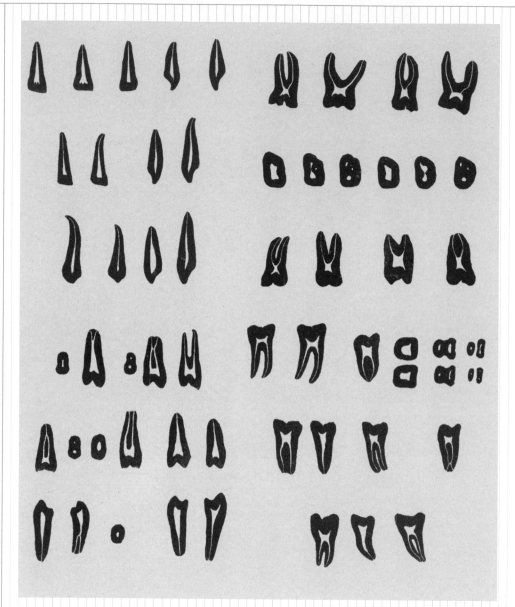

ABOVE | Pages from *Descriptive Anatomy of the Human Teeth* (1892) by G. V. Black, showing cross-sections of the pulp chambers and root canals.
OPPOSITE | Images from *Methods of Filling Teeth: An Exposition of Practical Methods Which Will Enable the Student and Practitioner of Dentistry Successfully to Prepare and Fill All Cavities in Human Teeth* (1899) by Rodrigues Ottolengui.

PREVIOUS | Examples of dental equipment available from the Arnold and Sons catalogue of surgical instruments (1885). Items include various hypodermic syringes, aspirators, a chloroform inhaler, nitrous oxide gas apparatus, a mouth prop and a naso-oral inhaling respirator.

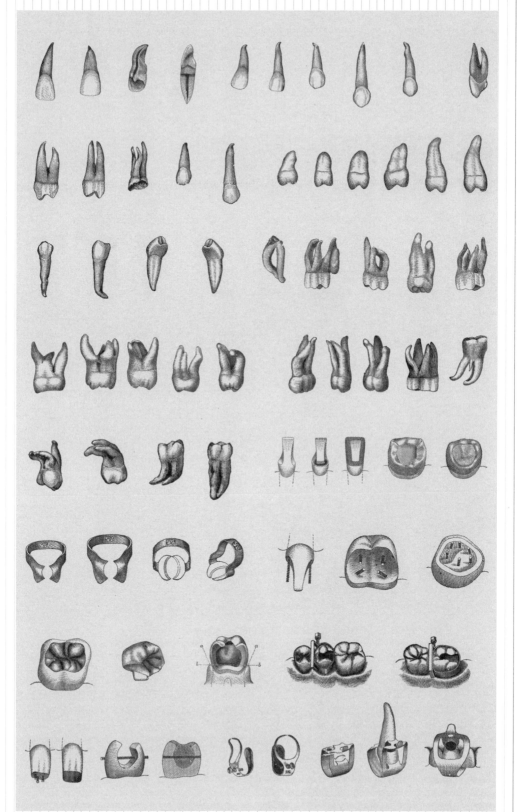

TEETH.

ARTIFICIAL TEETH.

DÉNANCE & CO.,
Surgeon Dentists,
ST. GEORGE'S CROSS
(231 New City Road).

Best Teeth, from 4s.
Upper or Lower Sets from
£2 10s.

June 24th 1885.

WITH TEETH

WITHOUT TEETH

ABOVE | Dénace & Co. emphasizes the effect of dentures on the shape of the jaw (1885). | Dentists advertise their services with before and after pictures (1900–15).

OPPOSITE (from top left) | According to this advertisement, the Civil Service Dental Company is highly recommended in the press (c. 1895). | Mr Davis has a range of services on offer (c. 1913). | Williams' Teeth Surgery guarantees customer satisfaction (1900–09). | Mr Foley advertises his American Dentistry services with a five-year warranty (c. 1896).

The best quality artificial teeth are on offer at the lowest prices from Mr Gardner (c. 1908). | Mr Mallan advertises the virtues of painless dentistry (1895–1910). | Mr Smedley offers a reduced fee service in London and Brighton.

OVERLEAF | Pages from Claudius Ash & Sons' trade catalogue for dental gold, including foils, pellets, cylinders and solders for filling, capping and bridging teeth (1908). Many of the pages show penny-sized gold samples to suit all budgets and types of repair.

Ash's Imperial Gold Cylinders.

Extra Soft.

Made from the same Gold as the Foil on page 1.

In Sizes
1. 2. 3. 4.

Nos. 1. 2. 3. 4. per ⅛ oz. 16 6
" " per oz. 128 0

Ash's Soft Non-Cohesive Gold Cylinders.

Style A. Loosely Rolled.

In Sizes
1. 2. 3. 4.

Nos. 1. 2. 3. 4. per ⅛ oz. 16 6
" " per oz. 128 0

Style B. – Closely Rolled. Same sizes and same price per ounce as style A.

Not less than half an ounce supplied.

Ash's Soft Non-Cohesive Gold Cylinders.

Style C. – Extra Dense.

In Sizes
1. 2. 3. 4.

Nos. 1. 2. 3. 4. per ⅛ oz. 16 6
" " per oz. 128 0

Ash's Pointed Cylinders for Root Filling.

In Sizes
1. 2. 3.

Nos. 1. 2. 3. per ⅛ oz. 16 6
" " per oz. 128 0

Ash's Gold Pellets (Cohesive and Non-Cohesive.)

Square in Sizes
1. 2. 3. 4.

Nos. 1. 2. 3. 4. per ⅛ oz. 16 6
" " per oz. 128 0

Pyramidal in Sizes closely rolled.
1 2 3.

Nos. 1. 2. 3. per ⅛ oz. 16 6
" " per oz. 128 0

NOTE. All our Cylinders and Pellets can be made cohesive by annealing before using.

Ash's Soft Non-Cohesive Gold Foil.

Our Soft Non-Cohesive Gold Foil has found great favour with those operators who prefer to work with a Non-Cohesive Foil, its purity being unsurpassed. As it can be made Cohesive by annealing immediately before using, the operator is in possession of a Foil which is either Non-Cohesive or Cohesive as required.

Nos. 3. 4. 5. 6. 8. per ⅛ oz. 16 3
" " per oz. 125 0

Higher numbers supplied to order.

Ash's Cohesive Gold Foil.

This Foil has proved its excellent qualities in the hands of the leading gold workers of the last fifty years, and is in use at all the Dental Schools ; therefore, in mentioning it, we are only bringing to the notice of those who may not have tried it, a gold which is perfect as a Cohesive Foil and which cannot fail to give satisfaction.

Nos. 3. 4. 5. 6. 8. 20. 30. 40. 60. per ⅛ oz. 16 3
" " per oz. 125 0

Nos. 30 and 40 are largely used for making the Matrix for porcelain inlays by those Operators who practise the burnishing-in method and who employ Mineral Bodies which are low-fusing enough to be fired in a Gold Foil Matrix.

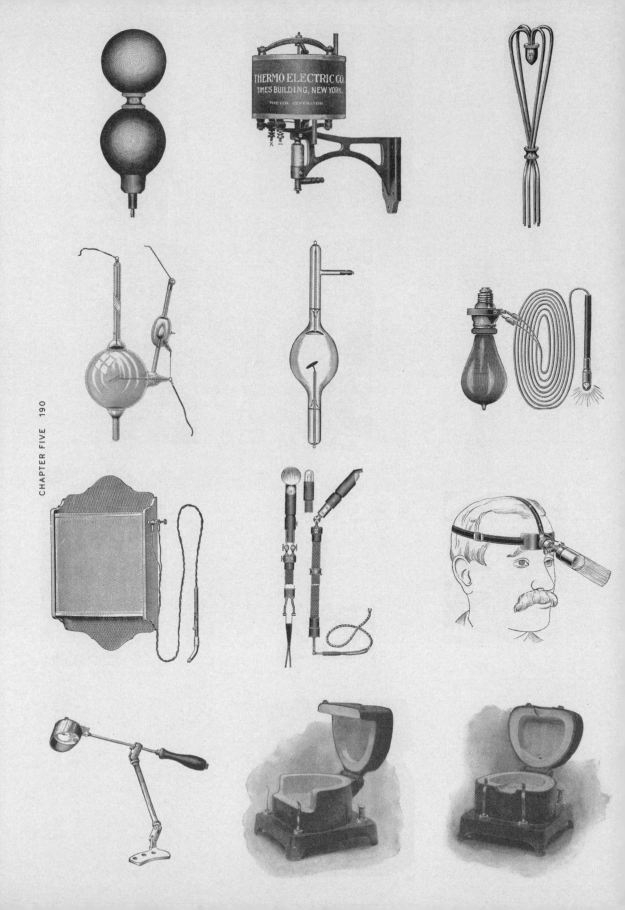

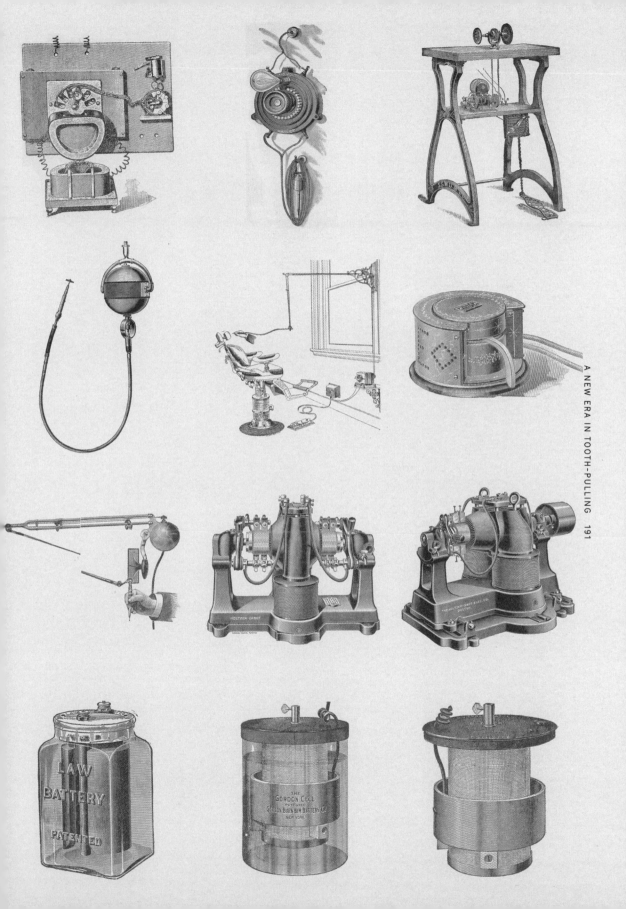

267

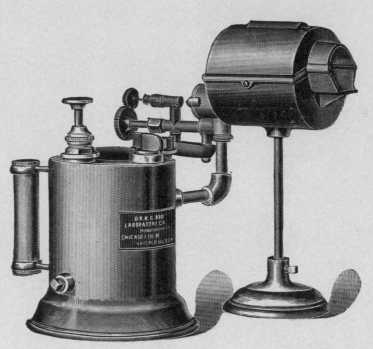

Fig. 208.

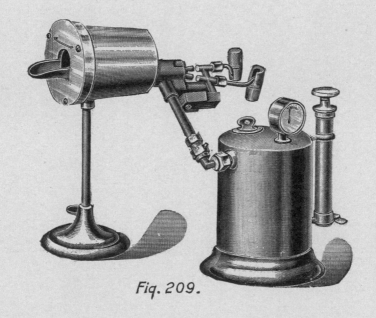

Fig. 209.

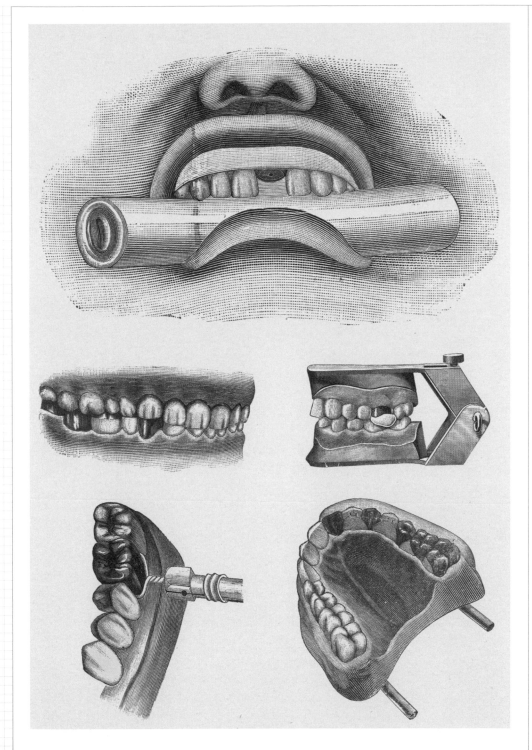

PREVIOUS | Examples of electrical dental equipment described in *Dental Electricity* (1901) by Levitt E. Custer. Items include an automatic timing appliance, dynamos, mouth lamps, dental engines and an A. W. L. tube with vacuum regulator.

Pages from *Principles and Practice of Crowning Teeth* (1903) by Hart John Goslee. OPPOSITE | Gasoline furnaces designed for crown and bridge work. ABOVE | A dental articulator – used to make models of the patient's teeth.

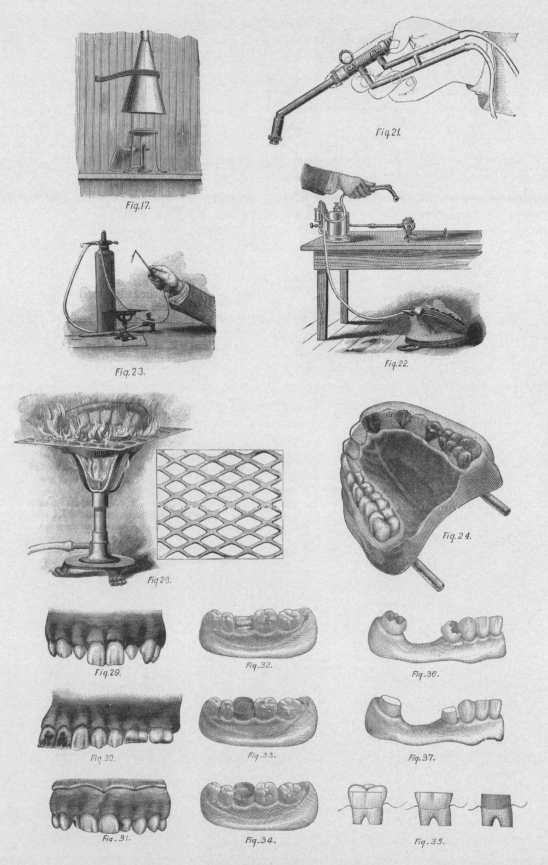

Fig. 17.

Fig. 21.

Fig. 23.

Fig. 22.

Fig. 28.

Fig. 24.

Fig. 29.

Fig. 32.

Fig. 36.

Fig. 30.

Fig. 33.

Fig. 37.

Fig. 31.

Fig. 34.

Fig. 35.

"INSIDE" AND "OUTSIDE" TOOTH BRUSHES.

BEST QUALITY.

Made with hard, medium, and soft bristles.

Price, in cardboard box per pair . . . 1 6 . . . per doz. . . . 9 0

Inside. Outside.

OUTSIDE AND INSIDE TOOTH BRUSHES.

PIERREPONT'S THOROUGH-CLEANSING.

Dr PIERREPONT'S PATENT OUTSIDE TOOTH BRUSH.

Dr PIERREPONT'S PATENT INSIDE TOOTH BRUSH.

The illustrations show (1) an "Outside" and an "Inside" brush; (2) the same applied on an upper dental arch; and (3) an "Inside" brush applied on a lower dental arch.

The brushes are made in the following Grades and Sizes :—

GRADES:

With Hard, Medium, and Soft bristles.

SIZES:

"Outside"—A—Full size. C—Small.
 B—Medium. D—Child's.
"Inside"—E—Full size. F—Smaller size.

In ordering, be careful to state grade and sizes required.

Price, in cardboard boxes per pair . . . 1 9 . . . per doz. . . . 9 0

TOOTH BRUSHES WITH BONE HANDLES.

(As shown on pages 65, 66.)

Made with Hard, Medium, and Soft Bristles.

FIRST QUALITY.

| | per gross.
s. d. | per doz.
s. d. |
|---|---|---|
| Adults' (Figs. 1 to 3 and 5) | 90 0 | 8 0 |
| (" 4) | 96 0 | 8 6 |
| Children's (" 4) | 84 0 | 7 6 |
| all forms except Fig. 4 | 57 0 | 5 3 |
| Palate Brushes, round and square forms | 90 0 | 8 0 |
| Any of the above with very hard bristles, extra . . | — | 1 0 |
| Double-ended Brushes in Composition Handles,
one end for the teeth, the other for the plate . per doz. | 11 0 | |
| Badger's-hair Brushes for solutions, Adults' . . | | 14 0 |
| " Children's . . | | 8 0 |
| Black Tooth Brushes, best quality, for tinctures and
solutions ; length of brush-head, 1½ inches, form of
Fig. 1 " | | 8 0 |

Tooth Brushes made to Dentists' own patterns by the gross.
All forms of Tooth Brushes made or obtained to order.
Steel Punches, with name, title, etc., made to order, 6d. per letter.
Tooth Brushes stamped with name, etc., free of charge.

DENTURE BRUSH.

FOR CLEANING ARTIFICIAL DENTURES.

The peculiar form of the brush, combined with the flat point at the end of the handle, is specially adapted for removing the unpleasant deposit so often found on artificial teeth. It is made with hard bristles.

Price per doz. . . . s. d. 9 0

DENTURE BRUSH (Registered).

(Mr. HENRY CARTER'S.)

Price, Double-ended each . . . s. d. 1 0
 " " per doz. . . 10 6

FORMS OF TOOTH BRUSHES.

M 1. 2. 3 4. F

PREVIOUS | Pages from Goslee's *Principles and Practice of Crowning Teeth* show artificial crowns and their fittings (left page) and soldering apparatus and crown and bridge work on malformed teeth (right page).

ABOVE | Pages from Claudius Ash & Sons' trade catalogue (1908) include inside and outside toothbrushes, brushes with bone handles and brushes with different-shaped heads.

DR. HORSEY'S
ORIENTAL FIBRE TOOTH BRUSH
(PATENTED).

The Oriental Fibre Tooth Brush is made from the fibre of a tree which grows in Arabia and the Soudan, and is known in Arabic as Al-Arak. This fibre has been used in the East for cleansing the teeth for thousands of years; probably as early as B.C. 3000.

The Brush is **sanitary, convenient, absorbent, very thorough in action, has a pleasant aromatic odour, is naturally astringent, and has a most healthful influence on the gums**.

SEND FOR DESCRIPTIVE BOOKLET.

| | | | s. | d. |
|---|---|---|---|---|
| Handles, in bone or ebony | . . . | per dozen | 12 | 0 |
| Brushes, one dozen in box | . . | per doz. boxes | 10 | 6 |
| Handles, in 6-dozen lots | | per dozen | 11 | 0 |
| Brushes, in lots of 6-dozen boxes, per doz. boxes | | | 10 | 0 |

HOLDER,
WITH BRUSH. *SOLE AGENTS*

For the Dental Profession in all parts of the World except the United States and Canada :

CLAUDIUS ASH, SONS & CO., Limited.
To be obtained of all Dental Dealers.

HYGIENIC TOOTH
BRUSHES.
Dr. G. HAHN'S.
(Patented in Germany.)

Dr. Hahn claims that these Tooth Brushes possess an advantage over all others in the market, in that they can be kept clean.

He holds that Brushes with solid heads are either very difficult to clean, or that they cannot really be thoroughly cleansed; that particles of food are forced between the bristles and remain there until they become putrid, and thus render such brushes dangerous to use.

In the Brushes here illustrated there are slits in the back—two in the Adults' size and one in the Children's size—by means of which the bristles can be thoroughly rinsed and kept sweet and clean; moreover, the air finds its way through all the tufts and helps to dry the bristles: this keeps the Brushes from becoming sodden, and prolongs their serviceableness.

| | | s. | d. |
|---|---|---|---|
| Adults' size, in celluloid handles | . per doz. | 18 | 0 |
| Children's size, in celluloid handles | . per doz. | 12 | 0 |

ADULTS'. CHILDREN'S.

TOOTH BRUSH
WITH THREE ROWS OF BRISTLES.
Designed by Mr. John Wessler, Director of the Stockholm Dental Clinic.

Mr. Wessler claims that this brush can be used "with equal success on both the interior and exterior sides of the teeth."

Supplied with Hard, Medium, or Soft Bristles.

| | | | s. | d. |
|---|---|---|---|---|
| Adults' | | per doz. | 10 | 0 |
| " | | per gross | 114 | 0 |
| Children's | | per doz. | 8 | 0 |
| " | | per gross | 90 | 0 |

TOOTH PICK.
(Mr. PALMER'S.)

Full size.

In Gold, set in Ivory, fitted in square ivory handle, inside which it slides.

PRICE each 5s.
Other Tooth Picks supplied to order.

Adults' full size.

MOUTH WASHES.

| | | | s. | d. | |
|---|---|---|---|---|---|
| Euthymol, in 4-oz. bottles | . | per bot. | 1 | 0 |
| " | 8-oz. " | " | 1 | 10 |
| " | 16-oz. " | " | 3 | 6 |
| Klenso, in 4-oz. bottles | . | " | 1 | 6 |
| " | 8-oz. " | . | " | 2 | 6 |
| Listerine, in 14-oz. bottles | . | " | 4 | 0 |
| Maghactis (Hydrate of Magnesia) | . | " | 0 | 10 |
| Myrrh (Fluid Extract), in 8-oz. bottles | . | " | 5 | 0 |
| Myrrh Gum | | per lb. | 5 | 9 |

Other Mouth Washes supplied to order.

SOLID TOOTH PASTE.

This Tooth Paste is composed of the best and purest materials obtainable; it is a most agreeable and refreshing dentifrice, and we can strongly recommend it as an elegant toilet requisite.

Supplied in Glass Boxes, also in Tin Boxes with glass lids, flavoured with **Rose, Cherry, or Peppermint**.

| | | | s. | d. |
|---|---|---|---|---|
| In Glass Boxes, any flavour | | per box | 0 | 10 |
| " | " " | " doz. | 9 | 0 |
| " | " " | " gross | 106 | 0 |
| In Metal Boxes with Glass Lids, any flavour | | " box | 0 | 9 |
| " | " " | " doz. | 8 | 0 |
| " | " " | " gross | 84 | 0 |

Solid Tooth Paste can be had stamped with the Dentist's own name and address on the following condition :—

Not less than one gross to be ordered at a time.

No charge is made for stamping beyond the first cost of the *die*, which is twenty shillings. The die will serve for a long time.

EXTRACTING FORCEPS.

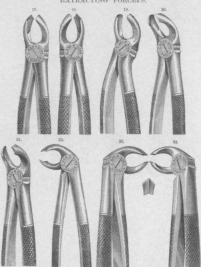

EXTRACTING FORCEPS.

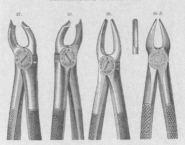

Fig. 17 for right Upper Molars.
 ,, 18 for left ,, ,,
 ,, 19 for Upper Wisdom.
 ,, 20 for Lower ,,
 ,, 21 ,, Molars.
 ,, 22 ,, ,, (Hawk's bill).
 ,, 23 for right Lower Molars ,,
 ,, 24 for left ,, ,,
 ,, 27 for right Upper ,,
 ,, 28 for left ,, ,,
 ,, 29 for Upper Roots.
 ,, 29 S ,, ,, ,,

 s. d.
Each, Nickel-plated 10 0

EXTRACTING FORCEPS.

This shows the bend of the handles of Figs. 76, 76 S and 76 N.

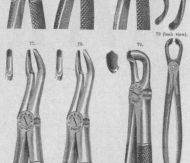

79 (back view).

EXTRACTING FORCEPS.

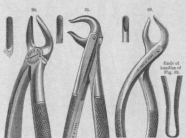

Ends of handles of Fig. 83.

Fig. 76 (Mr. Lawrence Read's) for Upper Roots.
 ,, 76 S ,, ,, ,, with short beaks, as used at the Royal Dental Hospital of London.
 ,, 76 N (Mr. Lawrence Read's) for small Upper Roots.
 ,, 77 and 78 (Dr. Redman's) for Upper Roots.
 ,, 79 for Lower Wisdom.
 ,, 80 (Mr. Coleman's) for Upper Molar and Wisdom Roots.
 ,, 81 (Mr. G. Walker's) with Pin joint, for Lower Bicuspids and Roots.
 ,, 83 ,, ,, ,, for Upper ,, ,,
Figs. 76, 76 S and 76 N are made with simple joint.

 s. d.
Each, Nickel-plated 10 0

GUNTHORPE'S
TORTOISE-SHELL PLASTIC INSTRUMENTS—
continued.

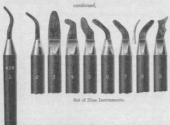

Set of Nine Instruments.

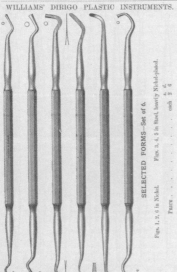

Box of Polishing Paste.
Hand Buff.
Felt Wheel with Wooden Centre, mounted on Engine Mandrel.

GUNTHORPE'S
TORTOISE-SHELL PLASTIC INSTRUMENTS—
continued.

Any cement which adheres to the Tortoise-shell can be removed by placing the instruments in water immediately after use and wiping with a dry cloth.

Since these instruments were designed we have come across the following extract from *The Dominion Dental Journal*, relating to the most suitable instruments for inserting silicate cement fillings, which will be read with interest:—

"After Dr. D. C. Smith had read a paper on Plastic Fillings, he introduced Dr. McCoy to the meeting as a Specialist in Silicate Cement Fillings, and asked him to state his experience. After doing so, and in replying to the questions put by various speakers, Dr. McCoy stated that 'the first question is : What instruments should be used for the insertion ? I use one made with a Tortoise-shell point ; that is what I am using now. In the first place I used steel . . . but recently, since I obtained these Tortoise-shell points, I have used them exclusively. I like them very much.'"

PRICES:

| | | s. | d. |
|---|---|---|---|
| Gunthorpe's Tortoise-shell Plastic Instruments | | | |
| (Figs. 1–9) | each | 1 | 8 |
| " " " | per set | 14 | 0 |
| Polishing Paste in Metal Boxes | per box | 0 | 6 |
| Felt Wheel with Wooden Centre | each | 0 | 6 |
| Parting-out Mandrel for carrying same | " | 0 | 9 |
| Buff Stick | " | 0 | 9 |

WILLIAMS' DIRIGO PLASTIC INSTRUMENTS.

SELECTED FORMS—Set of 6.

Figs. 1, 2, 6 in Nickel. Figs. 3, 4, 5 in Steel, heavily Nickel-plated.

| | s. | d. |
|---|---|---|
| Price | each 2 | 6 |

WUNSCHHEIM'S PLASTIC INSTRUMENTS.

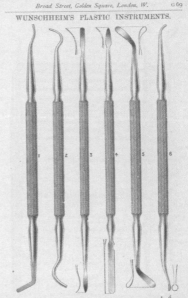

| | s. | d. |
|---|---|---|
| In file-cut handles, Nickel-plated | each 2 | 3 |

THE

SKULL

BENEATH

THE SKIN

6

As dawn broke on 30 August 1850, a most unlikely murderer stood on the gallows at the Leverett Street Jail in Boston. John White Webster was short, pudgy, amiable, nervous, a respected professor of chemistry at Harvard and a man on good terms with his students and his colleagues. After one of the most sensational trials in American history, he had been convicted of murdering George Parkman, a wealthy benefactor of Harvard and a man he had known for a quarter of a century. One particular piece of evidence, a set of porcelain dentures, had been crucial in putting the noose around Webster's neck. Nathan Cooley Keep, the dentist who had treated Parkman, broke down in the witness box as he described them.

This was not the first instance of what we would now call forensic odontology: identifying the dead, and elucidating the circumstances of their death, by examining their teeth. In March 1776, for example, the Boston silversmith Paul Revere was asked to identify the heavily decomposed body of Joseph Warren, killed in the Battle of Bunker Hill the previous year. Revere, more famous for his 'Midnight Ride' in the early days of the American Revolution, occasionally made bespoke dental work, and he picked Warren's body out of a common grave by a bridge of silver and ivory that he had made for his friend. But the Parkman–Webster murder case marks the beginning of a grimmer strand in the story of modern dentistry, one that has cast light into some very dark places.

In his physique and his character, Parkman could hardly have been more different from his murderer. Tall, resolute and occasionally abrasive, he had studied medicine but made his fortune in real estate, and by the time of his death he was one of the richest men in Boston. He and Webster had met as students, but their relationship had taken on a new and more difficult aspect when Webster had borrowed several thousand dollars, offering a valuable collection of geological specimens as security. When Webster wanted to sell the collection in the summer of 1849, a row broke out and Parkman called in his loans. He was last seen on the morning of Friday 23 November 1849, walking towards Harvard Medical College where Webster worked.

Webster's version of the story had Parkman entering his laboratory around 1.30 pm. Webster paid off part of his debt, enough to allow the sale of his

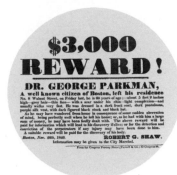

①

PAGE 200 This Japanese Pyramid dental chair (1930–38) is very similar to the Ritter dental chair. ① A substantial reward was offered for information leading to the whereabouts of Parkman or to the detection of any perpetrators of crime. ② and ③ Illustrations from the trial of John White Webster, for the murder of George Parkman. Reported exclusively for the *New York Daily Globe* (1850).

②

③

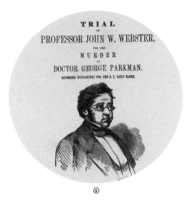

④

④ This portrait of John White Webster appears on the front of the published trial report (1950). ⑤ A diagram of the layout of Webster's laboratory was used to indicate where Littlefield found the body and where the police discovered body parts. ⑥ Illustrated plate showing images from Nathan Cooley Keep of the teeth and jaw of Parkman, from *The Report of the Case of John W. Webster* (1850).

⑤

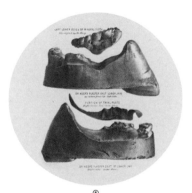

⑥

mineral collection, and Parkman hurried away, not even pausing to count his money. After spending the afternoon preparing oxygen for an experiment, Webster went home and spent the weekend with his family, playing whist and reading Milton. But a week after Parkman disappeared, Ephraim Littlefield, the college janitor, broke into a pit beneath the privy next to Webster's rooms and found a dismembered body. Littlefield called the police, who discovered more body parts and the fragments of a set of false teeth jammed into the furnace in Webster's laboratory. Although the head was never recovered, a coroner's jury found that the remains were those of Parkman, and Webster was indicted for causing his death 'by blow or blows, wound or wounds'.

The trial played out to a packed courtroom every day and was rehashed endlessly in newspapers and pamphlets. Although the absence of a head made conclusive identification difficult, the prosecution argued that the rich growth of body hair and the 'peculiar form and shape' of the corpse made it unlikely to be anyone other than Parkman. It was not a specimen taken from the college's dissecting room, but whoever had dismembered it possessed anatomical knowledge. Jabez Pratt, the Boston city coroner, described what he had found in Webster's laboratory furnace:

[I RECOVERED] WHAT LOOKED LIKE A PIECE OF JAW WITH MINERAL TEETH IN IT AND OTHER SINGLE TEETH NEAR IT. I ALSO FOUND PIECES OF CINDER AND BONE FUSED TOGETHER STICKING TO THE BRICK ON THE SIDE OF THE STOVE, AND WITH A CROOKED PIECE OF IRON I BROKE THEM OFF. TWO OR THREE SEPARATE MINERAL TEETH WERE AFTERWARDS FOUND. THE BONE SPLINTERS WERE PICKED OUT OF THE ASHES AND PUT INTO A PAPER BY THEMSELVES.

Keep testified that he had made a set of dentures for Parkman in December 1846 and still retained the copper 'trial plate' that he had used to obtain a good fit. Comparing this with the remnants taken from the furnace, he found that they matched perfectly:

I RECOGNIZED [THE REMAINS] AS BEING THE SAME TEETH THAT I HAD MADE FOR DR PARKMAN THREE YEARS BEFORE. THE LARGEST PORTION

THAT REMAINED, WHICH I NOW HOLD IN MY HAND, WAS THAT BELONGING TO THE LEFT LOWER JAW. I RECOGNIZED THE SHAPE AND THE OUTLINE AS BEING IDENTICAL WITH THE IMPRESSION LEFT ON MY MIND OF THOSE THAT I HAD LABORED ON SO LONG. ON COMPARING THE LARGEST FRAGMENT WITH THE MODEL, THE RESEMBLANCE WAS SO STRIKING THAT I COULD NO LONGER HAVE ANY DOUBT THAT THEY WERE HIS.

His evidence also provided a clue to the mysterious absence of the head. Littlefield recalled that on the afternoon of Parkman's disappearance Webster had locked himself in his laboratory, and the wall behind the furnace had become so hot that he could not place his hand on it. From the state of the surviving teeth, Keep concluded that they 'went into the fire in the head, or with some portion of it, or in some way were insulated, for if they were not, they would have exploded'. The defence summoned witnesses who claimed that Parkman had been seen alive long after his disappearance, and called William Thomas Green Morton, pioneer of ether anaesthesia and no stranger to a courtroom, to refute Keep's testimony:

THERE ARE NO MARKS ABOUT THE TEETH PREVIOUSLY IDENTIFIED BY DR KEEP BY WHICH IT WOULD BE POSSIBLE FOR HIM OR ANYONE ELSE TO IDENTIFY THEM. PERHAPS THE TEETH MIGHT BE SUSCEPTIBLE TO IDENTIFICATION IF THEY HAD NOT BEEN SUBJECTED TO THE FIRE. I COULD ALSO IDENTIFY INDIVIDUALS AMONG MY PATIENTS WHO HAVE AS PROMINENT A LOWER JAW AS DR PARKMAN, BUT PREFER NOT TO DO SO FROM MOTIVES OF PROFESSIONAL DELICACY.

But it was no use. Keep's performance in the witness box, and a wave of public revulsion, sent Webster to his death and provoked him to confess his guilt in the condemned cell – in the words of the legal historian Richard B. Morris, 'a classic example of how a jury can reach a sound verdict despite an unfair trial'.[1]

Almost a century later, a team of Russian military investigators found themselves facing a similar set of questions. After the fall of Berlin in May 1945, surviving Nazi officials told Russian interrogators that Adolf Hitler and Eva Braun had killed themselves in

①

① and ② An X-ray of Hitler's head and a hand-drawn diagram of his teeth helped to identify his body and to confirm the death of the dictator. ③ Serial killer Karl Denke committed suicide when the extent of his cannibalistic crimes was discovered.

②

③

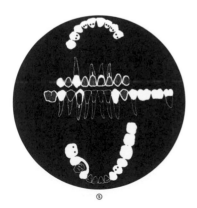

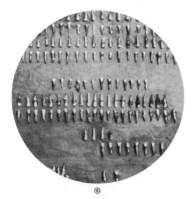

④ Extensive gold bridgework can be seen here on Hitler's teeth. ⑤ This dental chart of Hitler's teeth indicates which teeth were missing and which had been repaired. ⑥ Part of Denke's collection of the teeth of his many victims.

the last days of the battle, and that their bodies had been burned in the garden of the Reich Chancellery. Under pressure from Stalin, however, Soviet intelligence needed hard evidence that the Führer had not survived the war. Hugo Blaschke, Hitler's dentist, had escaped to Austria, but Fritz Echtmann, his technician, and Käthe Heusermann, his assistant, were questioned closely over the details of Hitler's dental arrangements. Shown an incinerated jawbone fitted with bridgework in gold, they recognized it as belonging to their former client.

Under questioning from US Army intelligence, Blaschke made drawings of Hitler's dentition, and also tried to recall the work he had done for other high-ranking Nazis. When repairs to a Berlin water main in 1972 uncovered a skeleton, Blaschke's sketches helped to prove that it belonged to Martin Bormann, Hitler's private secretary. Fragments of glass between the jaws suggested that Bormann had committed suicide by biting on a glass cyanide capsule. Dental evidence proved crucial in tracking down the remains of another notorious Nazi fugitive, Josef Mengele, the Auschwitz 'Angel of Death'. After the war, Mengele escaped to Brazil under an assumed name, and in 1979 he drowned after suffering a stroke while swimming. Six years later, an international team of investigators exhumed his body, and comparison of the skull with surviving photographs from his time in the SS, along with the distinctive diastema, or gap, between his upper incisors, provided the proof that the bones belonged to Mengele.

Through the twentieth century, forensic odontology has proved even more effective in analysing large and jumbled collections of remains – in mass graves, for example, or plane crashes. Teeth are strong and resilient, and they retain their features after centuries in the ground or exposure to all but the fiercest fires. Typically, modern dental records and X-rays provide enough information to identify a person if their full dentition survives. Programmes to recover *los desaparecidos* – Argentinians 'disappeared' by a military junta in the late 1970s – and American soldiers missing in action in Vietnam rely heavily on dental records. Dental evidence can also be used to estimate the numbers of individuals represented, as in the macabre case of the Silesian serial killer Karl Denke.

In the years after the First World War, Denke murdered dozens of people, curing and consuming their flesh and even selling it as pork. After one of his victims escaped, he was arrested but hanged himself in his cell before he could be questioned. Investigators found that Denke had kept more than three hundred teeth from his victims, and by counting the numbers of teeth from different positions in the mouth they were able to determine that the collection had come from at least twenty individuals. This figure doubled after the police discovered a ledger in which Denke had entered the names, ages and weights of his forty-two victims.

Bite mark evidence is more problematic, depending strongly on the characteristics of the medium in which the bite is preserved. Swelling and bruising can distort bites in tissue, while bite marks in food are affected by dehydration and decomposition. These difficulties became a major point of controversy in the Chamberlain case in Australia, in which Azaria Chamberlain, the infant daughter of Lindy and Michael Chamberlain, disappeared from the family tent near Ayers Rock in August 1980. Azaria's body was never found, and her parents argued that a dingo had carried her off. Experts disagreed, concluding that her shredded clothing, found outside the tent, had been cut with scissors rather than torn by the teeth of a dog. Lindy was found guilty and served several years in prison, but her conviction was overturned in 1988 after more of her daughter's clothing was found beside a dingo's lair.

As the Chamberlain case shows, forensic odontology is not necessarily a matter of analysing natural human teeth. Microscopic file marks on the teeth of the 'Piltdown Man', a skull found in Sussex in southern England in 1912, helped to prove that it was a forgery and not an ancient hominid fossil. And in the late 1940s, John George Haigh murdered at least six people in and around London, dissolving their bodies in sulphuric acid. Even after admitting what he had done to police, Haigh believed that he could not be charged: 'How can you prove murder if there is no body?'[2] Keith Simpson, a forensic pathologist, thought otherwise. All that remained of Haigh's last victim, Olive Durand-Deacon, was a patch of acidic sludge spread on waste ground outside his workshop. After a painstaking search, Simpson recovered

① Northern Territory pathologists and CSIRO technicians examine samples in November 1982. They were found near Ayers Rock, Australia, where baby Azaria Chamberlain disappeared two years earlier. ② The scratches on the surfaces of the Piltdown molars were made deliberately to make the teeth resemble those of a human. ③ A formal portrait of Tsar Nicholas II and the Romanov family.

②

③

④

④ An illustration of Ayers Rock and the surrounding area from October 1982. It includes the camp site where Azaria disappeared in August 1980. ⑤ This reconstruction of the skull of 'Eoanthropus Dawsoni' (Piltdown Man) was made as evidence of a human ancestor living 500,000 years ago. ⑥ The skulls of the tsar's family were found in 1991 in Porosenkov gorge near Yekaterinburg.

⑤

⑥

gallstones, bone fragments and – most importantly – a full set of acrylic dentures. Mrs Durand-Deacon's dentist testified that he had made them for her, and Haigh went to the gallows.

Forensic odontology has become a fairly common form of evidence in modern criminal trials, but some of the best-known cases involving dental evidence have been solutions to historical mysteries. For much of the twentieth century, speculation persisted over the eventual fate of the bodies of Tsar Nicholas II and his family, murdered by Soviet revolutionaries at Yekaterinburg in July 1918. In 1979 a mass grave was uncovered outside the town, now Sverdlovsk, and it was excavated in 1991. A team of American forensic scientists made a preliminary assessment of the remains, in which dental evidence played a central role. The tsarina's skull still bore a costly array of gold and platinum crowns, and her maid, Anna, had been fitted with a cheap gold bridge, but Nicholas himself had appallingly rotten teeth. The last tsar of all the Russias had, it seems, a horror of dentists.

① Richard B. Morris, *Fair Trial: Fourteen Who Stood Accused*, New York, 1952, p. 156.
② Keith Simpson, *Forty Years of Murder*, Harrap, 1980, p. 196.

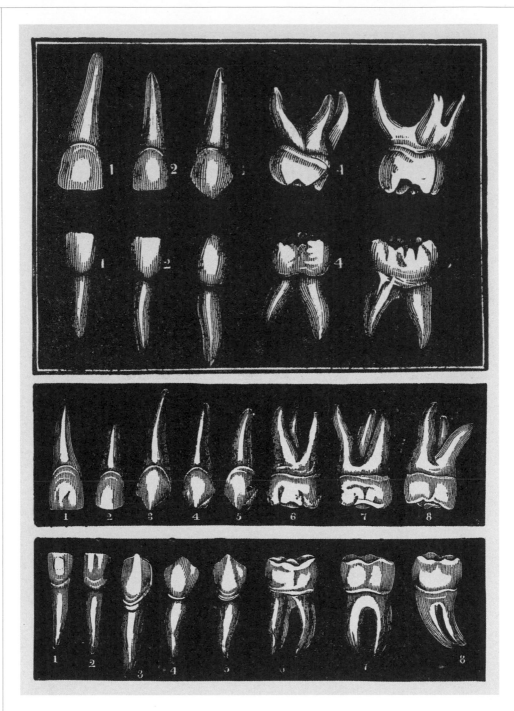

Pages from *The Teeth in Health and Disease* (1902) by George Read Matland. ABOVE | Illustrations of the temporary teeth on the left side of the upper and lower jaw (top) and the permanent teeth on the left side of the upper and lower jaw (centre and bottom).

OPPOSITE | Teeth in the upper jaw show a progression of decay from age five to nineteen (top); mouths display the accumulation of tartar and the erosion of the enamel of the teeth (centre); a case of irregularity in the teeth seen before and after treatment (bottom).

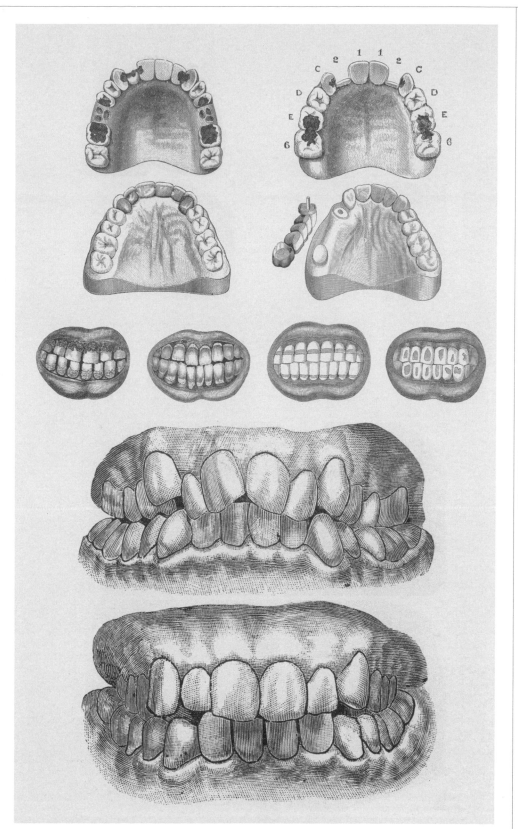

ABOVE | Carbolic, cherry and areca nut toothpastes and powders made various claims to maintain a healthy mouth, including white teeth and firm gums. Many chemists made their own versions. These printed labels are from 1895–1915.

OPPOSITE | Two labels from J. B. L. (*c.* 1890–*c.* 1910). One is for an antiseptic tooth wash (top) and the other is for Perfect Pearl toothpaste, which promises to clean and preserve the teeth and gums. The Floral Dentifrice (*c.* 1890–*c.* 1910). prepared by D. R. Harris and Co. makes the same claim. A gummed poster stamp (1890–1910) suggests that Calderara and Bankmann's Hygiodont toothpaste will make your teeth pearly white.

Imperial

TOOTH WASH

AND

TOOTH PRESERVER
(ANTISEPTIC)

DIRECTIONS: Dip the brush in water sprinkle 6 to 12 drops of the wash on the brush and apply in usual way.

PREPARED BY
Dr. J. B. Lynas & Son.
PERFUMERS,
LOGANSPORT, IND.

Zähne wie Perlen durch
HYGIODONT
Calderara & Bankmann
Wien.

THE
FLORAL DENTIFRICE

FOR CLEANSING, PRESERVING, & BEAUTIFYING
The Teeth and Gums.

PREPARED ONLY BY
D. R. HARRIS & Co., Chemists,
30 KING STREET,
ST. JAMES'S SQUARE,
Sole Proprietors of the Original Floral Hall Bouquet.

J. B. L.

PERFECT
PEARL
TOOTH
PASTE

A DELIGHTFUL ANTISEPTIC TOOTH PASTE FOR CLEAN-ING AND PRESERVING THE TEETH AND GUMS.
CONTENTS 2 OUNCES
DR. J. B. LYNAS & SON
PERFUMERS
Logansport, Ind.

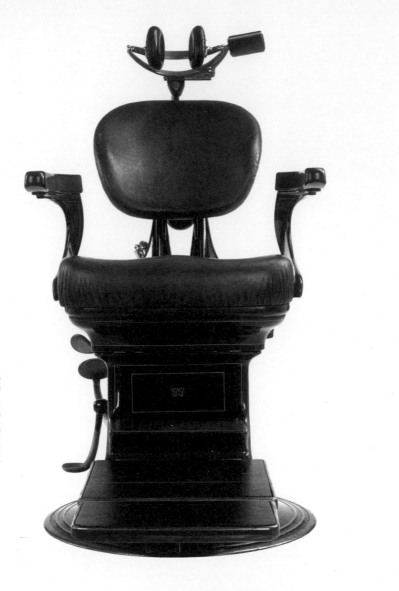

ABOVE AND OPPOSITE | Known as the 'Diamond 2',
this hydraulic dental chair (1925–35) was the first
to have a non-sprung anatomically shaped seat.
It was made by the S. S. White Dental Manufacturing
Company of Philadelphia and was easier to adjust
than older wooden ones, which were operated
using a hand-cranked mechanism.

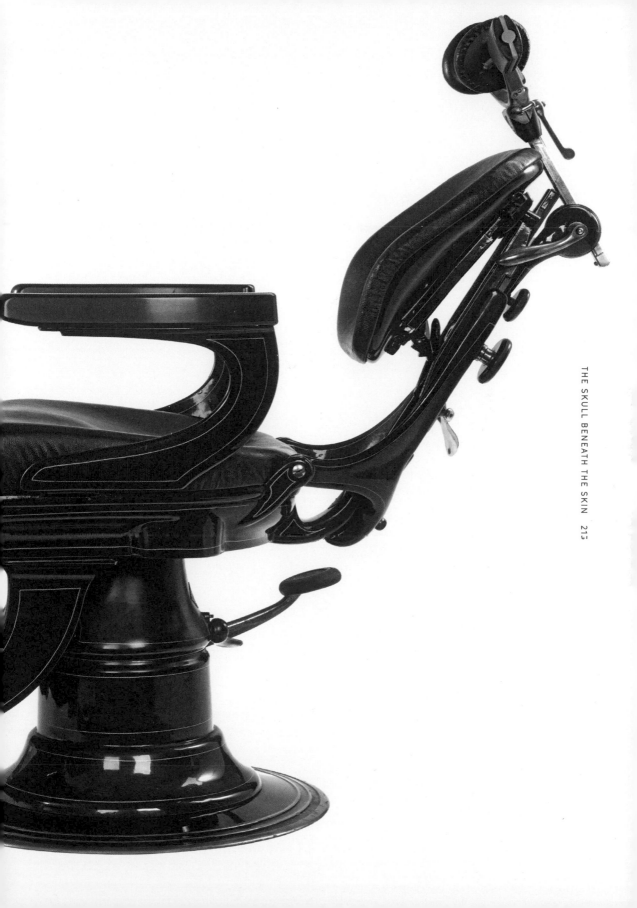

RADIOL
CHEMICALS FOR
X-RAY WORK

Folder 70.

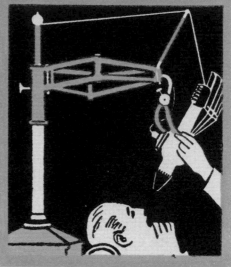

PREVIOUS AND ABOVE | Art Deco-inspired trade brochure covers, advertisements and illustrations from British dental equipment manufacturer Watson & Sons (1924–29). The firm specialized in X-ray equipment and chemicals, and the illustrations accompany explanations of the application of X-rays in dentistry.

OPPOSITE | The Ritter Model A – an innovative dental X-ray machine with an extendable and multi-directional arm, introduced in 1920. Its improved design made it the most efficient piece of equipment at the time for the correct diagnosis of dental problems. It greatly facilitated the use of X-rays in dentistry.

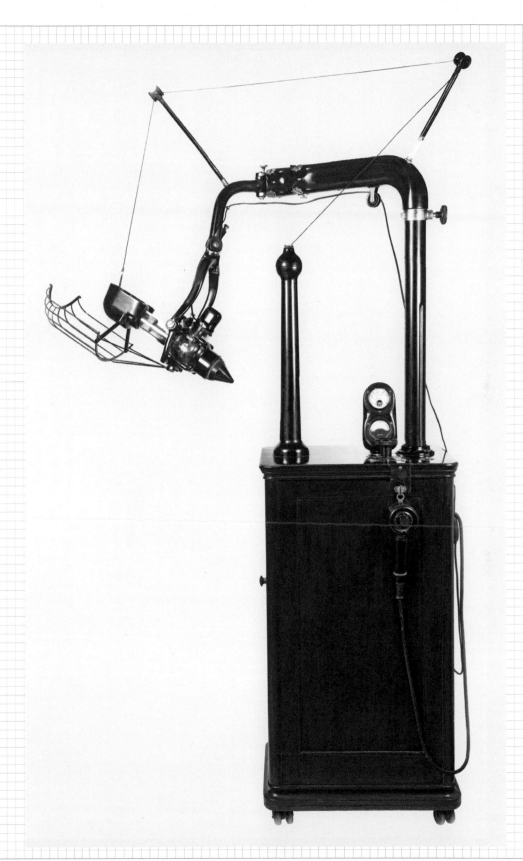

ABOVE | Photomicrographs of the molar teeth of a rat, from *Experimental Studies on the Physiological and the Pathological Chemistry of the Teeth* (1926) by Guttorm Toverud.

OPPOSITE | Dental X-rays showing the extraction of a wisdom tooth and a second molar tooth, from *Petite chirurgie de la bouche* (1974) by Marcel Parant.

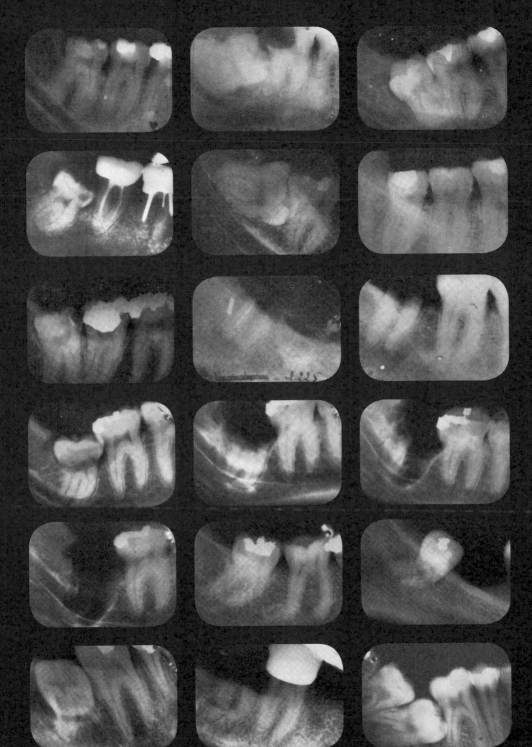

RATHBONE
DENTAL UNIT

ABOVE AND OPPOSITE | Trade catalogue cover and illustrations of four models of the Rathbone dental unit (1933). Options include dental drill (powered by a cord arm electric motor), self-flushing spittoon, instrument cabinet, tool trays and multi-directional lighting. The manual reads as follows:

'The Rathbone Unit creates an atmosphere of scientific efficiency and modernity tempered with dignity. It arouses the patient's interest and awakens in him a new respect for dental science and a greater appreciation of the importance of the treatment he is undergoing.'

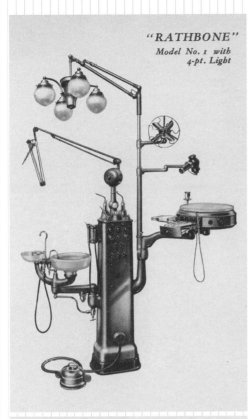

"RATHBONE"
Model No. 1 with
4-pt. Light

"RATHBONE"
Model No. 2.

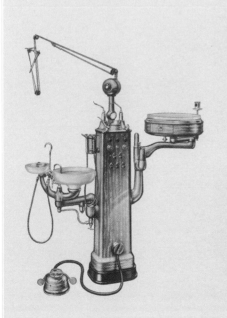

"RATHBONE"
Model No. 3.

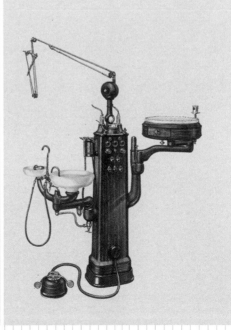

"RATHBONE"
Model No. 3 in Mahogany

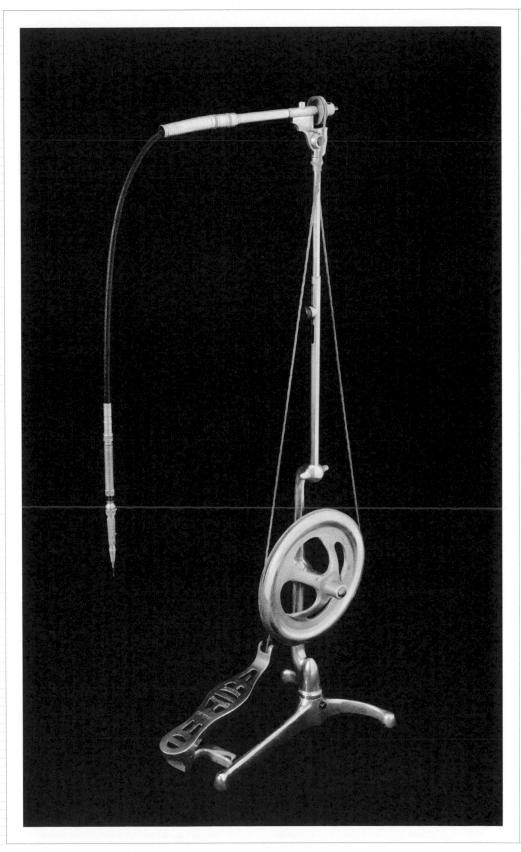

Главлит №А46798 Тираж 10.000

ИЗДАНИЕ

PREVIOUS LEFT | Ritter dental unit with cable-drive drill, lamp and spittoon basin (*c.* 1930). PREVIOUS RIGHT | A German treadle drill (1910–20), operated by a foot pedal.

ABOVE | A Soviet propaganda poster encouraging workers to brush with precision and vigour. The text reads: 'Be accurate. Don't Be Lazy. Clean Your Teeth – Daily'. Moscow (1926–29).

БУДЬ АККУРАТЕН,

ЗАБУДЬ ЛЕНЬ,

ЧИСТЬ ЗУБЫ

АЖДЫЙ ДЕНЬ

ИЗДАТ.

12 лит. „Раб. Дело". Мосполиграф. Москва.

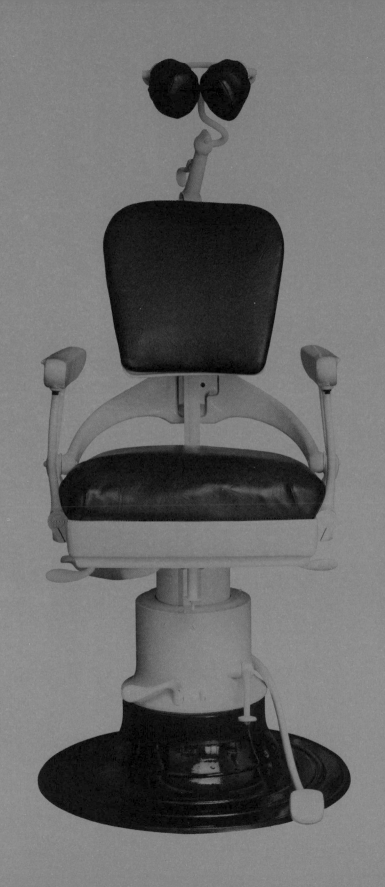

THE

SMILE

OF

SUCCESS

7

MANY A REFRACTORY CHILD WILL ALLOW A
LOOSE TOOTH TO BE REMOVED IF HE KNOWS
ABOUT THE TOOTH FAIRY. IF HE TAKES HIS
LITTLE TOOTH AND PUTS IT UNDER THE
PILLOW WHEN HE GOES TO BED THE TOOTH
FAIRY WILL COME IN THE NIGHT AND TAKE IT
AWAY, AND IN ITS PLACE WILL LEAVE SOME
LITTLE GIFT.

Parents have long found ways to console children
over the loss of their milk teeth, but this 'Household
Hints' column from the *Chicago Daily Tribune* of 27
September 1908 appears to be the first reference
in print to the tooth fairy. This contribution to popular
folklore gained widespread attention through a
three-act play for children written by Esther Watkins
Arnold in 1927. Since then the tooth fairy has been
depicted, like *Peter Pan*'s Tinker Bell, as a tiny,
shapely woman with butterfly wings, and in the
twenty-first century she speaks to children through
websites, social media and public health campaigns.
　　But the most potent invention of twentieth-
century dentistry was no benign inhabitant
of fairyland. The smile of success – burnished,
expensive, ostensibly natural and deeply unnatural –
had its roots in the work of the *dentistes*, but it was
in the image-saturated and American-dominated
second half of the twentieth century that this
modern version of *la bouche orneé* emerged as a
truly global myth. Just as the *dentistes* had promoted
the counter-intuitive notion that one should visit
them when not in immediate pain, so twentieth-
century dentists began to argue that regular trips
to the dentist were necessary for maintaining
the health of individuals and the well-being of
nation states. Teams of practitioners – assistants,
hygienists, technicians and therapists working
alongside dentists – began to fulfil the promises
that dentistry had been making for three centuries
and more. The imperial rise of the smile of success
reflected the growing power of visual media and the
struggle for political dominance in the second half
of the American Century, alongside new systems
of state health care and new technologies for
preserving and maintaining teeth. And it brought
a fresh twist to old arguments, pitting one vision
of dentists as public servants against another in
which they figured as self-sufficient entrepreneurs.

①

PAGE 226 Adjustable hydraulic dental
chair, 1950s.
① An illustration from *A Midsummer
Night's Dream* (1908) by Arthur Rackham.
② Marilyn Monroe shows the world her
perfect smile (1953), having had her front
teeth straightened by an orthodontist.
③ Children are photographed brushing
their teeth outside school in *c.* 1910,
Washington, D.C.

②

③

④ This silver-plated tooth fairy box was manufactured by Reed and Barton. Inside is a red 'pillow' for the tooth. ⑤ Cary Grant was quite the charmer but his smile was less than perfect; he had an upper central incisor missing. ⑥ British children pose with toothbrushes in front of their school building as part of a tooth-brushing drill (c. 1920).

In the early years of the twentieth century, European and American welfare programmes took a close interest in the health of children, as governments sought to strengthen the next generation of workers, soldiers and empire-builders and to fight off the perceived threats of international competition or racial degeneration. Give children strong teeth, the argument ran, and they will require fewer expensive, time-consuming and painful interventions as adults. From 1880 the British Dental Association drew attention to the poor state of British schoolchildren's teeth, and some of its members established a School Dentists' Society in the 1890s. George Cunningham, a Cambridge dentist, established the first dental clinic expressly for children in 1907, and 'Toothbrush Clubs' in British schools encouraged children to brush their teeth morning and night. As the historian Alyssa Picard noted, school dental programmes in the United States tended to mix public and private, as public schools and state officials collaborated with charities and individual dentists.[1] Involvement in these schemes brought many benefits for dentists eager to improve their standing. They were educating the nation in the value of dental care, but also getting American children into a lifelong and lucrative habit of visiting the dentist.

Concerns over future military strength were intensified by the outbreak of the First World War, and this marked the beginning of a major shift in medical attitudes towards dentistry. In the field hospitals and operating theatres of the Western Front, leading doctors and surgeons gained a new-found respect for what dentists could do. The ghastly conditions of warfare in Flanders made facial reconstruction a major problem for military surgeons. Trench warfare could leave the head and face exposed to sniper fire and shell fragments, and in early fighter planes the fuel tank sat directly in front of the pilot, thus causing terrible burns if it exploded. Around 15 per cent of those wounded badly enough to require evacuation from the front line had facial injuries, and their survival came to depend on small things. Stretcher parties quickly discovered, for example, that soldiers with the worst facial injuries could choke on their tongues if they were left lying on their backs. Those who survived the perilous and painful journey from trenches to dressing stations

and hospitals required swift, precise and expert treatment over months and years. That many of them regained some measure of facial function and appearance was due to the work of a dandyish Franco-American dentist, Auguste Charles Valadier.

Born into a wealthy Parisian family, Valadier had studied at Columbia and the Philadelphia Dental College before setting up practice in Paris. At the outbreak of war, he volunteered his services to the Red Cross and arrived at the British Expeditionary Force's No. 13 General Hospital outside Bolougne-sur-Mer in his chauffeur-driven Rolls-Royce Silver Ghost. Harold Gillies, Valadier's assistant surgeon and later a leading figure in British surgery, recalled him as:

> A GREAT FAT MAN WITH SANDY HAIR AND A FLORID FACE, WHO HAD EQUIPPED HIS ROLLS-ROYCE WITH DENTAL CHAIR, DRILLS AND THE NECESSARY HEAVY METALS ... HE TOURED ABOUT UNTIL HE HAD FILLED WITH GOLD ALL THE REMAINING TEETH IN BRITISH GHQ. WITH THE GENERALS STRAPPED IN HIS CHAIR, HE CONVINCED THEM OF THE NEED OF A PLASTIC AND JAW UNIT.

In his military work, Valadier was alive to the complexity of facial anatomy, and he drew on his dental experience to devise new techniques for treating facial wounds. Inspired by his time with Valadier, Gillies returned to England and in 1917 became chief surgeon to the Queen's Hospital, Sidcup, the major British centre for facial reconstructive surgery. At Sidcup, Gillies worked with another dental surgeon, William Kelsey Fry, who designed innovative prostheses for patients with damaged jaws and teeth.

Shortly after the end of the war, British dentistry gained a marginally greater degree of independence with the Dentists Act of 1921. This set up a separate Dental Board with a membership of dentists and laypeople, although three representatives from the General Medical Council ensured a strong medical voice in the regulation of dentistry. Under the Act, entry was limited to registered dentists and physicians (along with some pharmacists, who retained a legal right to carry out dental procedures into the 1980s). As with the Dentists Act of 1878, unqualified practitioners who were already established in

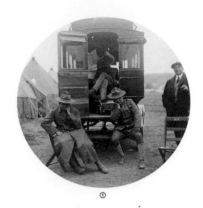

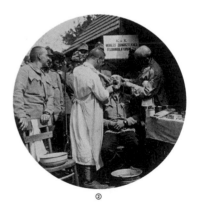

① The US Army's new portable dental ambulance is tried out in 1917 at the guardsman's camp at Van Cortlandt Park, New York City, and later sent to Hancock, Georgia. ② Soldiers are treated at a mobile dental clinic in Giedlarowa, Poland, during the First World War. ③ From an album of photographs of plastic surgery cases at the King George Military Hospital, London (1916–18).

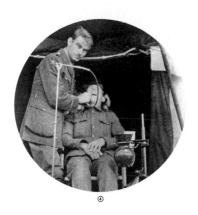

④

④ This field dentist, seen here in 1915, is working at a casualty clearing station near Poperinghe. His field kit includes a folding chair, foot engine and a spittoon on a stand, but no gas or oxygen apparatus. ⑤ A female English dentist treats a soldier in France (1915). ⑥ From an album of photographs of plastic surgery cases at the King George Military Hospital, London (1916–18).

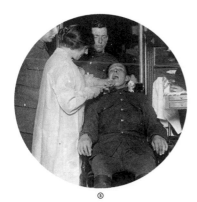

⑤

⑥

practice – around seven thousand, more than half the total number of British dentists – were allowed to remain on the Dental Register, a factor that continued to shape British dentistry for another generation and more. And in civilian life, access to dental care was still patchy, highly dependent on income and location. Well into the 1930s, some working-class British women received a full set of dentures as a present for their twenty-first birthday or their wedding – hardly romantic, but cheaper and less painful than a series of extractions over two or three decades.

For American dentists, political arguments over national health offered an opportunity to find an authoritative voice in public life. The late nineteenth and early twentieth centuries were the first great age of industrially processed food, and the diet of Americans – particularly poor city-dwellers – had changed radically. Inferior dental health was, in the view of eugenically minded dentists such as Eugene Solomon Talbot, a symptom of a national malaise, linked with alcoholism, madness, crime and other markers of physical and mental degeneracy. Just as scientists were beginning to propose model 'balanced' diets and to advise mothers on what to feed their infants, so dentists began to claim that they could guide the nation towards a brighter and better dental future. How to do this, though, was another matter. From the 1920s, a minority of American dentists began to advocate a socialist model of national dental care, with the state taking responsibility for education and prevention, and employing dentists to provide free treatment. The majority endorsed the idea that they could contribute to the well-being of their fellow citizens but, in what they saw as an American spirit of free enterprise, they wanted to do so as businessmen rather than as state employees. Some argued that socialism went hand in hand with dental disease: in 1923 one American dentist told the journal *Oral Hygiene* that he had 'never seen a Bolshevist with other than bad teeth. Proper care of the teeth obviates the mental explosions that cause Bolshevism.'[2]

Back in Britain, arguments like these were informed by a growing crisis in dentistry. In the Boer War and the First World War, a high proportion of recruits were unfit for service because of rotten teeth, and under the Dentists Act of 1921 the

profession stagnated, with few new entrants and a rising average age. The outbreak of the Second World War proved to be a turning point, and in 1941 the wartime National Government commissioned the economist William Beveridge to investigate British social welfare provision. His report, published in 1942, advocated the foundation of a national health service, providing treatment free at the point of delivery. In the following year, the Teviot Committee was given the job of working out the details for dentistry. Its members devised a scheme for a 'comprehensive dental service' with three 'priority classes' of patients: pregnant and nursing mothers, children and adolescents. Although public support for Beveridge's proposals was overwhelming, the British Dental Association (BDA), like the British Medical Association, opposed the scheme and threatened that its members would simply refuse to co-operate. The BDA demanded a contract that would allow its members to retain their still-insecure standing as independent professionals.

On 5 July 1948 the Labour government under Clement Atlee brought the National Health Service (NHS) into existence. Administrators had made allowances for a high initial demand, but the sheer number of patients exceeded all predictions. People who had endured years or decades of pain could get abscesses drained and rotten teeth extracted, and those who could not afford to spend a month's wages on a set of dentures received them for nothing. NHS dentists issued nearly two million sets of dentures in the first year of the service and, despite the BDA's unease, its members did well out of it. By the end of 1948 some British dentists were earning £4,000: twice the typical salary of NHS GPs, and three times the pre-war average.[3]

Some American dentists may have dismissed British socialized medicine as an outbreak of Bolshevism, but what was the state of Soviet dental care as the Iron Curtain came down across Europe? Perhaps the most distinctive feature of the Soviet medical system was its integration with industry. Across the cities of the USSR, doctors, dentists and pharmacists worked together in workplace 'polyclinics'. Although dental treatment and prostheses were free for veterans of the Great Patriotic War, and to anyone awarded a 'personal' pension (typically handed out to senior Communist

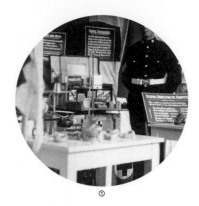

① This display from the Royal Army Medical Corps Muniments Collection (1932) includes various items of field equipment and anaesthetic apparatus. ② Designed in 1929 after John Onwy, this Belgian dental poster claims that Glycodont toothpaste whitens the teeth. ③ The well-rehearsed Toothbrush Brigade promotes dental hygiene with its over-sized toothbrushes in Long Beach, California (c. 1950).

④

⑤

⑥

④ A young crowd watches a demonstration given as part of a dental health publicity campaign in Bermondsey, London.
⑤ The text of this poster issued by the UK Ministry of Health in the 1960s reads: 'First teeth are important. If they are lost too soon there won't be enough space for second teeth to come through properly.'
⑥ Patients at the dentist's surgery wait to be seen by the hygienist (c. 1950).

Party members), most ordinary Russians had to pay – a point on which Soviet propaganda was silent. State public health campaigns targeted children, who were taught in schools to brush their teeth and sent home to persuade or to shame their parents into line. Posters and advertisements showed muscular Socialist Realist heroes clutching rifle-sized toothbrushes and mouthing slogans of Soviet efficiency and hygiene: 'Be Accurate. Don't Be Lazy. Clean Your Teeth – Daily.'[4]

As the Cold War heated up, some American dental health campaigners sought to open up a new front in the fight against communism. In the words of an article published in 1953:

'DENTAL CARIES' IS MERELY A 'FRONT' TO CONCEAL THE DEVILISH MACHINATIONS OF A HANDFUL OF EVIL CONSPIRATORS ... FLUORIDATION HAS BEEN USED IN COUNTRIES TAKEN OVER BY DICTATORS TO IMMOBILIZE THE PEOPLE'S WILL AND ABILITY TO THINK.

This hysterical claim neatly captures the anxious atmosphere of the early nuclear age, but (as Picard pointed out) it suggests misleadingly that debates over water fluoridation came down to a clear and polarized struggle between scientific reason and political panic.[5] Scientists and dentists had begun to take an interest in fluoride after the First World War, when the residents of some Midwestern mining towns were found to have teeth that, although mottled and deformed, were resistant to decay. Research by the US Public Health Service showed that drinking water fluoridated to a level of one part in a million would cut tooth decay without discolouring teeth, and in the late 1940s a handful of American cities began to fluoridate their water supplies. This decision provoked nationwide controversy across a range of political positions. Was fluoridation the work of a crypto-communist Big Government, a sensible form of collective responsibility for public health or a way for aluminium-mining companies to get rid of sodium fluoride, an industrial by-product? Would it prevent painful tooth decay, or cause ugly staining?

In this era of the 'Red Scare' and McCarthyism, accusations of communist sympathy could ruin a career overnight, and bruising public encounters over

fluoridation led many American dentists to reject any kind of state involvement in the provision of dental care. Americans were coming to see advantages in some sort of federal health and dental insurance, but proposals for legislation along these lines faced consistent opposition from medical and dental organizations. Medicaid, introduced by President Lyndon Johnson in 1965, included provisions that gave all children access to comprehensive preventative and restorative dentistry, but uptake was, and remains, fairly low – partly because of the comparatively small numbers of dentists participating in the scheme.

For all British governments in the early years of the NHS, the major challenge was money. Dentistry made up a disproportionate 10 per cent of the total NHS budget, and dental fees had already been halved in 1949 in a bid to reduce expenditure. A Conservative government under Winston Churchill, elected in 1951, introduced a flat rate charge for dental treatment, and throughout the post-war period the cost of NHS dental treatment for British patients continued to rise. Free dental check-ups were abolished in 1987, and at the time of writing patients pay around 80 per cent of the cost of NHS dental treatment. Increasing numbers of Britons have opted to go private and pay for routine dental cleaning and maintenance, turning to the NHS only for complex or extensive treatment.

One major change in post-war dentistry has been the appearance of new kinds of practitioners. The first 'dental assistants' appeared in the offices of American dentists in the first decade of the twentieth century, not only assisting with procedures but also serving as an office secretary and receptionist. Not formally qualified and often poorly paid, these assistants – typically young women – supported their employer without posing a threat to his status. Women dentists, still a small minority in Europe and the United States, tended to oppose the notion of female assistants, arguing that they should gain formal dental qualifications rather than accept lower pay. During the Second World War, the Royal Air Force, concerned about the poor dental health of its aircrew, introduced a short training programme for female dental hygienists.

Under the terms of the Dentists Act of 1921 hygienists were not officially permitted to practise. After the passage of a third Dentists Act in 1956, the new and fully autonomous General Dental Council established an experimental school for

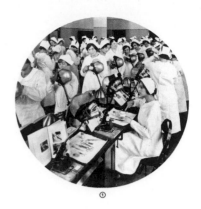

① After the war, dentistry benefited from the development of new equipment and techniques, as well as an influx of students training to be dentists. ② Two trainee dental hygienists practise their operating techniques on a dummy ③ A young patient in the dentist's chair holds a giant model of a set of dentures, which the dental hygienist uses to demonstrate effective brushing techniques (c. 1950).

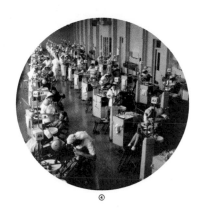

④

④ General view of the dental treatment room at the New Zealand Free dental clinic, which could treat up to fifty children at any one time (1948). ⑤ Airwoman Maureen O'Leary trains to be a dental hygienist (1960). ⑥ Young patients at the dentist's surgery examine giant models of molar teeth, which the dental hygienist uses to teach about the importance of dental care (c. 1950).

⑤

⑥

dental hygienists at the New Cross Hospital in London. Based on a programme developed in New Zealand, the New Cross scheme trained dental auxiliaries to go into schools and to carry out basic treatment and preventative work. Although initially they were not allowed to work alongside dentists in general practice, the appearance of qualified expert ancillaries changed the nature of post-war dentistry. Hygienists and therapists began to specialize in treating children, leaving dentists to focus on the more complex and more lucrative demands of adult patients. Pioneered in the 1970s and 1980s and now standard around the world, 'four-handed dentistry' enabled dentists working with assistants to treat many more patients in a single session.

Efficiency, along with prevention, became the watchword of technical developments in dentistry after the Second World War. In the late 1940s, British dental practice had been fairly basic, mostly extractions, amalgam fillings and dentures, with instruments and local anaesthetic needles sterilized in boiling water. Under the NHS, the balance of treatment started to move away from removal and replacement, towards a more conservative model based on prevention, maintenance and repair. Air turbines, capable of spinning half a million times a minute, began to replace older electric drills, and when equipped with diamond burr bits they made drilling and filling faster than ever. Growing concerns over the safety and environmental impact of mercury amalgam drove the development of new composite filling materials, some of which could be cured quickly by exposure to powerful artificial lights. Computer-aided scanning and milling could make dentures more accurately and more quickly than ever before, and dental implants – a ceramic tooth screwed into a titanium base set in the jaw – provided a permanent replacement for lost teeth.

But the most conspicuous shift in post-war dental practice has been what British historian Colin Jones called 'the second Smile Revolution': the dramatic rise of orthodontics and, with it, the appearance of new cultural and aesthetic attitudes to the mouth and the teeth.[6] The first orthodontic specialists emerged in the United States in the second half of the nineteenth century, and in St Louis in 1900 Edward H. Angle – inventor of the bracket-and-wire orthodontic brace – established the American

Society of Orthodontists. At the same time, cameras – especially movie cameras – were changing the way in which people thought about their appearance and their self-presentation. Cheap mass-produced cameras with fast film could capture snapshots of faces and mouths in motion, fleeting moments of emotional weather. In silent films, faces and mouths were conduits of feeling and mood, and white teeth stood out well in early black and white.

One early marker of this changing attitude is a 1920 advertising campaign for Listerine mouthwash. Jordan Wheat Lambert, owner of the company that manufactured Listerine, had coined the term 'halitosis' as a scientific-sounding name for bad breath, and readers of his advertisements were warned of the social obloquy and romantic rejection they would face if they lacked lustrous teeth and fragrant breath. In his multimillion-selling *How to Win Friends and Influence People* (1936), Dale Carnegie put a more positive spin on the same idea: a broad, white-toothed smile was a prerequisite for success in any friendship, love affair or business deal. As Carnegie climbed the best-seller lists in the years after the Second World War, the post-war population boom was creating a generation of children whose teeth, strengthened by fluoridation, would require less basic filling and extraction, and whose parents, influenced by Carnegie and the growing cult of self-improvement, were willing and wealthy enough to pay for orthodontic work. In the late 1970s, the US Federal Trade Commission forced the American Dental Association to abandon its long-standing ban on advertising. Dentists and orthodontists developed a more overtly commercial identity, forming franchises and setting up in shopping malls alongside fried chicken joints and liquor stores.

This second Smile Revolution was the product of a web of cultural, technical and political influences. Americans smiled; Soviets scowled. Americans expressed themselves through consumption, believing that dress, physique, hairstyle and teeth revealed status, taste and values. If the American body were understood as a kind of property, straight white teeth could be a way to maximize its value, an investment for which it was well worth paying high fees and enduring long and uncomfortable sessions in the dental chair. To be American, to be beautiful, was to conform, to embody a mainstream

①

① This set of grillz has been inlaid with precious stones. Although grillz are removable, bacteria can get trapped and lead to gum disease and tooth decay. ② The gap between Brigitte Bardot's front teeth only added to the French star's captivating charm. ③ A teenage girl proudly displays her 'yaeba'. Yaeba, or double tooth, is a cosmetic procedure in which an upper canine is capped to create a crooked tooth with a fang-like appearance.

②

③

④ Grillz are seen by some as essential hip hop jewelry accessories. This gold set is made from stainless steel plated with 18 carat gold. ⑤ The distinctive gap-toothed smile of supermodel Georgia May Jagger is so coveted that demand among models for orthodontic procedures to emulate the look has grown enormously. ⑥ Yaeba is extremely popular in Japan, where a quirky smile is associated with innocence and youthfulness.

notion of healthy good looks.[7] Orthodontists offered men square masculine teeth and women rounded feminine teeth, and they encouraged their black patients to adhere to the beauty norms expressed in white middle-class Protestant culture and media – a target for the pioneers of hip hop in the early 1980s, who adopted gold or diamond tooth inlays as a way of mocking the materialistic mindset and racial inequalities of the Reagan years.

Over four centuries and more, our relationship with our teeth has changed radically. We expect them to remain strong, beautiful and useful throughout our lives, as long as we fulfil our side of the bargain by keeping them clean and well-maintained. When they cause us pain or practical difficulties, we visit a member of a respected and regulated profession, one that has gained equality with physicians and surgeons. Many children and adolescents will spend a decade or more in and out of dental surgeries, having braces fitted and tightened, so that as adults their smile will meet a cultural expectation of pearly perfection. Like previous generations, we buy toothbrushes and toothpastes and mouthwashes, and worry about bad breath and crooked teeth. Unlike our predecessors, we expect our dental care to be painless and effective. In terms of technical ability, twenty-first-century dentistry is better than anything that has come before – but the dental health of the world's poor, even in the wealthiest nations, is declining. The NHS faces an embattled future, while the American Dental Association continues to oppose the expansion of state programmes providing dental care. In an era of unprecedented wealth and continual crisis, of astonishing achievements in scientific medicine and growing global health inequality, dentistry remains a potent and troubling symbol of the challenges that lie behind a healthy, happy smile.

① Alyssa Picard, *Making the American Mouth: Dentists and Public Health in the Twentieth Century*, Rutgers University Press, 2009, p. 18.
② See Picard, 2009, p. 108.
③ Quoted in Nairn Wilson and Stanley Gelbier (eds), *The Regulation of the Dental Profession by the General Dental Council*, John McLean Archive, Witness Seminar 1, British Dental Association, 2014, p. 21.
④ Quoted in Tricia Starks, *The Body Soviet: Propaganda, Hygiene and the Revolutionary State*, University of Wisconsin Press, 2008, p. 173.
⑤ See Picard, 2009, p. 117.
⑥ Colin Jones, *The Smile Revolution in Eighteenth-Century Paris*, Oxford University Press, 2014, p. 15.
⑦ See Picard, 2009, p. 161.

A selection of advertising cards and packaging from the late nineteenth and early twentieth centuries. Kolynos emphasizes the scientific and economic advantages of its products whereas Gibbs and J. F. Hart promote the importance of looking after the teeth and preserving the gums. Dr W. Ziemer uses a portrait of Princess Alexandra to advertise his dentifrice in a magazine in *c.* 1890 and fragrant and antiseptic qualities are highlighted by both Dentyl and Doctor Smoker's Tooth Paste. The advertising leaflet for Dr Pierre's Eau Dentifrice, tooth paste and tooth powder was illustrated by Bernard Boutet de Monvel (with elements of his Morocco work, 1920–30).

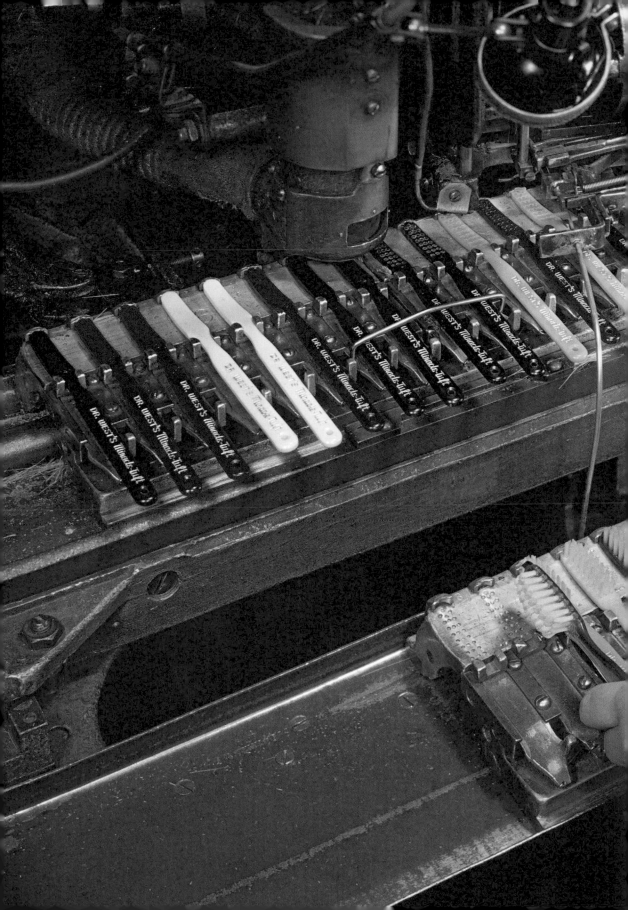

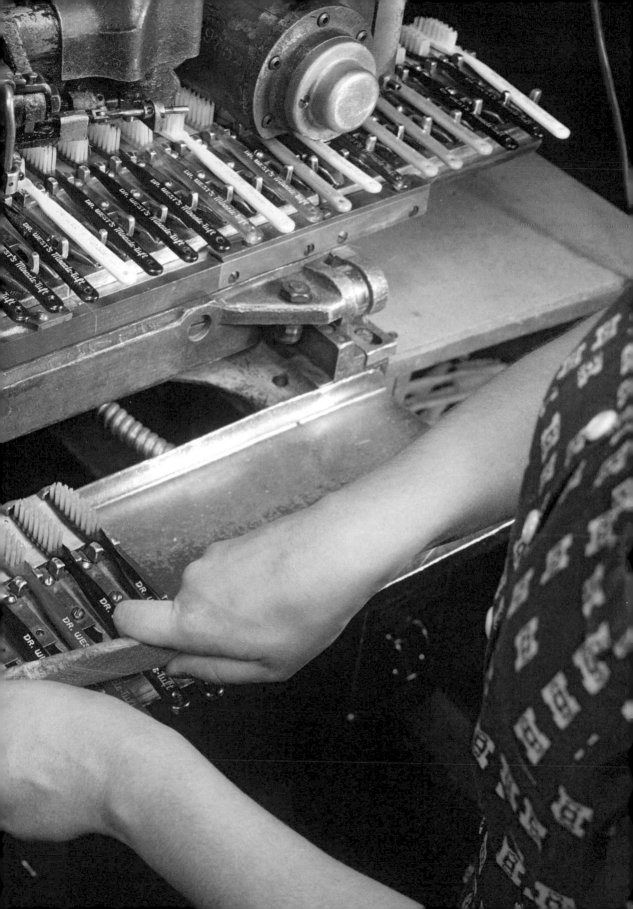

БИБЛИОТЕКА ЮНОГО ПИОНЕРА

Л. М. ВАСИЛЕВСКИЙ

ГИГИЕНА ПИОНЕРА

1925 РИД

НОВАЯ МОСКВА

PREVIOUS | Nylon is formed and hardened into toothbrush bristles at the DuPont factory in Leominister, Massachusetts (1939). The machine drills the holes in the handles, inserts the bristles and secures them.

ABOVE | The cover of L. M. Vasilevskii's book *Pioneer Hygiene* (1925).

TOP LEFT | An Italian advertisement from *c.* 1930
promotes the restorative properties of Lauro Olivo's
balsamic toothpaste. TOP RIGHT | This 1945 poster for
Binaca toothpaste is by Swiss artist Niklaus Stoecklin.
The text reads: 'Healthy teeth, shine like pearls!'

BOTTOM LEFT | Austrian firm Odol
promises 'beautiful teeth' in its poster
advertisement, originally published in 1925.
BOTTOM RIGHT | A mid-century Czech
advertisement for children's toothpaste.

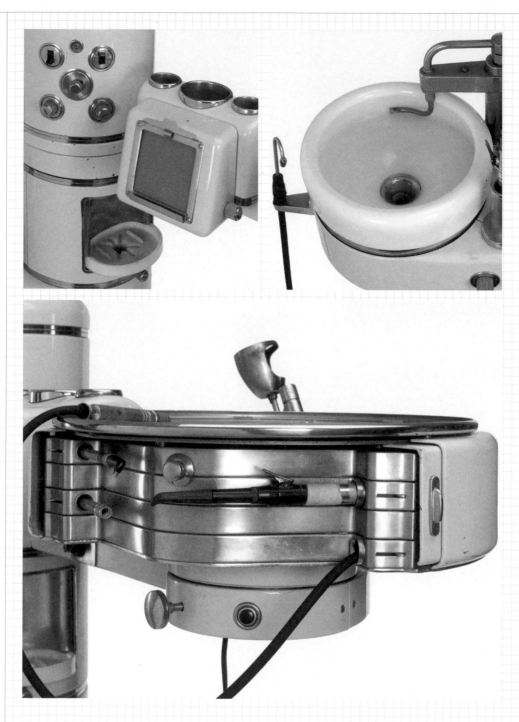

ABOVE | Details from a dental unit marketed as
the S.S. White Master Unite 'A', manufactured by
the S.S. White Dental Manufacturing Co. (1938–50).

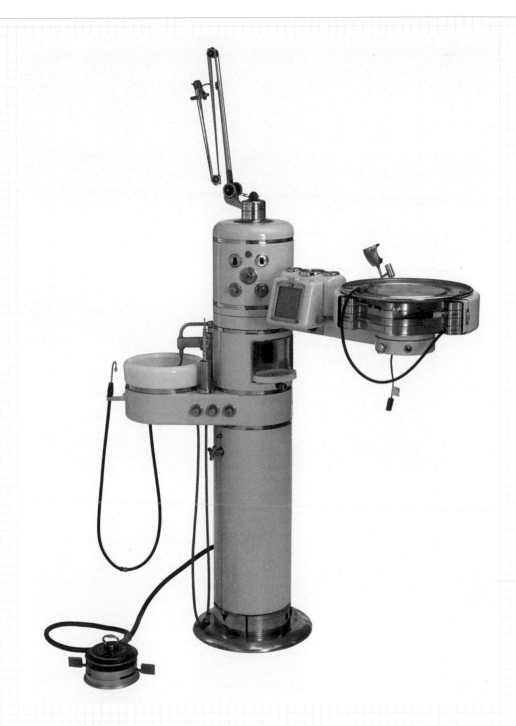

ABOVE | The S.S. White Master Unite 'A',
manufactured by the S.S. White Dental
Manufacturing Co. (1938-50) featured
a foot pedal to operate the drill.

OVERLEAF | Free-standing show card advertising
Phillips' dental magnesia toothpaste (c. 1969).
The paste contained milk of magnesia, which
dentists advised would dispel mouth acid.

RESOURCES

PLACES TO VISIT

Berliner Medizinhistorisches Museum der Charité · Charitéplatz 1, D 10117 Berlin, Germany · bmm-charite.de

British Dental Association Museum 64 Wimpole Street, London W1G 8YS, UK · bda.org/museum

Dema Foundation Dental Museum Ilesa Road, Ile-Ifa, Osun State 220005, Nigeria · demafoundation.org/home

Deutsches Hygiene-Museum Lingnerplatz 1, 01069 Dresden, Germany · dhmd.de

Dittrick Medical History Center Allen Memorial Medical Library, 11000 Euclid Avenue, Cleveland, OH 44106-1714, USA · case.edu/artsci/dittrick/museum

Henry Forman Atkinson Dental Museum, University of Melbourne 720 Swanston Street, Carlton 3053 Victoria, Australia · henryformanatkinsondentalmuseum.mdhs.unimelb.edu.au

Historical Dental Museum, Temple University · 3223 North Broad Street, Philadelphia, PA 19140, USA temple.pastperfect-online.com

Hunterian Museum at the Royal College of Surgeons · 35–43 Lincoln's Inn Fields, London WC2A 3PE, UK rcseng.ac.uk/museums/hunterian

Kotteman Gallery of Dentistry, University of Illinois at Chicago 801 S. Paulina Street, MC621, Chicago, IL 60612, USA · dentistry.uic.edu/alumni/historic_conservation

Macaulay Museum of Dental History, Medical University of South Carolina 175 Ashley Avenue, MSC 403 Charleston, SC 29425, USA waring.library.musc.edu/macaulay.php

Musee d'Art Dentaire Pierre Fauchard, Paris · Académie Nationale de Chirurgie Dentaire, 22 Rue Émile Ménier, Paris, France

Museo de Odontología, University of Madrid · Ciudad Universitaria, 28040 Madrid, Spain · ucm.es/english/dentistry

Museum of Medicine & Dentistry, Nippon Dental University · 1–8 Hamaura-cho Chuo-ku, Niigata 951-1500, Japan · www2.ndu.ac.jp/museum/

Muzeum w Raciborzu · ul. Rzeźnicza 15, 47-400 Racibórz, Poland · muzeum.raciborz.pl/

National Museum of Civil War Medicine 48 East Patrick Street, Frederick, MD 21705, USA · civilwarmed.org

National Museum of Dentistry, University of Maryland · 31 South Greene Street, Baltimore, MD 21201, USA · dentalmuseum.org

Old Operating Theatre and Herb Garret 9A St Thomas's Street, London SE1 9RY, UK · thegarret.org.uk

Science Museum · Exhibition Road, London SW7 2DD, UK sciencemuseum.org.uk

Sindecuse Museum of Dentistry, University of Michigan · 1011 North University Avenue G565, Ann Arbor, MI 48109, USA · dent.umich.edu/about-school/sindecuse-museum/sindecuse-museum-dentistry

Sirindhorn Dental Museum · First floor, HRH Princess Maha Chakri Sirindhorn 50th Birthday Anniversary Celebration Building, No. 6, Yothi Road, Rajthawee District, Bangkok 10400, Thailand dt.mahidol.ac.th/division/en_Museum_and_Archive_Unit/

Surgeon's Hall Museums · Nicolson Street, Edinburgh EH8 9DW, UK museum.rcsed.ac.uk/dental-collection

Thackray Medical Museum Beckett Street, Leeds LS9 7LN, UK thackraymedicalmuseum.co.uk

Wellcome Collection · 183 Euston Road, London NW1 2BE, UK wellcomecollection.org

Wellcome Library · 183 Euston Road, London NW1 2BE, UK wellcomelibrary.org

Zahnmuseum Linz · Hauptplatz 1, 4020 Linz, Austria · zahnmuseum-linz.at

Zahnmuseum Wien · Währinger Straße 25a, Λ-1090 Wien, Austria zahnmuseum.at

ORGANIZATIONS AND WEBSITES

American Academy of the History of Dentistry · historyofdentistry.org

American Dental Association Archives ada.org/en/member-center/ada-library/ada-archives

British Association of Dental Therapists badt.org.uk

British Dental Association bda.org

London's Pulse: Medical Officer of Health reports 1848–1972 wellcomelibrary.org/moh/

Virtual Dental Museum, University of the Pacific · dentalmuseum.pacific.edu/

Wellcome Images
wellcomeimages.org

JOURNALS

Dental Historian · bda.org/museum/
dental-links/lindsay-society

Journal of the History of Dentistry
histden.org/drupal/journal

GENERAL HISTORIES

Rachel Bairsto, *The British Dentist*,
Shire Library, 2015.

Robert Gregory Boddice (ed.),
Pain and Emotion in Modern History,
Palgrave Macmillan, 2014.

Constance Boquist and Jeannette
V. Haase, *An Historical Review of
Women in Dentistry: An Annotated
Bibliography*, US Department of
Health, Education, and Welfare, 1977.

Joanna Bourke, *The Story of Pain:
From Prayer to Painkillers*, Oxford
University Press, 2014.

Ann Dally, 'The lancet and the gum-
lancet: 400 years of teething babies',
The Lancet 348, 1996, pp. 1710–1711.

Peter Davis, *The Social Context of
Dentistry*, Croom Helm, 1980.

Umberto Eco (ed.), *On Ugliness* (trans.
Alastair McEwen), Harvill Secker, 2007.

Richard A. Glenner et al., *The
American Dentist: A Pictorial History
with a Presentation of Early Dental
Photography in America*, Pictorial
Histories, 1990.

Ove Hagelin and Deborah
Coltham, *Odontologia: Rare and
Important Books in the History
of Dentistry*, Swedish Dental
Society, 2015.

Gretchen E. Henderson, *Ugliness:
A Cultural History*, Reaktion, 2015.

Christine Hillam (ed.), *The Roots of
Dentistry*, British Dental Association /

Lindsay Society for the History of
Dentistry, 1990.

Roger King, *History of Dentistry:
Technique and Demand*, Wellcome
Unit for the History of Medicine, 1997.

Gerald Shklar and David Chernin, *A
Sourcebook of Dental Medicine: Being
a Documentary History of Dentistry
and Stomatology from the Earliest
Times to the Middle of the Twentieth
Century*, Maro Publications, 2002.

Ben Z. Swanson, *Methods and Media
of Dental Advertising, ca. 1700–1921,
with a catalogue of the dental
advertising ephemera in the
Wellcome Institute Library including
a scrapbook entitled 'Dental
Memoranda' collected by T. Purland,
1844*, University College, London,
M.Phil. thesis, 2 vols, 1987.

James Wynbrandt, *The Excruciating
History of Dentistry: Toothsome Tales
& Oral Oddities from Babylon to Braces*,
St Martin's Press, 1998.

**DENTISTRY IN PREHISTORY
AND THE ANCIENT WORLD**

Tammy R. Greene, *Diet and Dental
Health in Predynastic Egypt: A
Comparison of Dental Pathology,
Macrowear, and Microwear at
Hierakonpolis and Naqada*, PhD thesis,
University of Alaska, 2006.

Simon Hillson, *Teeth*, Cambridge
Manuals in Archaeology, Cambridge
University Press, 2005.

Fred Rosner, *Dentistry in the Bible,
Talmud and Writings of Moses
Maimonides*, American Academy
of the History of Dentistry, 1994.

EARLY EUROPEAN DENTISTRY

Charles Allen, *The Operator for the
Teeth* [1685] (ed. Ronald A. Cohen),
Dawson's, 1969.

Bartholomaeus Eustachius, *A Little
Treatise on the Teeth: The First
Authoritative Book on Dentistry* [1563]

(ed. David A. Chernin and Gerald
Shklar, trans. Joan H. Thomas),
Dental Classics in Perspective, 1999.

Arnauld Gilles, *The Flower of
Remedies Against the Toothache:
The First French Text on Dentistry
and the Disease of the Teeth* [1621]
(ed. Milton B. Asbell, trans. Jacques
R. Fouré), Dental Classics in
Perspective, 1996.

A. S. Hargreaves, *White as Whale
Bone: Dental Services in Early Modern
England*, Northern Universities Press,
1998.

Roger King, *The Making of the
Dentiste, c. 1650–1760*, Ashgate, 1998.

EIGHTEENTH-CENTURY DENTISTRY

Mark Blackwell, 'Extraneous
Bodies: The Contagion of Live-Tooth
Transplantation in Late Eighteenth-
Century England', *Eighteenth-Century
Life* 28, 2004, pp. 21–68.

Robert Darnton, *George Washington's
False Teeth: An Unconventional
Guide to the Eighteenth Century*,
W. W. Norton, 2003.

Christine Hillam, *Brass Plate and
Brazen Impudence: Dental Practice
in the Provinces, 1755–1855*, Liverpool
University Press, 1991.

Christine Hillam (ed.), *Dental Practice
in Europe at the End of the Eighteenth
Century*, Rodopi, 2003.

John Hunter, *The Natural History
of the Human Teeth*, J. Johnson, 1778.

Colin Jones, *The Smile Revolution
in Eighteenth-Century Paris*, Oxford
University Press, 2014.

Stephanie Pain, 'The Great Tooth
Robbery', *New Scientist*,
16 June 2001.

Ruth Richardson, 'Transplanting Teeth:
Reflections on Thomas Rowlandson's
"Transplanting Teeth"', *The Lancet* 354,
1999, p. 1740.

NINETEENTH-CENTURY DENTISTRY

Arden G. Christen and Peter M. Pronych, *Painless Parker: A Dental Renegade's Fight to Make Advertising 'Ethical'*, American Academy of History of Dentistry, 1995.

J. A. Donaldson, *The National Dental Hospital 1859–1914*, British Dental Association, 1992.

Joseph Fox, *The Natural History and Diseases of the Human Teeth*, E. Cox and Son, 1814.

Alfred Hill, *The History of the Reform Movement in the Dental Profession in Great Britain During the Last Twenty Years*, Trübner & Co, 1877.

Christine Hillam, *James Robinson (1813–1862): Professional Irritant and Britain's First Anaesthetist*, Lindsay Society for the History of Dentistry, 1996.

Helen Scott Marlborough, *The Emergence of a Graduate Dental Profession, 1858–1957*, University of Glasgow PhD thesis, 1995.

Richard Skinner, *A Treatise on the Human Teeth* [1801] (ed. Max Geschwind), Argosy Antiquarian, 1967.

Ernest G. Smith and Beryl D. Cottell, *A History of the Royal Dental Hospital of London and School of Dental Surgery, 1858–1985*, Athlone Press, 1997.

Nairn Wilson and Stanley Gelbier (eds.), *The Regulation of the Dental Profession by the General Dental Council*, British Dental Association, 2014.

TWENTIETH-CENTURY DENTISTRY

Anthony Freeman and Tom Sholl, *This is the DPB: The History of a Quango 1948 to 1998*, Dental Practice Board, 2000.

Stanley Gelbier, *Development of Industrial Dental Services in the United Kingdom*, Lindsay Society for the History of Dentistry, 1999.

Bernard Harris, *The Health of the Schoolchild: A History of the School Medical Service in England and Wales*, Open University Press, 1995.

Ruth Roy Harris, *Dental Science in a New Age: A History of the National Institute of Dental Research*, Iowa State University Press, 1992.

Alyssa Picard, *Making the American Mouth: Dentists and Public Health in the Twentieth Century*, Rutgers University Press, 2009.

Michael Ryan, *The Organization of Soviet Medical Care*, Blackwell, 1978.

David Charles Sloane and Beverlie Conant Sloane, *Medicine Moves to the Mall*, Johns Hopkins University Press, 2003.

Tricia Starks, *The Body Soviet: Propaganda, Hygiene and the Revolutionary State*, University of Wisconsin Press, 2008.

Nicholas Timmins, *The Five Giants: A Biography of the Welfare State*, HarperCollins, 1995.

Charles Webster, *The National Health Service: A Political History*, Oxford University Press, 2002.

Nairn Wilson and Stanley Gelbier (eds.), *The Changes in Dentistry Since 1948*, British Dental Association, 2014.

Nairn Wilson and Stanley Gelbier (eds.), *The Changing Role of Dental Care Professionals*, British Dental Association, 2014.

Nairn Wilson and Stanley Gelbier (eds.), *The Dental Press*, British Dental Association, 2014.

DENTISTRY AND WAR

Leslie J. Godden, *History of the Royal Army Dental Corps*, Royal Army Dental Corps, 1971.

Handbook for Royal Naval Dental Surgery Assistants, HMSO, 1957.

Jacqueline Healy (ed.), *Compassion and Courage: Australian Doctors and Dentists in the Great War*, Medical History Museum, University of Melbourne, 2015.

John M. Hyson Jr. et al., *A History of Dentistry in the US Army to World War II*, US GPO, 2008.

Emily Mayhew, *Wounded: From Battlefield to Blighty, 1914–1918*, Bodley Head, 2013.

FORENSIC DENTISTRY

Christopher Joyce and Eric Stover, *Witnesses from the Grave: The Stories Bones Tell*, Little, Brown & Co, 1991.

Søren Keiser-Nielsen, *Teeth That Told: A Selection of Cases in which Teeth Played a Part*, Odense University Press, 1992.

William R. Maples and Michael Browning, *Dead Men Do Tell Tales: The Strange and Fascinating Cases of a Forensic Anthropologist*, Doubleday, 1994.

Robert Sullivan, *The Disappearance of Dr Parkman*, Little, Brown & Co, 1971.

DENTAL TOOLS AND MATERIALS

William J. Carter and Jean Graham-Carter, *Dental Collectibles and Antiques*, Dental Folklore Books, 1992.

Janine E. Meads, *The History and Development of Denture Materials*, University of Wales, 1993.

Hans Sachs, *The Toothpick and its History* (trans. Anna C. Souchuk), Steven R. Potashnick, 2010.

Nairn Wilson and Stanley Gelbier (eds.), *The History and Impact of Development in Dental Biomaterials over the Last 60 Years*, British Dental Association, 2014.

John Woodforde, *The Strange Story of False Teeth*, Routledge & Kegan Paul, 1968.

SOURCES OF ILLUSTRATIONS

All images courtesy of
Wellcome Library, London,
unless otherwise stated.

a = above
b = below
c = centre
l = left
r = right

25l AF archive/Alamy Stock Photo; 25c, 25r Warner Bros./The Kobal Collection; 26l Museum of Fine Arts, Budapest; 27l Galleria Borghese, Rome; 27c Uffizi, Florence; 27r Museo Nazionale di San Martino, Naples. Photo akg-images/De Agostini Picture Lib./A. Dagli Orti; 28 British Museum, London (EA2479); 32a Chronicle/Alamy Stock Photo; 32c Museum of Egyptian Antiquities, Cairo; 32b Ottoman miniature, reproduction; 33a The Print Collector/Alamy Stock Photo; 33c Museo Egizio, Turin. Photo akg-images/De Agostini Picture Lib./G. Dagli Orti; 33b 'The Tooth Worm as Hell's Demon', 18th century carved ivory, unknown artist, Southern France; 34b, 35b Stichting Vrienden Tandheelkundig Erfgoed, University Museum, Utrecht; 38, 39 Kyoto National Museum (A甲679); 40cl, 40c, 40cr, 40bl, 40bc, 40br, 41 (all images) Stichting Vrienden Tandheelkundig Erfgoed, University Museum, Utrecht; 42 Photo Steve Gordon/Dorling Kindersley/Getty Images; 44c Musée du Louvre, Paris. Photo Masterpics/Alamy Stock Photo; 44b Illustration by Gustave Doré, prologue from book 1 of The Works of Rabelais, 1894, François Rabelais, translated by Sir Thomas Urquhart of Cromarty and Peter Antony Motteux; 45c Elizabethan Gardens of North Carolina; 45b Illustration by Gustave Doré, Pantagruel's Meal, from Gargantua and Pantagruel, François Rabelais, published in The Works of Rabelais, 1894, translated by Sir Thomas Urquhart of Cromarty and Peter Antony Motteux; 46c Bibliothèque nationale de France, Paris; 47a Bibliothèque nationale de France, Paris/akg-images; 47c Prado Museum, Madrid; 48a, 49a, 49c, 60a, 61a, 61bl, 61br, 66a, 66b, 67a Stichting Vrienden Tandheelkundig Erfgoed, University Museum, Utrecht; 67b Gift of Dr G. J. Schade, Stichting Vrienden Tandheelkundig Erfgoed, University Museum, Utrecht; 72a Stichting Vrienden Tandheelkundig Erfgoed, University Museum, Utrecht; 72c Photo De Agostini Picture Library/M. Carreri/Getty Images; 73c Galleria dell'Accademia/Leemage/Getty Images; 74a, 75a Stichting Vrienden Tandheelkundig Erfgoed, University Museum, Utrecht; 82–83 Museum of Anthropology, St Petersburg (4336). Photo akg-images; 90a, 91a Collection of George Washington's Mount Vernon, VA; 92a Church of Santa Maria della Vittoria, Rome; 92c National Gallery of Art, Washington, D.C. Andrew W. Mellon Collection (1942.8.5); 93a Spanish Embassy, Rome; 93c State Hermitage Museum, St Petersburg; 94a Photo phisick.com; 95a Early set of ivory dentures; 95c Photo phisick.com; 98c Shipley Art Gallery, Gateshead, Tyne & Wear, UK; 98b Victorian bottle of clove oil; 99c Private collection/Mondadori Portfolio/Getty Images; 102a, 103b Stichting Vrienden Tandheelkundig Erfgoed, University Museum, Utrecht; 164a Photo Mark Jay Goebel/Getty Images; 164c Library of Congress, Prints and Photographs Division, Washington, DC. (LC-DIG-det-4a11783); 164b Library of Congress, Prints and Photographs Division, Washington, D.C. (LC-DIG-nclc-05174); 165a Library of Congress, Prints and Photographs Division, Washington, D.C. (LC-USZ62-35751); 165c Photo dentalposterart.com; 165b New York Public Library, The Miriam and Ira D. Wallach Division of Art, Prints and Photographs: Photography Collection, 1956; 166a, 167a Photo phisick.com; 167c Photo acuriouscollector.com; 167b Cocaine medicine advert, 1885; 168a Photo of a woman dentist performing tooth extraction, 1909; 168b Photo of a promotional stunt by Painless Parker, c. 1900; 169a New York Public Library. Schomburg Center for Research in Black Culture, Jean Blackwell Hutson Research and Reference Division; 169c Collections of Strong Historical Society/Courtesy vintagemaineimages.com; 169b Photo Museum of the City of New York/Byron Collection/Getty Images; 202a Massachusetts Historical Society; 202c, 202b, 203a, 203c US National Library of Medicine, Bethesda, MD; 203b Harvard School of Dental Medicine, Boston, MA. Collections of the Boston Medical Library Museum, Rare Books Collection (Ref. KF224.W38B4 1850); 204a U.S. National Library of Medicine, Bethesda, MD; 204c Moscow Special Archive; 204b Only known photograph of Karl Denke, 1924, after his suicide; 205a, 205c Moscow Special Archive; 205b Photograph of teeth of the victims of Karl Denke, 1920s; 206a Photo Russell McPhedran/Fairfax Media via Getty Images; 206c Natural History Museum/Alamy Stock Photo; 206b Library of Congress, Prints and Photographs Division, Washington, D.C. (LC-B2- 2868-2); 207a Photo Fairfax Media via Getty Images; 207b Skulls of the Tsar Romanov's family, found in St Petersburg cathedral; 217, 222 British Dental Association Museum/Science Photo Library; 224–225 Russian State Library, Moscow; 226 © jondpatton/istockphoto.com; 228a Illustration by Arthur Rackham from A Midsummer Night's Dream, by William Shakespeare. William Heinemann Ltd, London, 1908; 228c akg-images/Album/Frank Powolny; 228b Photo dentalposterart.com; 229a Private collection; 229c Bettmann; 230a Bettmann/Getty Images; 230c Photo K.K. Kriegspressequartier, Lichtbildstelle, Vienna/ÖNB-Bildarchiv/picturedesk.com/TopFoto; 230b Army Medical Services Museum, Keogh Barracks, Aldershot, UK. Wellcome Images; 231c Roger-Viollet/TopFoto; 231b Army Medical Services Museum, Keogh Barracks, Aldershot, UK. Wellcome Images; 232a RAMC Muniment Collection in the care of the Wellcome Library; 232c, 232b Photo dentalposterart.com; 233a Southwark Local History Library and Archive, London. Wellcome Images; 233c Poster issued by the Ministry of Health, UK 1960s; 233b Photo Orlando/Three Lions/Getty Images; 234a Photo dentalposterart.com; 234c Photo Fox Photos/Getty Images; 234b Photo Orlando/Getty Images; 235a Photo Popperfoto/Getty Images; 235c TopFoto; 235b Photo Orlando/Three Lions/Getty Images; 236a Set of grillz, precious stones; 236c Photo Du Film/Del/REX/Shutterstock; 236b Tomomi Itano; 237a Set of grillz, gold; 237c Georgia May Jagger; 237b Aki Toyosaki; 240-241 The Art Archive/Willard Cukver/NGS Collection; 242 Russian State Library, Moscow; 243al Lauro Olivo toothpaste advert, Italy, c. 1930; 243ar Binaca toothpaste advert, Germany, 1945; 243bl Odol toothpaste advert, Austria, 1925; 243br Snežienka toothpaste advert, Czechoslovakia.

INDEX